York Hovest

HEROES
OF THE SEA

**A Marine Journey
with the Protectors
of our Great Oceans**

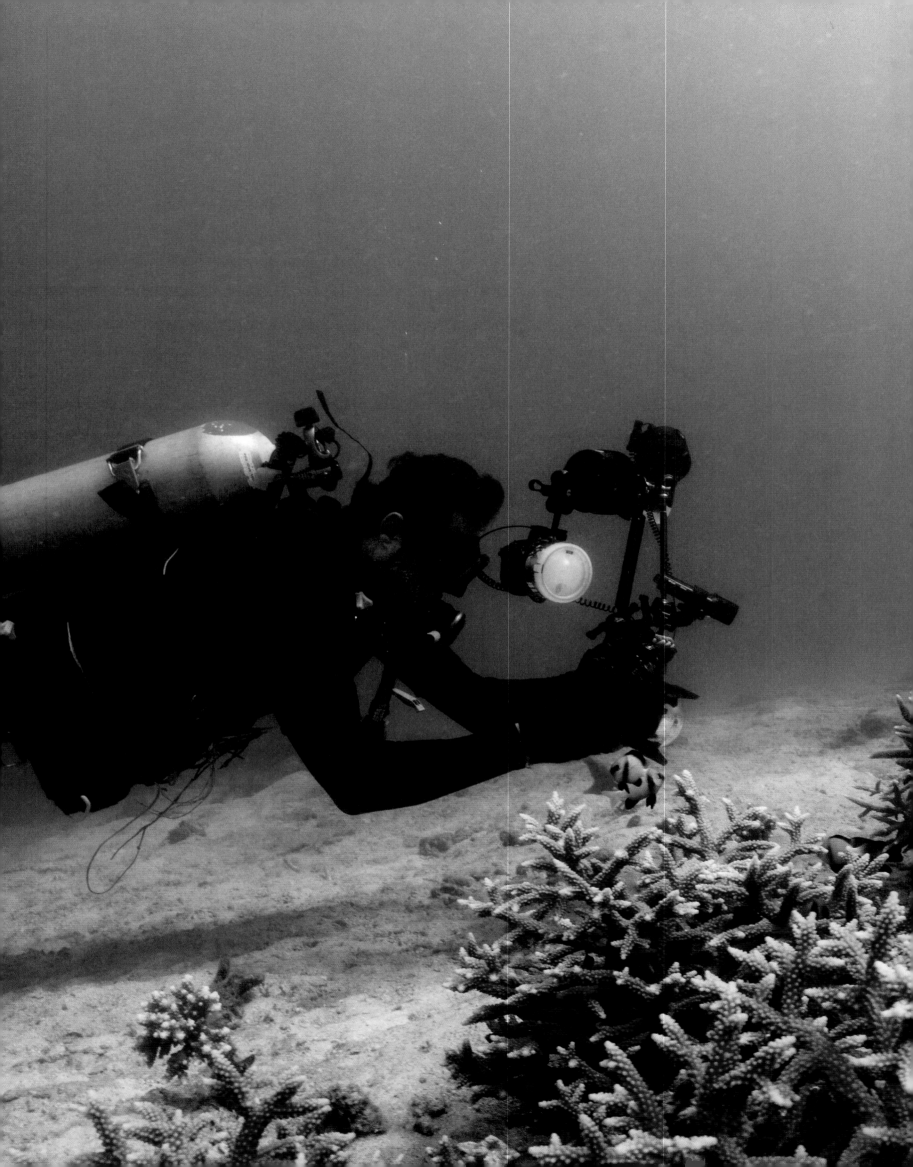

York Hovest

HEROES
OF THE SEA

**A Marine Journey
with the Protectors
of our Great Oceans**

teNeues

Foreword

"If the ocean dies, we die!"

This quote, by Paul Watson, who founded the marine conservation organization Sea Shepherd, is pretty much to the point. It ought to be a wake-up call for all of us!

For it is no longer possible to deny one fact: The sea is dying. And that is a catastrophe, not only for someone like me who has felt connected to the sea for as long as he can remember; this catastrophe concerns all of us. It is a global tragedy.

Pollutants, such as untreated waste water, plastics or petroleum, are still finding their way into the oceans in far-too-large quantities. Overfishing, bycatch, and climate change are threatening the existence of entire species in marine habitats. Unbridled extraction of raw materials from the sea as well as ocean acidification are also contributing to marine ecosystems teetering on the verge of collapse in many places.

At the same time, we are dependent on the sea. It serves as a fundamental source of food for millions of people. The oceans supply 70 percent of the worlds' oxygen. They regulate the climate and they are the driving force behind the water cycle, without which there would be no life on earth. If the sea dies, not only humanity will perish, but likely all other life on our planet.

But of course, sticking your head in the sand is no alternative. So the questions we ought to be asking ourselves are very clear: What could be solutions to the problems faced by our oceans and by the animals and plants living in them? What steps must be taken to save our seas from ecological collapse? And above all: What is the best way to spread the knowledge of these solutions?

With this book, an important part of my global project "Heroes of the Sea," I would like to demonstrate the beauty of what we stand to lose if we do not start on a path of sustainably protecting our seas—and soon. I would also like to introduce my readers to some impressive ideas of what those solutions look like. Above all, there is one thing to be learned from the people I am portraying here: The main thing is that we all begin to take action. Naturally, not everyone has to suddenly become an activist or a certified diver; rather, these examples show that there are many ways to get involved.

A Gift from the Sea-Gods?

My own path toward saving our oceans (the one that led me to this project) opened up a few years ago with a twist of fate. By the time it happened, I had already committed myself to the topic of oceans and had realized how urgently we all need to do something.

The only thing I didn't have at that time was the seed money for this project. I sat on the beach, in a funk over my situation of wanting to do something, and just not having the financial means. The sound of the waves crashing, the wind ... alone with my thoughts. But late in the afternoon, while walking back to my parking spot, I came across a strange, foul-smelling hunk of material. Its extraordinary shape fascinated me and I decided to take it with me.

At that moment, it wasn't clear to me what I had found. But afterwards it would end up enabling me to pay for the important first journeys: It all began with a clump of ambergris. A valuable gift of the sea and of fate is, what enabled me to launch this project. This wax-like substance, a secretion of sperm whales that sometimes washes up on ocean beaches, is very rare and is used in the manufacture of expensive perfume. Today, with so many journeys and a successful crowdfunding campaign behind me, I would like to give something back to the sea. My goal with this book is to show how urgently we all need to begin acting on behalf of our oceans—just like the heroes depicted on the following pages are already doing. They are role models who we all can learn from. Not only will the sea benefit from their work, but ultimately, so will we. Because if the oceans survive, maybe humankind will survive too.

York Hovest

Contents

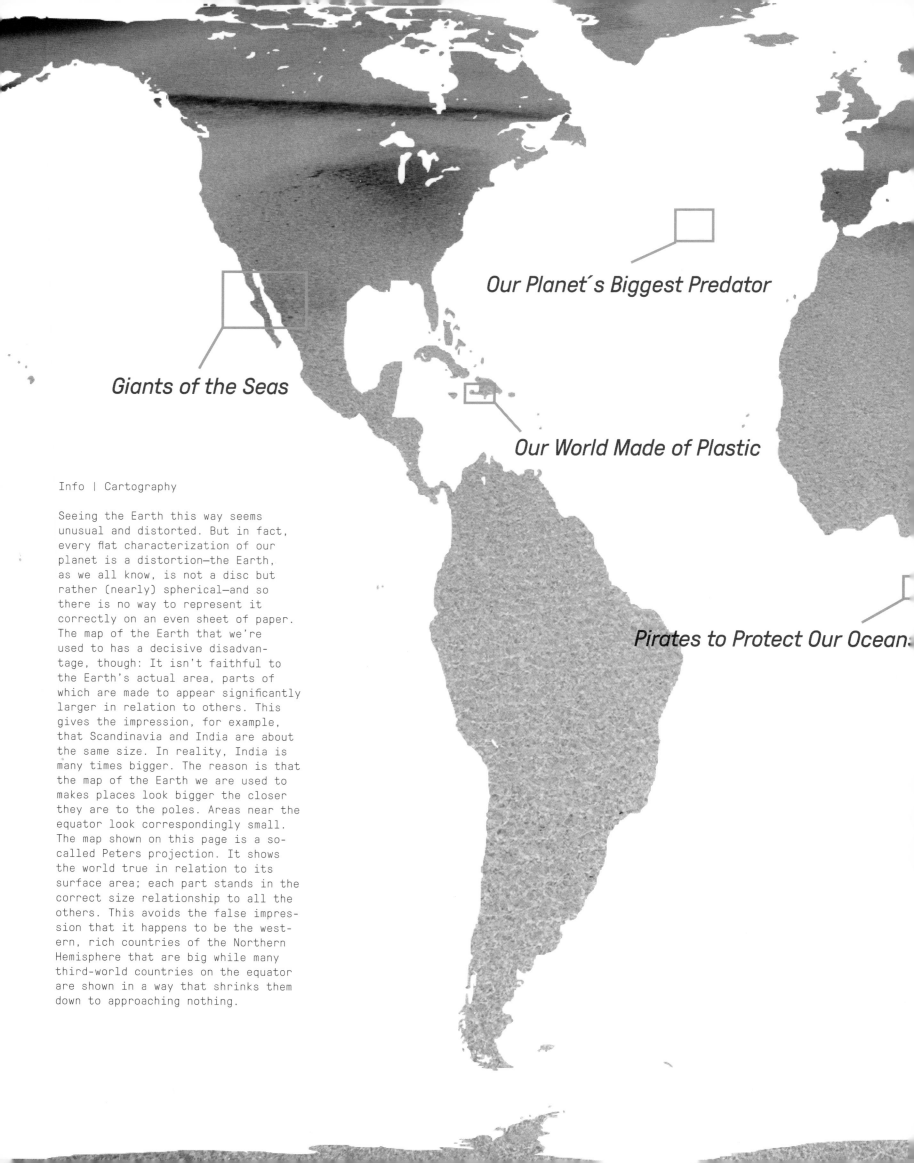

Our Planet´s Biggest Predator

Giants of the Seas

Our World Made of Plastic

Pirates to Protect Our Ocean

Info | Cartography

Seeing the Earth this way seems unusual and distorted. But in fact, every flat characterization of our planet is a distortion—the Earth, as we all know, is not a disc but rather (nearly) spherical—and so there is no way to represent it correctly on an even sheet of paper. The map of the Earth that we're used to has a decisive disadvantage, though: It isn't faithful to the Earth's actual area, parts of which are made to appear significantly larger in relation to others. This gives the impression, for example, that Scandinavia and India are about the same size. In reality, India is many times bigger. The reason is that the map of the Earth we are used to makes places look bigger the closer they are to the poles. Areas near the equator look correspondingly small. The map shown on this page is a so-called Peters projection. It shows the world true in relation to its surface area; each part stands in the correct size relationship to all the others. This avoids the false impression that it happens to be the western, rich countries of the Northern Hemisphere that are big while many third-world countries on the equator are shown in a way that shrinks them down to approaching nothing.

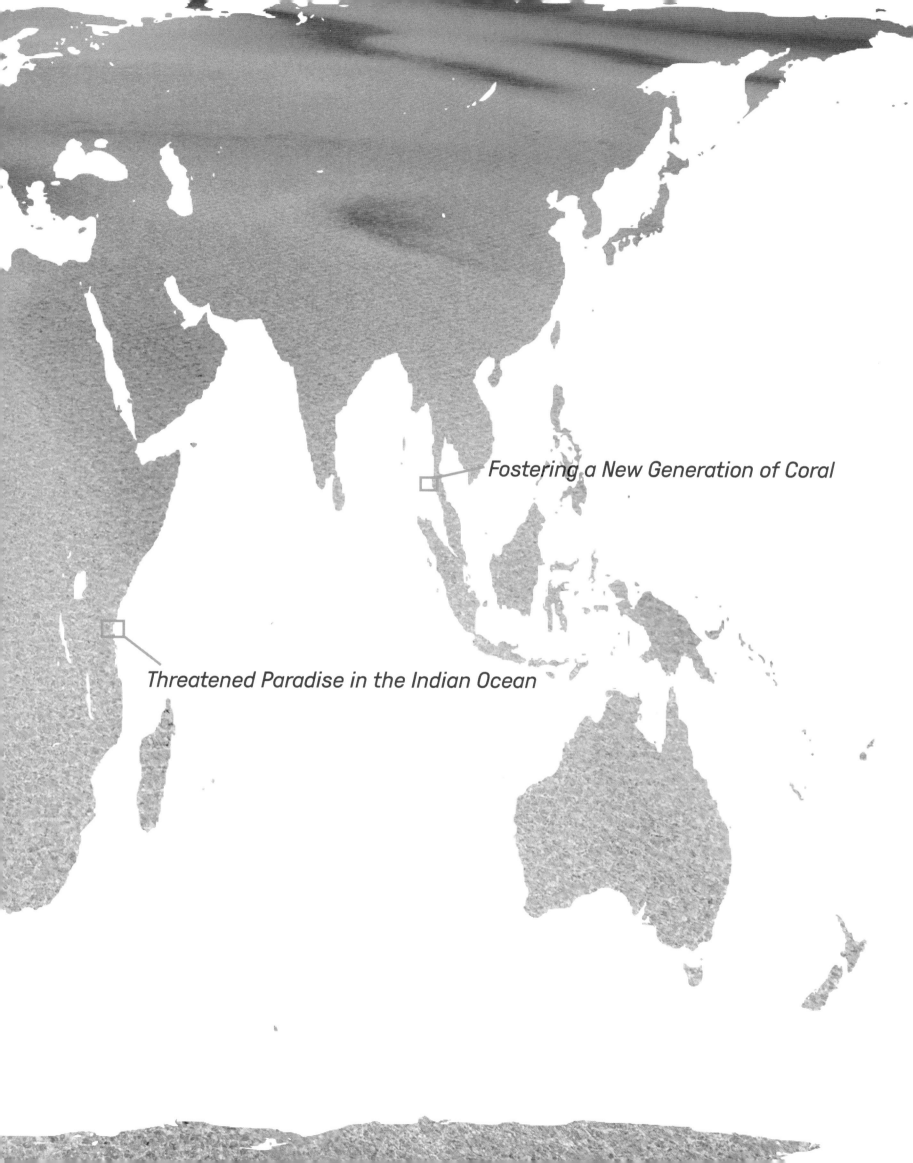

Fostering a New Generation of Coral

Threatened Paradise in the Indian Ocean

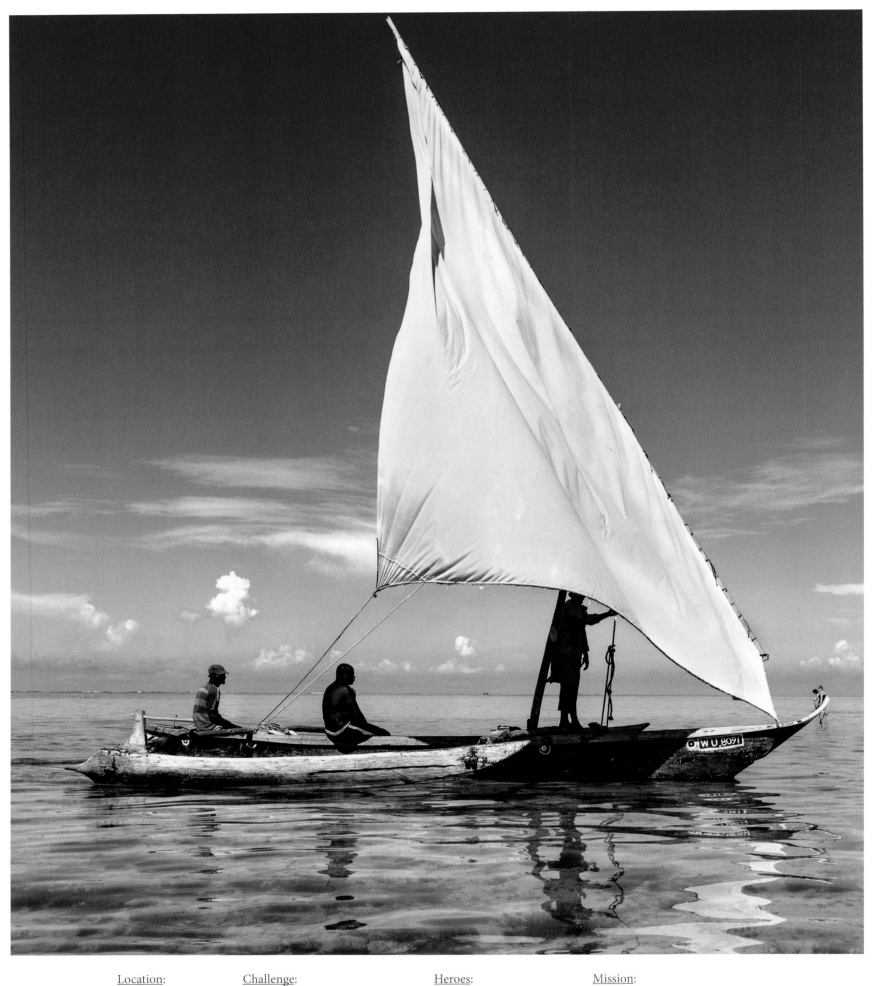

Location:	Challenge:	Heroes:	Mission:
Indian Ocean	Exploitation of coastal seas	Scientists and marine biologists	Research
East Africa			Education
Tanzania		Leibniz Centre for Tropical Marine Research (ZMT)	Fieldwork and determining what measures to put in place
Zanzibar			
Chumbe Island			

Threatened Paradise in the Indian Ocean

Zanzibar. The origin of countless tales of adventure and a place that inspires longing in many travelers the world over. Like almost nowhere else on earth, the mystical sound of the name arouses a feeling of wanderlust.

Azure water off endless white beaches; a labyrinthine, picturesque old town bearing the imprint of Islam; an exotic culture with fascinating customs, traditions and histories; and, of course, the everlasting near-equatorial sun. Zanzibar sounds, to the ears of many, like the purest of paradises.

But together with climate change, it is precisely this pull that puts the biggest burden on the ecosystems along the region's coasts. For wherever tourists go in droves, the souvenir trade is not far away. Who doesn't like to take a little memento home to those we left behind? Here a small carving by a local; there a brightly-colored shell from the beach around the corner. It supports local business. And nobody gets hurt. Or do they?

A study being conducted here in Zanzibar by two scientists from the Leibniz Centre for Tropical Marine Research (for short: the ZMT) focuses on precisely these keepsakes, these handsome, colorful shells that are sold on every corner, in many shops, on the beach and in the hotels.

Zanzibar: A Hotspot in the Indian Ocean

The trip to Zanzibar goes off without a hitch. Of course it does: Since it is so popular with vacationers, all the logistical components are perfectly arranged, carrying tourists from all over the world to this island off the coast of Tanzania, in East Africa, just a few hundred kilometers south of the equator, every day, right on target. The dozens of hotels lining the most popular beaches offer a Western standard of accommodation.

I too, have booked an air-conditioned room for the first few days, but in a small, family-run apartment building in Stone Town instead, where the ZMT staff members are also staying. Like me, they have made the trip from Germany. My plan for the next few days is to accompany the biologists Gita and Theresa to learn something about their work which is so important for the survival of our seas.

The findings of biologists and other scientists will be indispensable when it comes to planning suitable measures towards effective solutions to the problems facing our oceans. They are the ones with the ability to research the complex biological and social relationships within an ecosystem and to interact with the people directly affected. They can figure out what steps to take. Especially somewhere like here, in Zanzibar.

I meet the two young women at breakfast and together we go over the agenda for the day. First come the obligatory stops at a few government offices to get the paperwork they and I both need for our work here. After that, we are to meet some local scientists who work closely with the ZMT. Though I maintain a discreet presence in the background, I quickly realize that the actual fieldwork will have to wait for a lot of bureaucracy and formalities. The task before us is a difficult one. On the one hand, the researchers are studying the health of the coastal waters, collecting data, and taking and evaluating samples. That's the scientific part. And then comes the human side of things; for the local residents here are also suffering from increasing exploitation of our seas and from the pollution and overburdening of our planet. In Zanzibar, the locals are no longer able—and for a

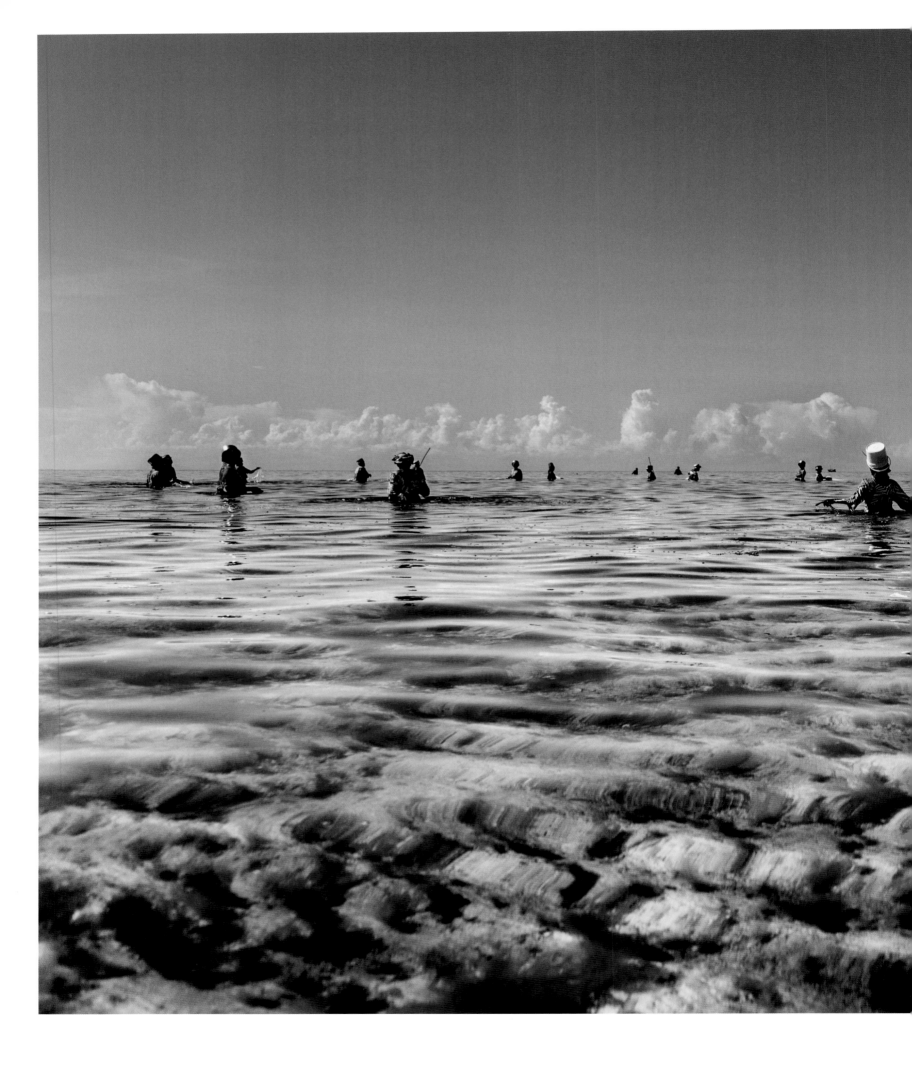

Threatened Paradise in the Indian Ocean

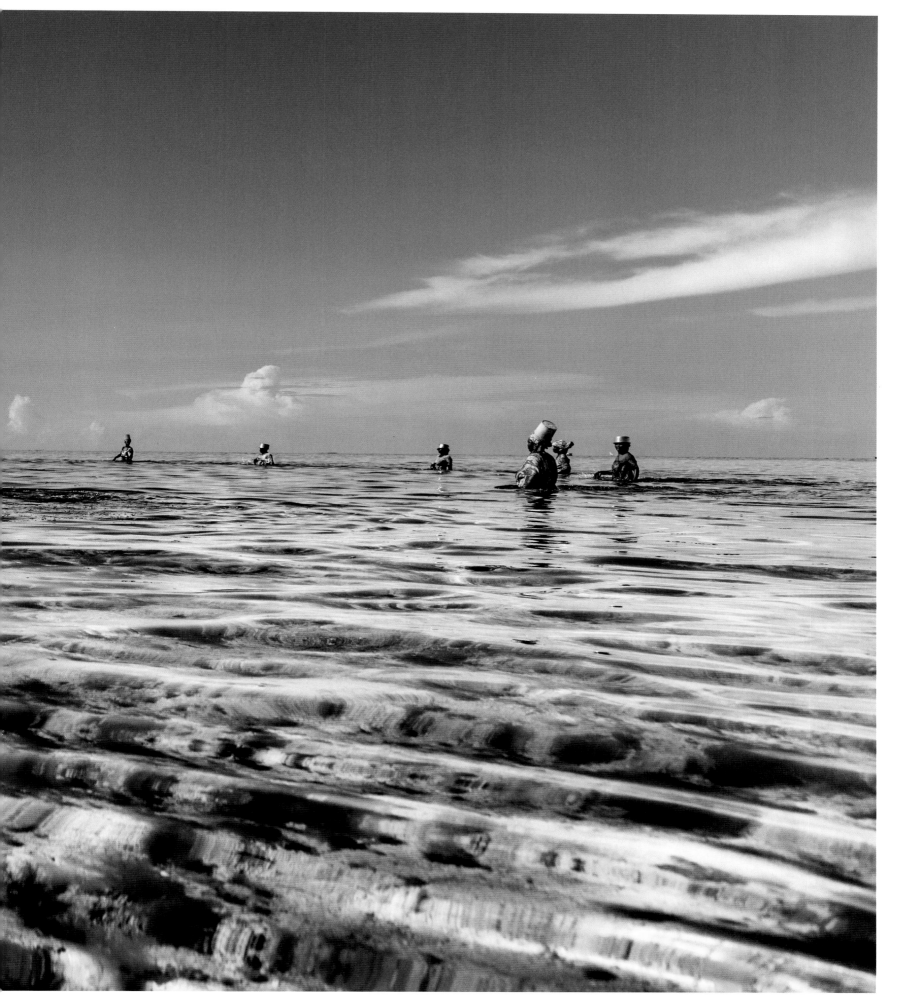

The women of Zanzibar are hunting for squid and shellfish in the shallow waters. Most of them have never learned to swim, therefore they do not venture into deeper regions. They carry the buckets on their heads in order to keep their hands free for gathering and hunting.

The approach here is thus to look for solutions in partnership with those affected, so that everyone ends up better off.

INFO | LANGUAGE

Arabian merchants travelled to the Zanzibar Archipelago as early as the eighth century. Communication between the merchants and the natives was difficult, and the result was Swahili, a language that merges Arabic and the language of the indigenous Zanzibaris. Today, there are more than 80 million Swahili speakers in the world.

long time now have no longer wanted—to rely on fishing for their livelihood. Even here, the consequences of climate change have almost completely destroyed the coral—and with it, the means of survival of many other sea creatures. This has resulted in a gradual disappearance of the resident animal population, which in turn has forced fisherman to look elsewhere for sources of additional income.

The trade in seashells is so lucrative that many here engage in it, despite the fact that the exportation of many species is banned (including in Tanzania) under the Washington Convention on international trade in endangered species. Originally, the mollusks were simply part of the traditional local diet, and their shells were usually discarded. Big piles of them would accumulate behind people's houses, or they were fed to the chickens; and a few particularly beautiful specimens would be made into jewelry. Not until it became apparent that tourists were prepared to pay high prices for the seashells did collecting them become a business of significant consequence. Since then, the number of animals taken from the sea has risen sharply.

Through their fieldwork, Gita and Theresa would like to determine how much the mollusk populations in the harvesting areas differ from those in comparable nature preserves. But in order to use all this information to develop measures that can help improve coastal ecosystems, the researchers are also interviewing the locals to find out what they know about the species of mollusks being collected (whether traditionally or for sale) and incorporate that knowledge into

the study. The approach here is thus to look for solutions in partnership with those affected so that everyone ends up better off.

Seashells: Indispensable to the whole Ecosystem

Mollusks are as much a part of an intact ecosystem as the coral, the fish, or any other marine creature. They are an important indicator of water quality, because they filter large amounts of water in search of food; they are therefore exposed to whatever toxins the water is carrying. Their bodies can later be analyzed for such toxins, and the findings support inferences about the quality of the water.

As a source of calcium carbonate, even the empty shells of dead bivalves and snails are essential to a functioning coastal ecosystem. The calciferous shells they leave behind gradually dissolve in or are pulverized by the action of the water. What the shells yield can then be taken up by other sea creatures (such as corals and subsequent generations of bivalves and snails) to build their own skeletons of calcium carbonate. But if large quantities of bivalve and snail shells are removed from the sea and wind up as bathroom or windowsill ornaments, then they are missing from the ecosystem, and its inhabitants are deprived of the chemical; the creatures can no longer support their bodies sufficiently or protect themselves from predators. The scientists are interested in future developments in the regions they are working in, and in possible ways

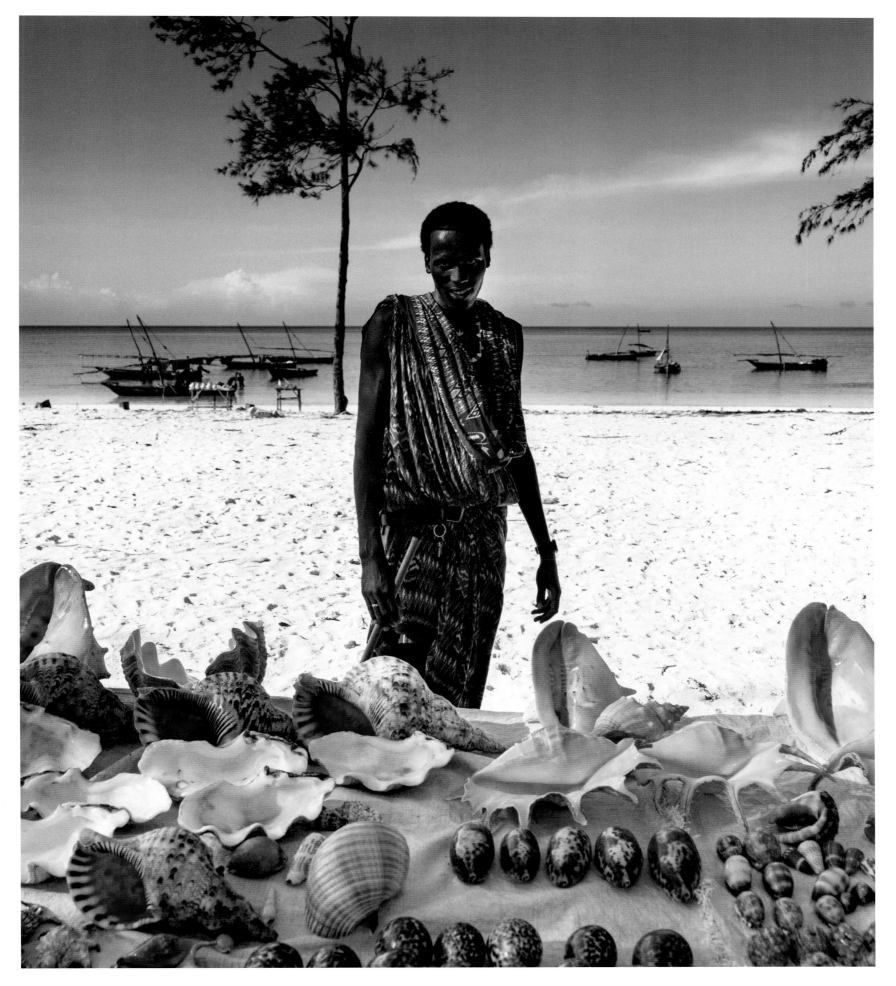

One of the many sea shell vendors on the beaches in Zanzibar. For many locals, selling sea shells is an important supplementary income. It can make up for the financial losses that are the result of increasingly poor catches.

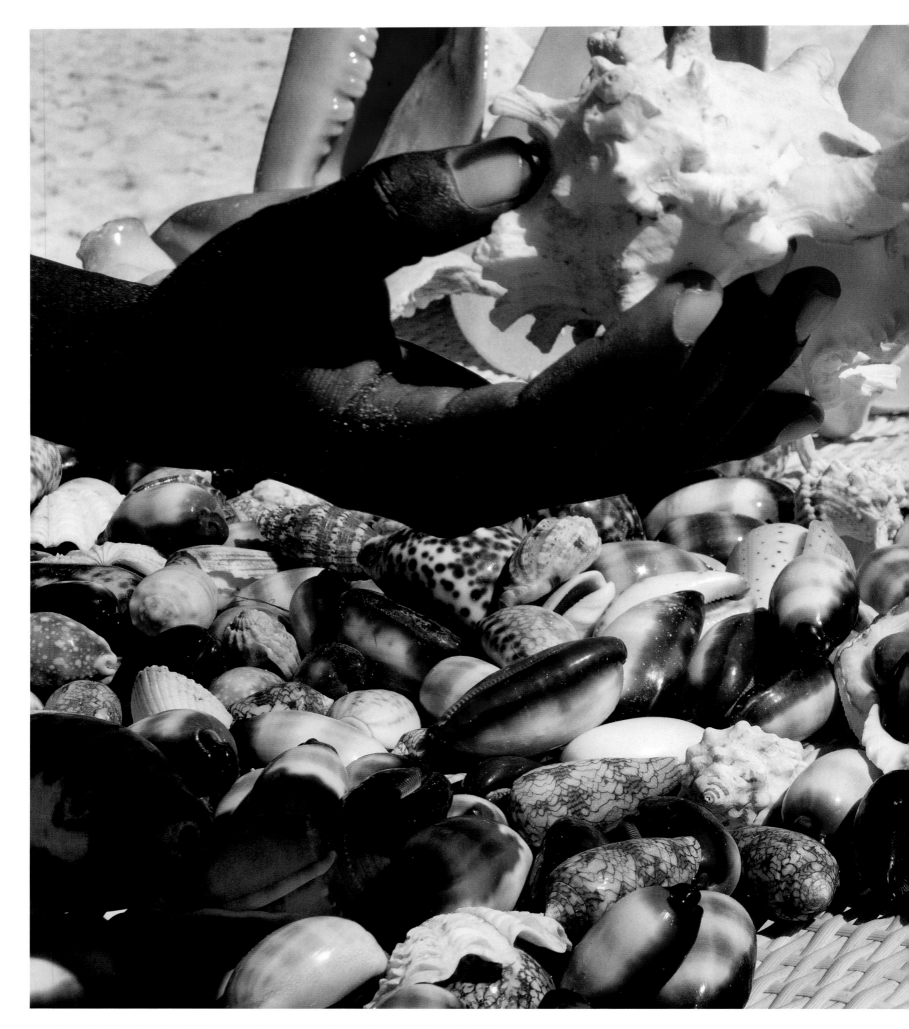

They shine in various beautiful colors and shades, from bright white to apricot to rich mahogany brown. Sea shells are a popular souvenir for tourists in Zanzibar and most buyers do not stop to think about whether this trade might be illegal, or how important these animals might be for the marine and coastal ecosystems.

Threatened Paradise in the Indian Ocean

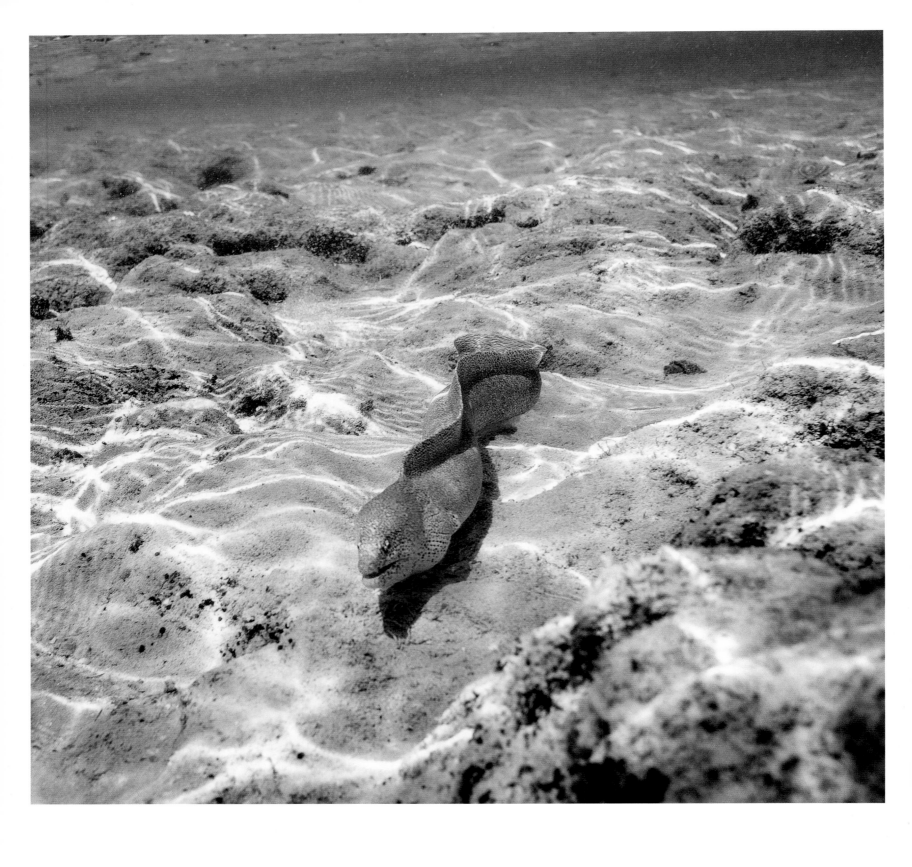

This moray eel hides in plain sight and
slithers across the sandy ocean floor
just off the Tanzanian coast. A rare sight;
usually, these animals do not leave their
hiding places during daytime.

Threatened Paradise in the Indian Ocean

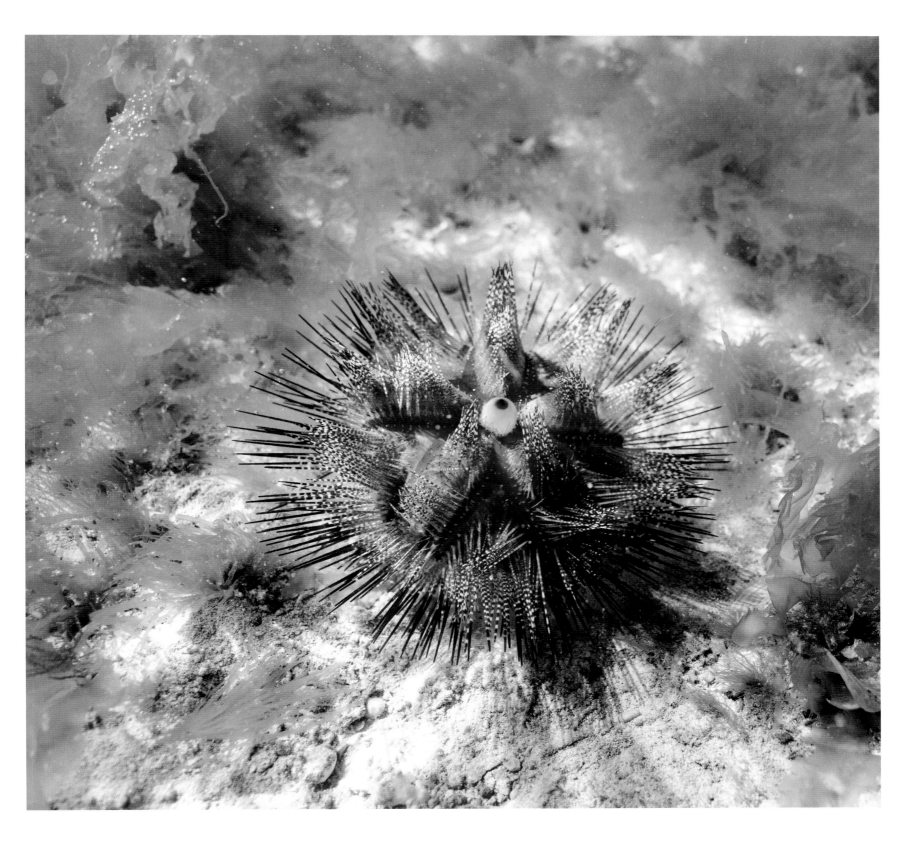

Handle with care. Just like with many other species of sea urchin, this fire urchin's spines are poisonous; and yet it is a beautiful creature. This species prefers shallower waters and can be found along the East African coast.

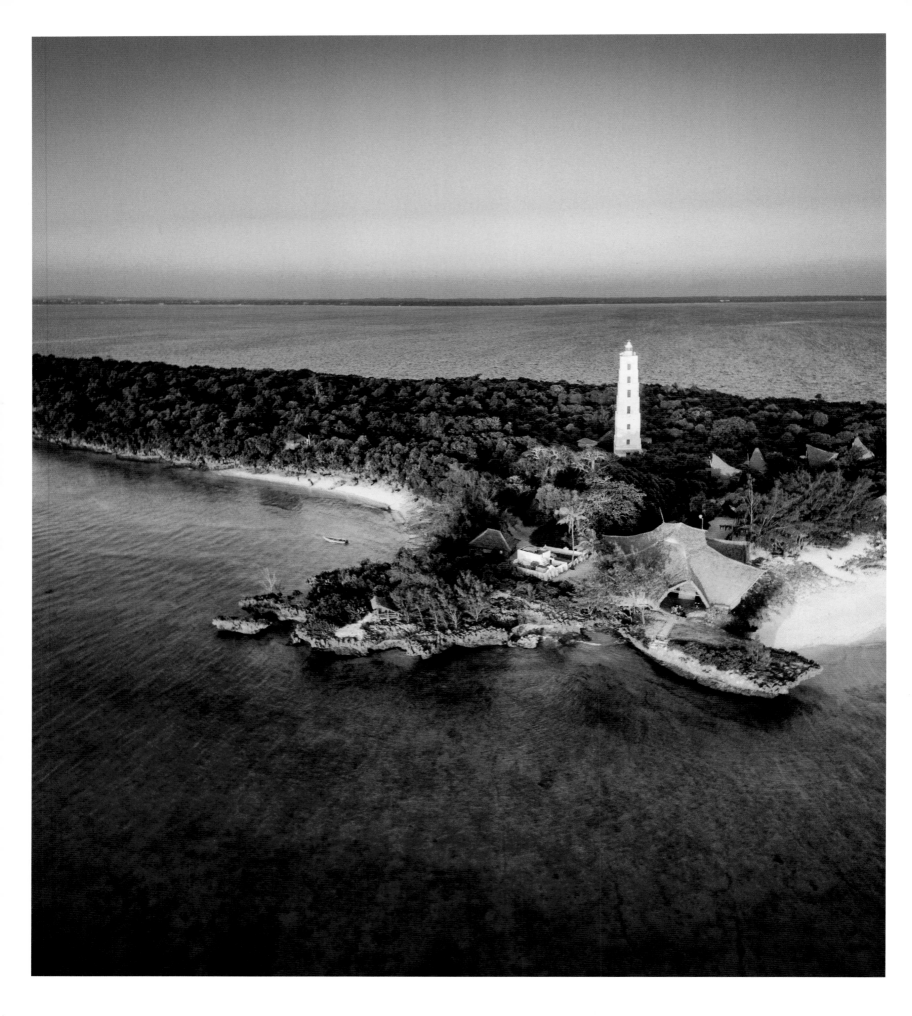

The old Chumbe light tower glows white
in the evening sun. At dusk, the coconut
crabs appear. They are the world's biggest
terrestrial crabs, and dozens of them live
on this small island.

Threatened Paradise in the Indian Ocean

natural flora and fauna were able to survive largely intact. A nature preserve since 1994, the reef off the coast remains home to more than two hundred species of stony corals; but even here, they are in decline.

I've decided to go snorkeling with my camera to explore the underwater world here. Tourists are not permitted to scuba-dive in the nature preserve. At low tide, the surface of the water lies only a few centimeters above the pointy, sharp-edged aragonite structures, making it impossible to explore. Only once high tide has put about two meters of water between the surface and the coral on the bottom is it possible to go snorkeling without significant danger. While Gita and Theresa collect shell and sediment samples, I dive into a tropical underwater world whose very strangeness is what makes it so incredible.

The Life and Death of a Coral Reef

One thing I notice very quickly: Although the strict conservation measures have allowed quite a lot to survive here, the diversity one would normally expect is no longer present.

Even here, large parts of the reef are already dead; the scene is dominated by the leftover skeletons of the coral. A grey desert spreads out before me, and my understanding of coral bleaching takes on a whole new dimension. Coral bleaching describes the effect of warming seas on the delicate symbiosis between the coral and the algae (called zooxanthellae) that inhabit their cells.

When the temperature rises above twenty-nine degrees Celcius, the single-celled organisms become stressed and begin to secrete toxins; and when that happens, the coral expel them. Not only do the coral lose their rich color, they also lose the vital sugars the zooxanthellae provide them with. In the worst cases, the coral will perish. Coral bleaching is not a new phenomenon. But with the ever-accelerating pace of ocean warming, the intervals between bleaching events are getting shorter and shorter. In some cases, recovery can take many decades depending on the size and age of the reef. But the progression of climate change is relentless, leaving the corals hardly any opportunity to regenerate.

And coral bleaching is just one of the many dangers facing the reefs. They suffer damage at the hands of careless divers and are set upon by negligently cast or lost ship anchors and by turbulence from passing commercial vessels. Scientists estimate that by the year 2030, around 60 percent of all coral reefs worldwide will have been destroyed.

The kind of appearance that such a heavily damaged reef can take on is clearly displayed at Chumbe Island. The only colors to be seen down here are those of the colorful little fish that have toughed it out and are still finding food. Unlike in the shallow waters off Zanzibar, here I do not see any patches of seagrass. The small island is completely surrounded by shallow banks covered with coral. And although fishing and tourism in this area are subject to extreme regulations, nature is recovering only very slowly. It is

INFO | HISTORY

The Anglo-Zanzibar War is the shortest war in world history. It was fought on August 27, 1896 from 9am until 9.38am. After the death of the Sultan of Zanzibar, his cousin Khalid bin Barghash tried to assert his claim of succession to the throne. It took the British colonial canons all of 38 minutes to deter him from pursuing this plan.

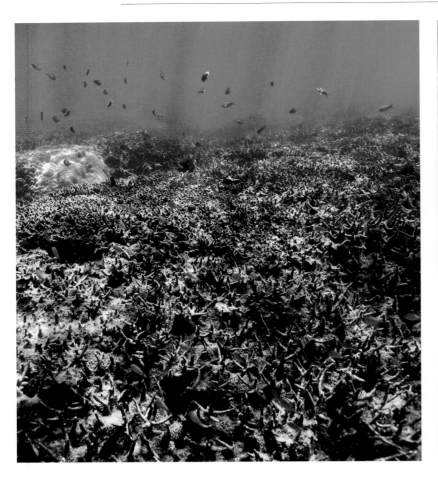

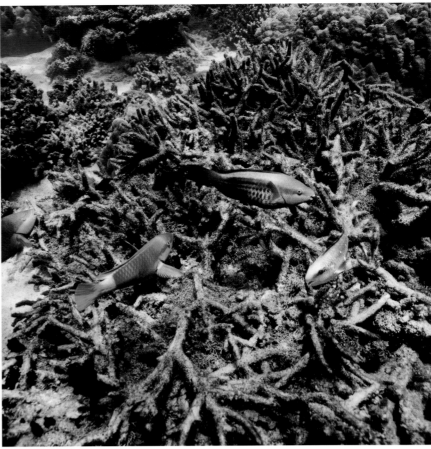

questionable whether life will ever return in all its former abundance and color. But these developments are precisely what we have come to observe. Only with the aid of longitudinal studies can scientists get a picture of how human activity is affecting the changes. It is therefore all the more important to talk to the locals: to get familiar with their traditions, and to understand their needs. The knowledge of the underwater world they have accumulated over the centuries is unique and complex, and it helps the scientists recognize how an individual fish or mollusk species is important for human survival here. It is always a delicate undertaking to balance conservation against meeting basic human needs and upholding tradition. And tourism in particular exerts a considerable influence on this balancing act. Hordes of vacationers seeking perfect relaxation in innumerable hotels bring a lot of money into the country. They are also all too happy to spend it on exotic keepsakes like seashells—another area for Gita and Theresa to go in and study the situation in which the locals find themselves. Countless stands decked out with colorful and unusually shaped seashells line the beaches in front of the big hotels that cater to the tourists.

It is a vicious cycle that requires careful consideration; it can only be stopped by a joint effort of local residents, national governments, international organizations and the tourism industry, supported by scientific research. Every traveler is capable of taking responsibility and decisively influencing these matters; tourists' demand for seashells is one of the factors that determine whether the trade in them and related products remains a profitable business. Acting responsibly is certainly one of the likeliest ways we can save our oceans, and this is not lost on Gita and Theresa. But it's a path that must be tread carefully, and more than anything, the locals have to be offered alternatives. For humankind and the natural world always go hand in hand; one cannot exist without the other.

It is evening and a deep-red sun is hanging over the darkening vegetation as I return ashore, dripping wet, from the sea. Near the equator, the sunsets are short—it will only be a few more minutes until a pitch darkness falls. Just before the end of my visit to this threatened underwater world, I saw a young humphead wrasse among the dying coral: a fish that divers say is really hardly ever seen here anymore. A good sign, I think.

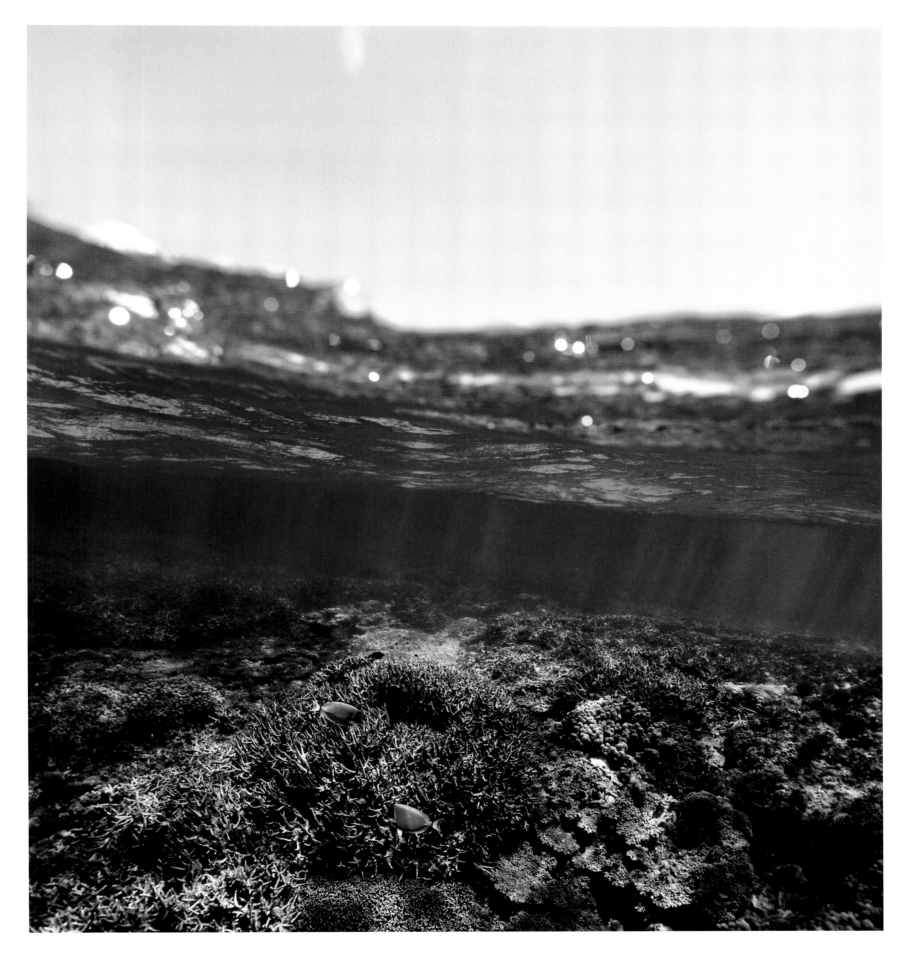

Coral reefs are dying due to coral bleaching, and it is almost impossible to stop this process. By now, many coral reefs are as colorless as this one just off the East African coast in Tanzania. The reefs have become grey deserts, and just a few remaining fish look for food and shelter here.

Two powder blue surgeonfish are the only splashes of color amongst the dead coral. Nowadays it is rare for divers to see a healthy coral reef full of colorful abundance, vibrant fish, and rich red coral.

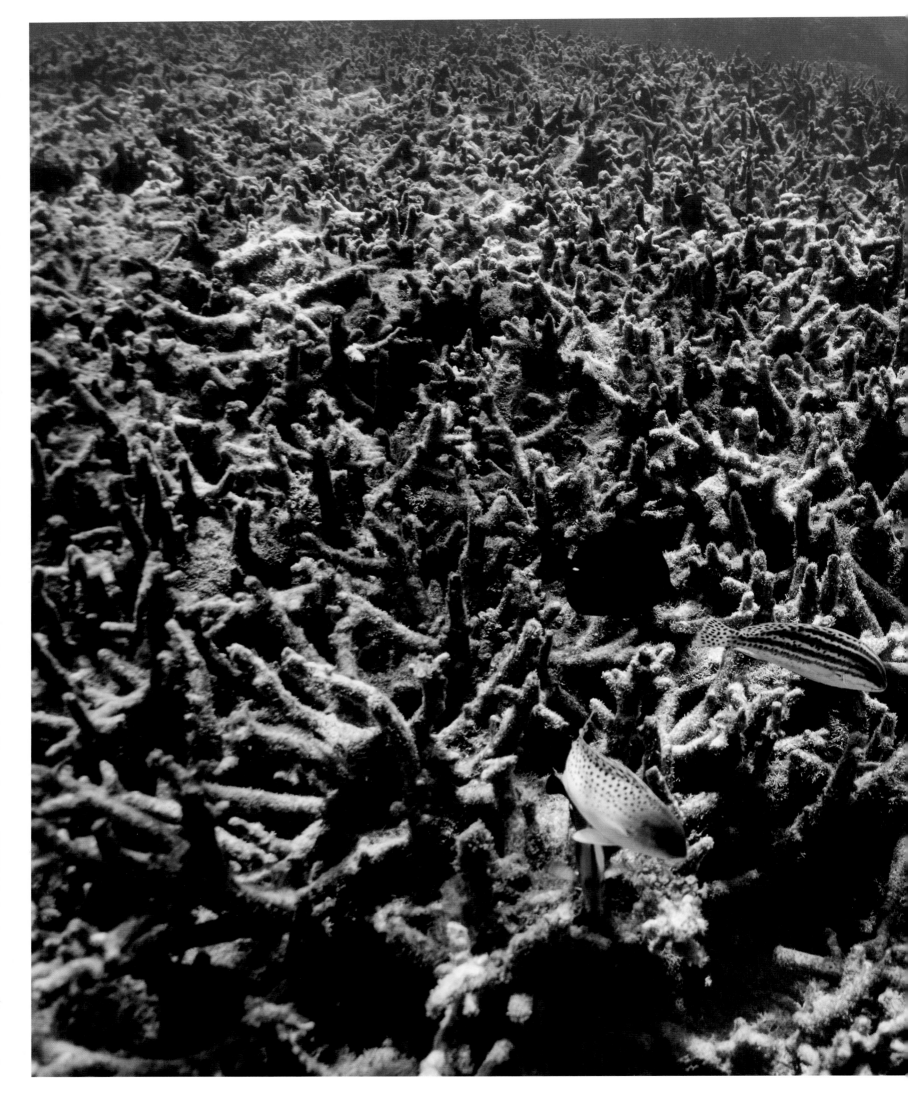

Threatened Paradise in the Indian Ocean

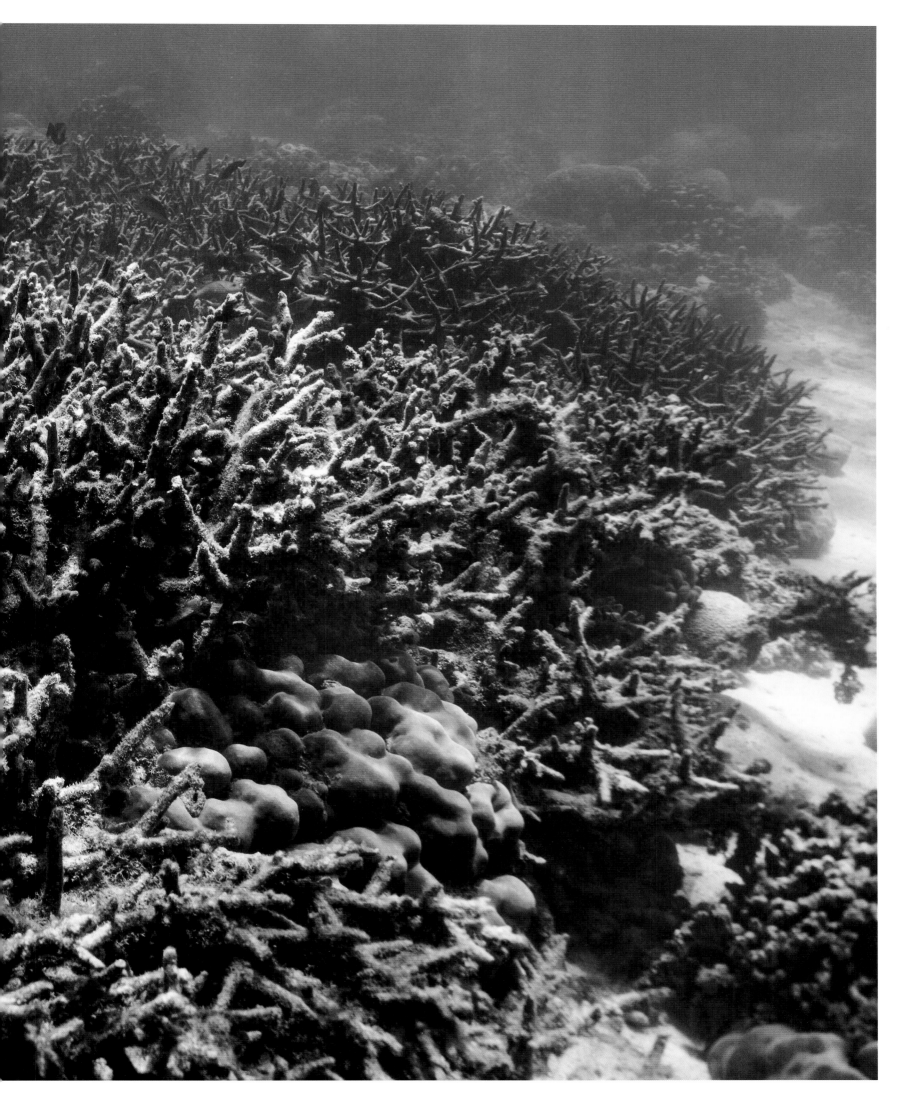

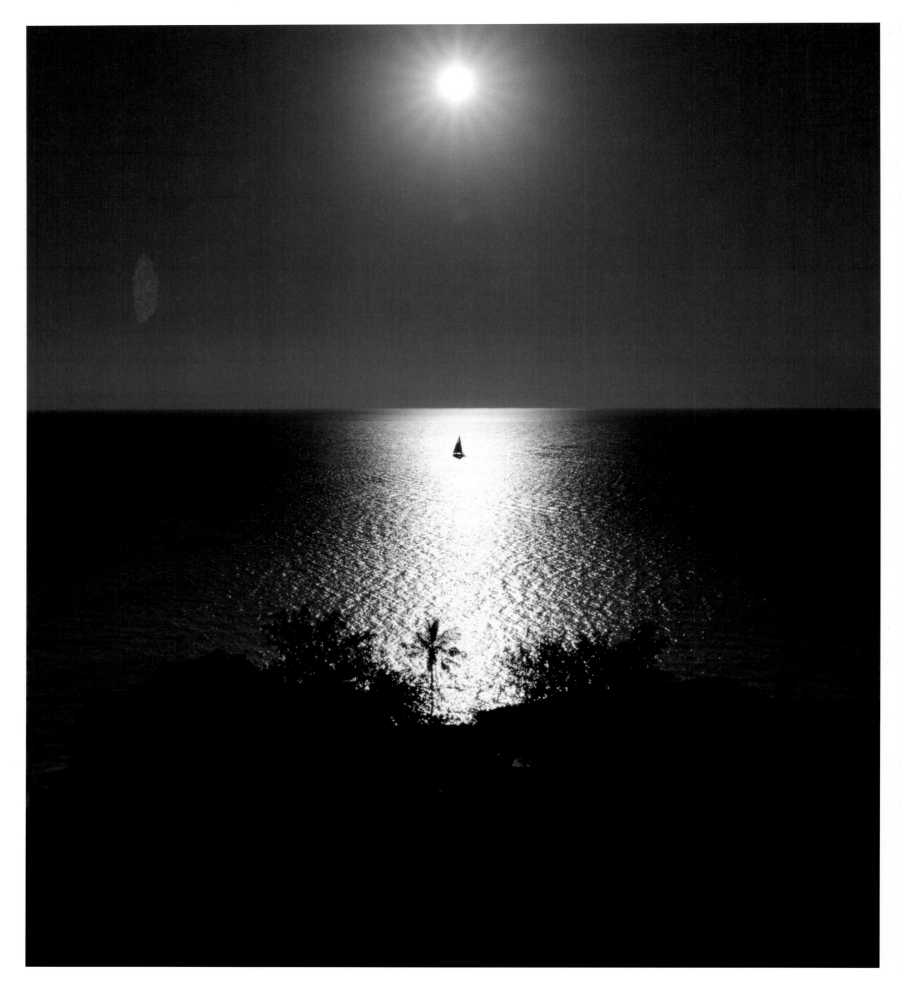

A lonesome sailboat appears black
against the Indian Ocean's setting sun.
It is the type of romantic image that will
make many people feel a longing and
the sudden urge to set sail in search
of paradise.

Near the equator, the sunsets are short—it will only be a few more minutes until a pitch darkness falls.

Threatened Paradise in the Indian Ocean

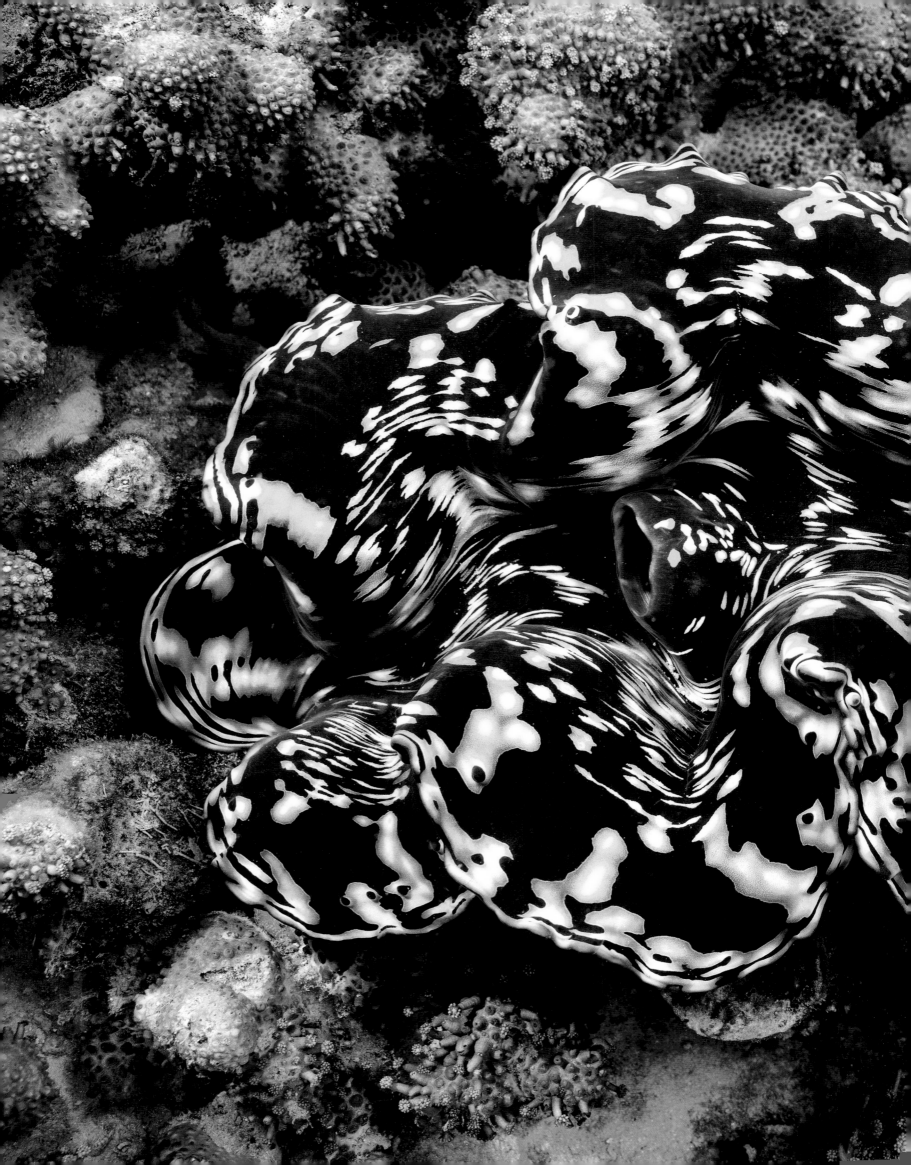

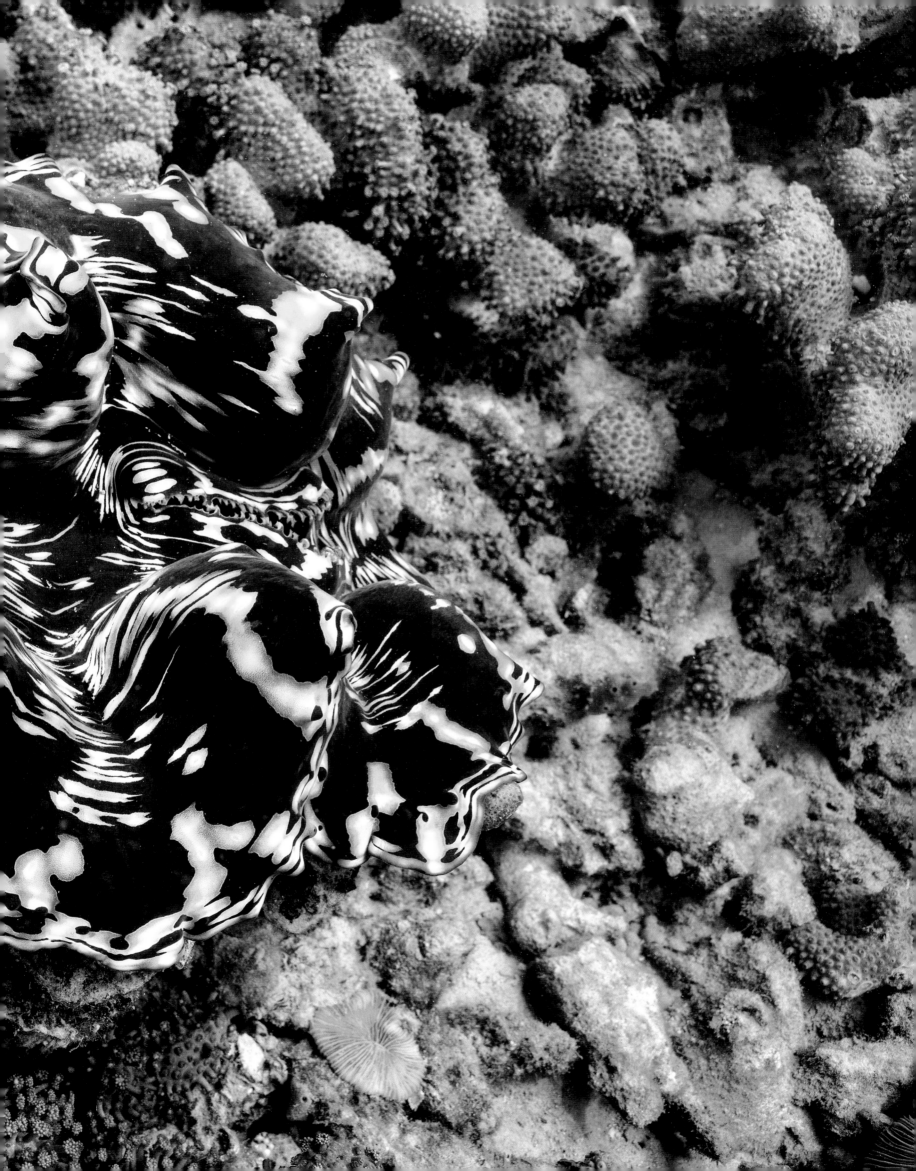

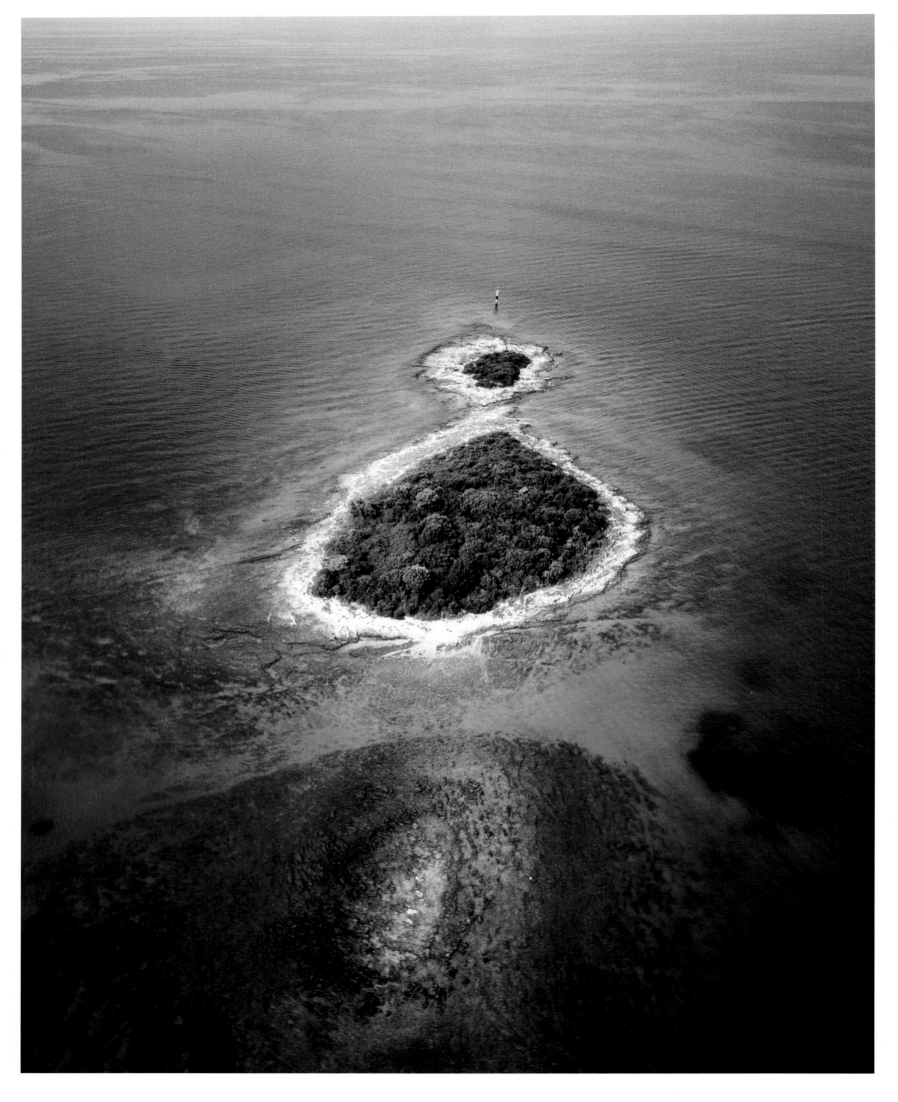

Threatened Paradise in the Indian Ocean

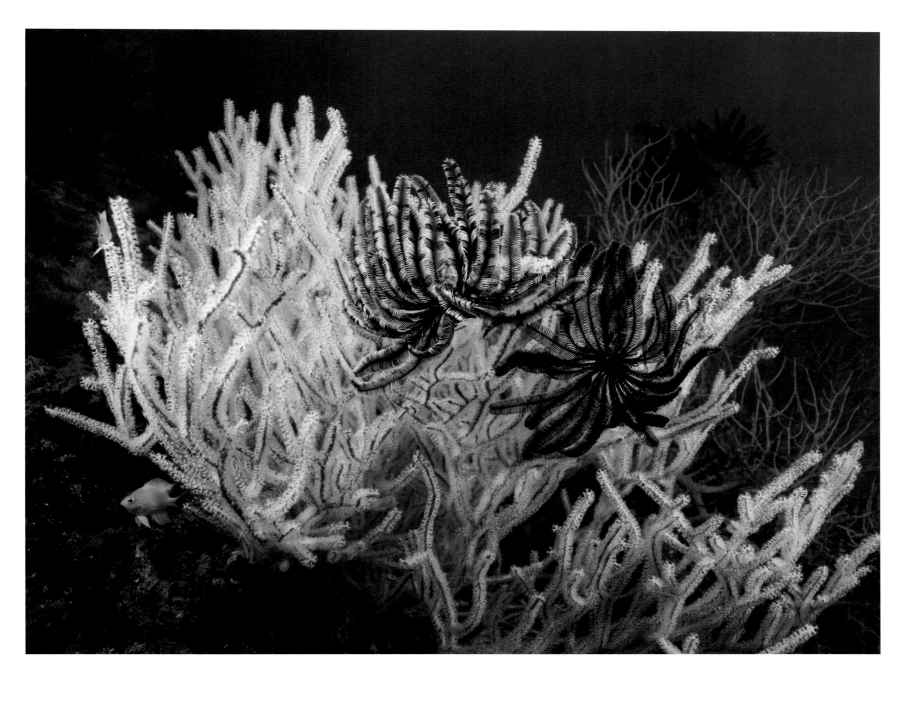

Just like coral, feather stars are often mistaken for plants. It is easy to see why, for the feather star's tentacles do look a lot like fern branches. Yet feather stars can crawl across the sea floor; some species are even able to swim. At night and during twilight hours they filter plankton from the water around them, usually positioning themselves in elevated places above the seabed. During the day, they roll up their arms and hide in cavities and cracks.

Threatened Paradise in the Indian Ocean

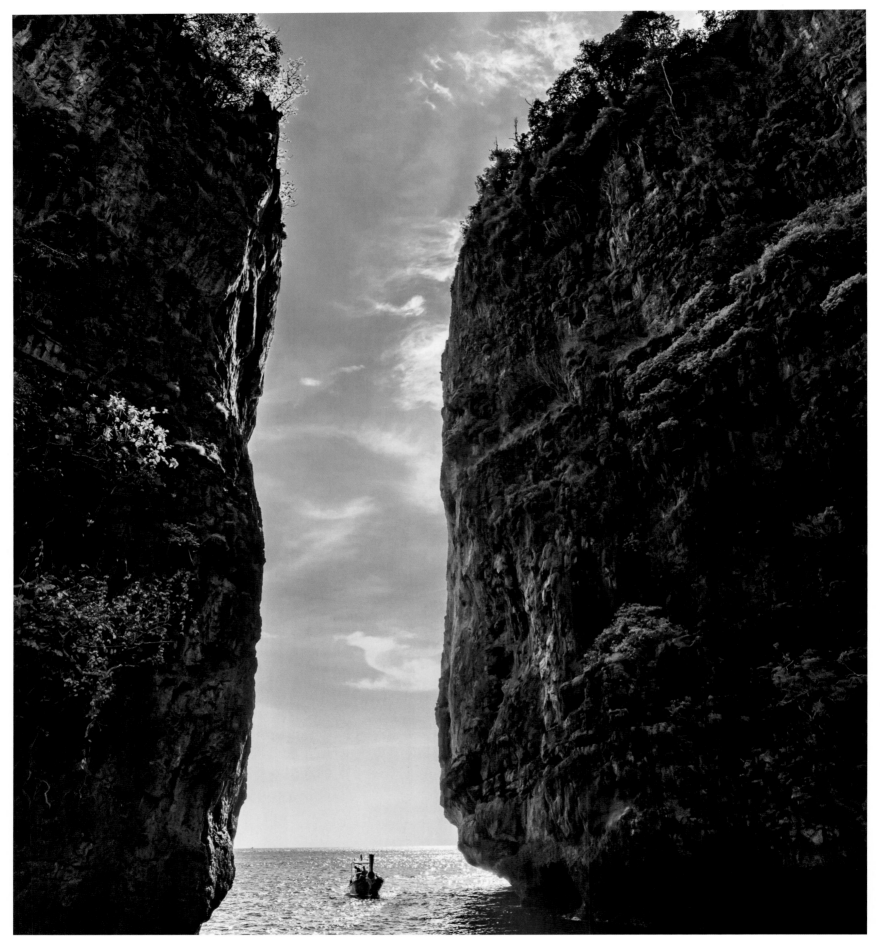

Location:	Chalenge:	Heroes:	Mission:
Indian Ocean	Coral Bleaching	Andrew Hewett	Coral Nursery
Andaman Sea	Mass Tourism	Divers and Volunteers	The fight against coral bleaching
West Coast of Southern Thailand			Raising awareness of the need to protect the reefs
Phi Phi Islands			

Fostering a New Generation of Coral

Every day, untold tourists come here to visit probably the most famous beach in Thailand for a few minutes. Maya Bay—better known to many as "The Beach"—is a small bay made famous by the film of the same name that starred Leonardo DiCaprio.

It is a tourist magnet on the island of Ko Phi Phi Le that for decades has had to bear the brunt of hordes of visitors. Brought here on boats, the visitors would stand in long lines for the privilege of setting foot on the beach for a short time, only to turn around and make room for the next wave of tourists. But what had become an ecological catastrophe is now being strictly regulated by the government. At present, the beach is closed indefinitely—which, at the very least, benefits this famous bay's nature preserve. The crowds are still here, just farther away.

Of course the sight is worth it: Especially from above, Maya Bay looks like a landscape out of the monumental James Cameron film "Avatar," an almost bizarre setting composed of rock formations in front of breathtaking tropical vegetation. But Ko Phi Phi Le and its bigger neighboring island Ko Phi Phi Don have a lot to offer and, so, quicken the pulse of many a diver. In the midst of the Andaman Sea, they answer to the dream of white beaches beneath palms surrounded by turquoise-blue water. At the same time, in some spots there are forested limestone cliffs rising hundreds of meters up out of the sea, the abrupt cliffs forming an odd contrast to the gentle green-and-blue of the sea all around them: Seems like paradise.

A Real Hero of the Sea

Of course we, too, are thrilled to have finally arrived at the Zeavola resort on Ko Phi Phi Don, one of the most sustainable hotels in world, which respects and actively protects the environment like almost none other. This is going to be our base for the next few weeks. This time the team includes Katrin Eigendorf, who is running our filming and interviewing, as well as my cameraman Michael Schinner. Starting from Zeavola, we are planning to go diving around the island, and we meet a man who, to me, rightly deserves the title "Hero of the Sea."

Andrew Hewett is not an actor and did not make these islands famous. But he loves the outdoors here and, through his work, has made more happen than many others—and has done so with heart and passion. After a tsunami destroyed large swaths of the Phi Phi Islands (above as well as underwater) in 2004, Andrew, a diving instructor, was in charge of the Phi Phi Tsunami Dive Camp, which began working to rid the beaches of washed-up trash and debris with the help of many volunteers. But that would not suffice. In 2006, Andrew joined the Phuket Marine Biological Center in constructing a coral nursery off the Phi Phi Islands that he still operates in conjunction with his diving school, The Adventure Club. His goal is to repopulate corals onto artificial reefs so that the unique diversity of life in these waters can have new opportunities to thrive.

INFO | GEOGRAPHY

The Phi Phi Islands are an island group in Thailand. They comprise Ko Phi Phi Don, Ko Phi Phi Le, and several smaller neighboring islands. Its surrounding coral reefs still maintain a high marine biodiversity, making the islands popular with divers. They are part of Hat Noppharat Thara-Mu Ko Phi Phi National Park.

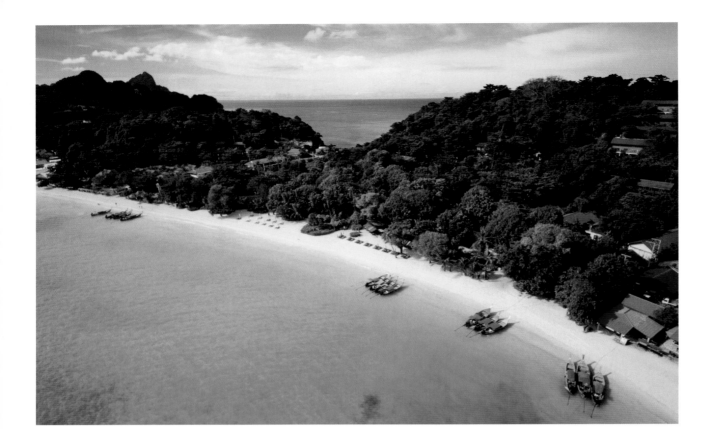

But what does it really look like down there right now? How have the flora and fauna offshore been developing over the past few years? Might there even be reason to breathe a sigh of relief? Or is it more a case of the opposite?

A More-Than-Sobering Dive

We are all familiar with the wondrously beautiful banks of coral that burst with color, where a myriad of colorful fish congregate. Whether experienced in person or seen on TV or the big screen: When we imagine a coral reef, we picture Nemo, parrotfish, and sea anemones.

But these mental images are going to get a revision on our very first dive. Together with a locally savvy diving instructor, we head for one of the most popular spots on the island, where we intend to check out the condition of the reefs first-hand. Indeed, our initial feeling of joy quickly yields to the realization that climate change has left its mark here as well. Coral bleaching is taking its toll all over the world; and so we witness a unique world of animal life in the process of dying. This formerly so colorful world now lies there before us, almost gray-in-gray. No doubt, bright, neon-colored fish still peek out from between protrusions of rock and banks of coral, and colorful sea anemones sway slightly back and forth in the current. But in many places, there are withered, faded coral with bone-like, upward-reaching fingers—like skeletons, it seems to me—and

in my mind's eye, I am picturing this reef in perhaps ten years. The world here will then be ashen and dead—if we do not manage to get a handle on climate change.

Soon, Andrew will tell us how delicate the equilibrium is in which these animals are (still) living; but not until we, sobered, are out of the water and back at the hotel. There, the catastrophe is no secret. They make quite an effort to explain the fragile relationships to the guests, to sensitize them. Many times it works, but unfortunately sometimes it doesn't. The hotel itself is a good example of how the tourism industry can minimize its ecological footprint. The hotel operates its own closed water cycle (with treatment plant), recycles its waste, and holds regular beach cleanings. The staff gets training in sustainability, and even tourists receive information about how they can proceed with the least possible effect on the environment in and near the water. You will search in vain for plastic straws at Zeavola; instead, they provide their own drinking water in glass bottles you can refill at a dedicated drinking water station. It is a bright spot on this day of our sobering first dive. It was more than we had reckoned with.

A Nursery for Corals

The next day, we go to visit Andrew at his diving station and learn more about his work. In particular, I am very much anticipating the dives at

Zeavola Resort is located on the beautiful island of Ko Phi Phi Don. Various measures to improve environmental protection and sustainability are in place. People here know that environmental protection is our responsibility towards nature.

Fostering a New Generation of Coral

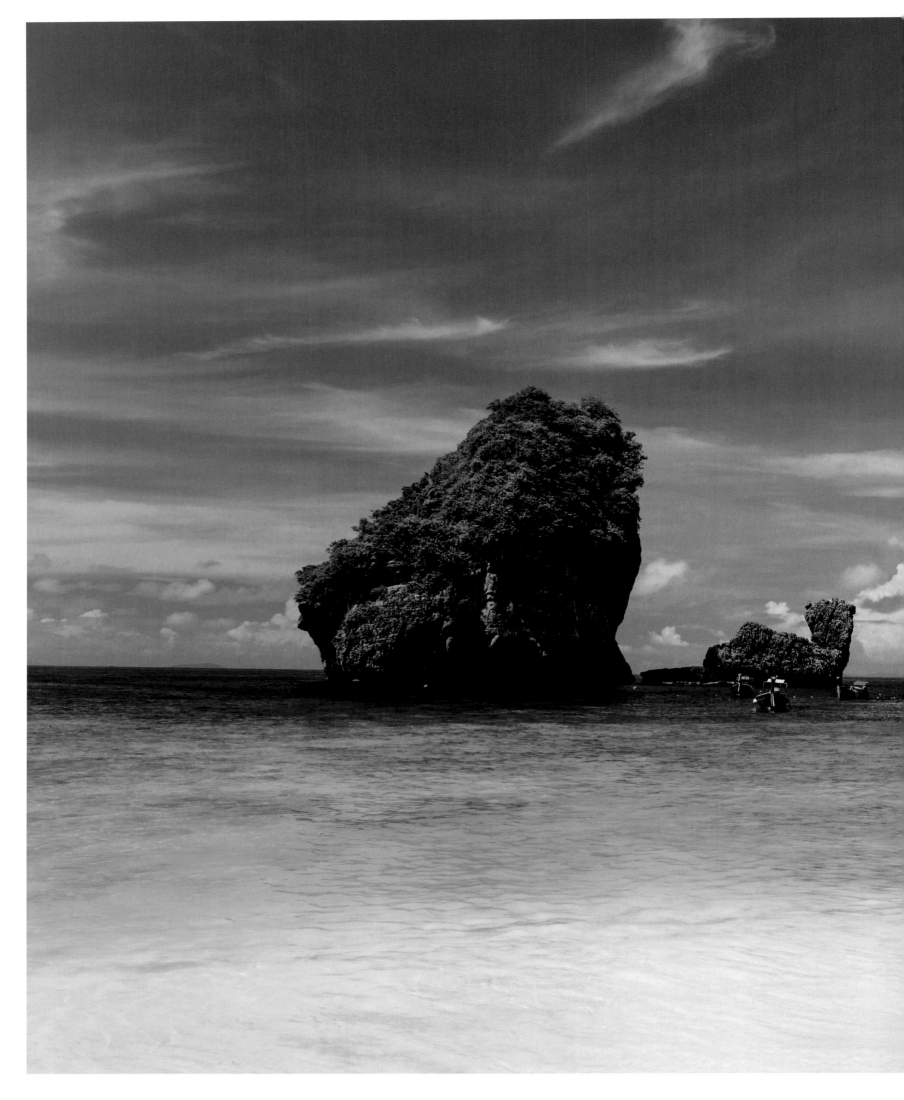

Fostering a New Generation of Coral

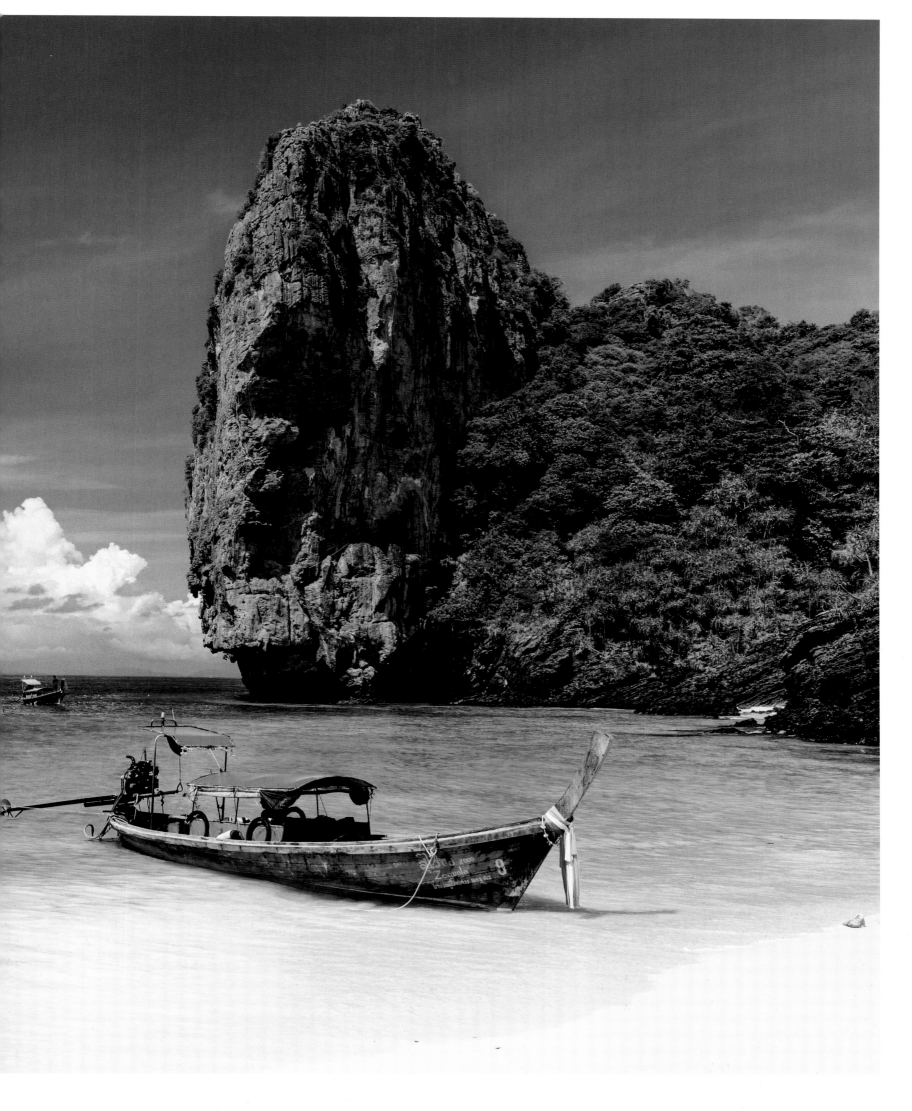

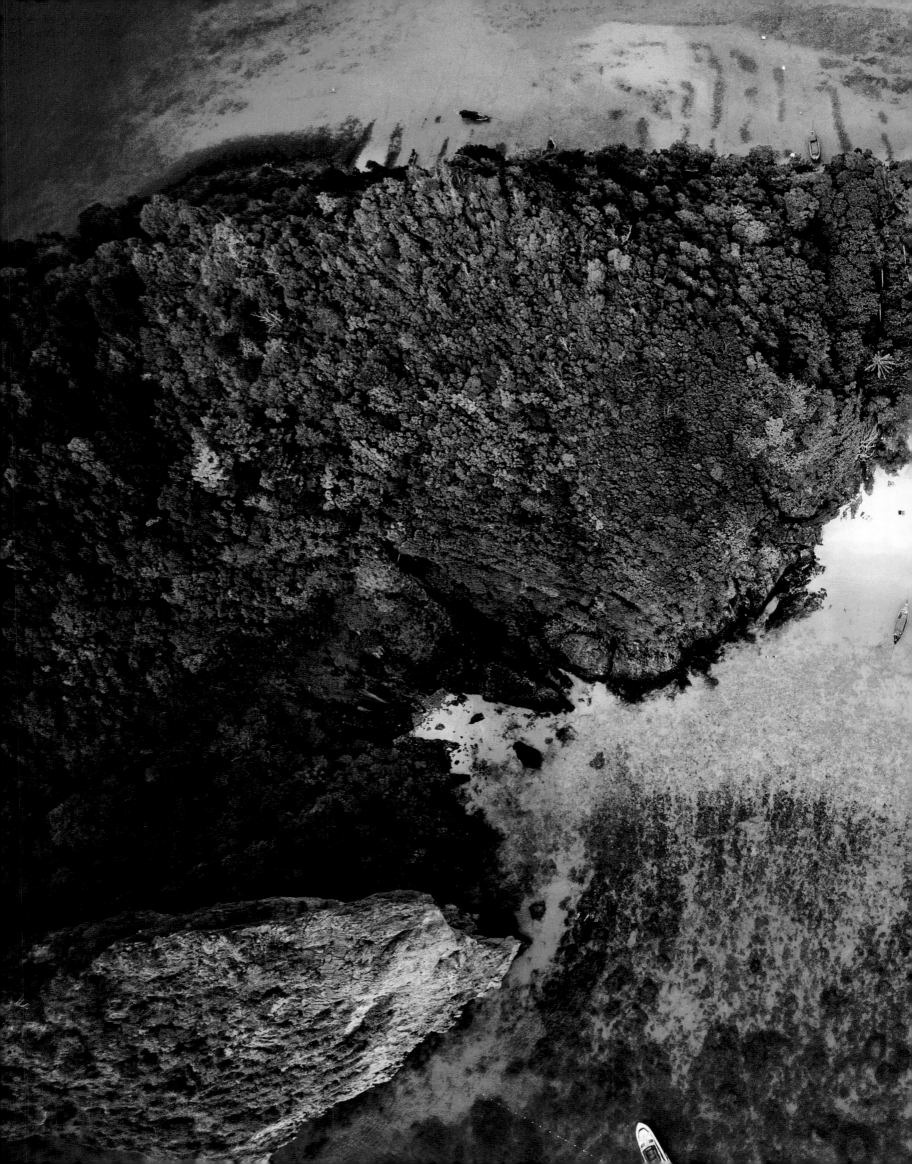

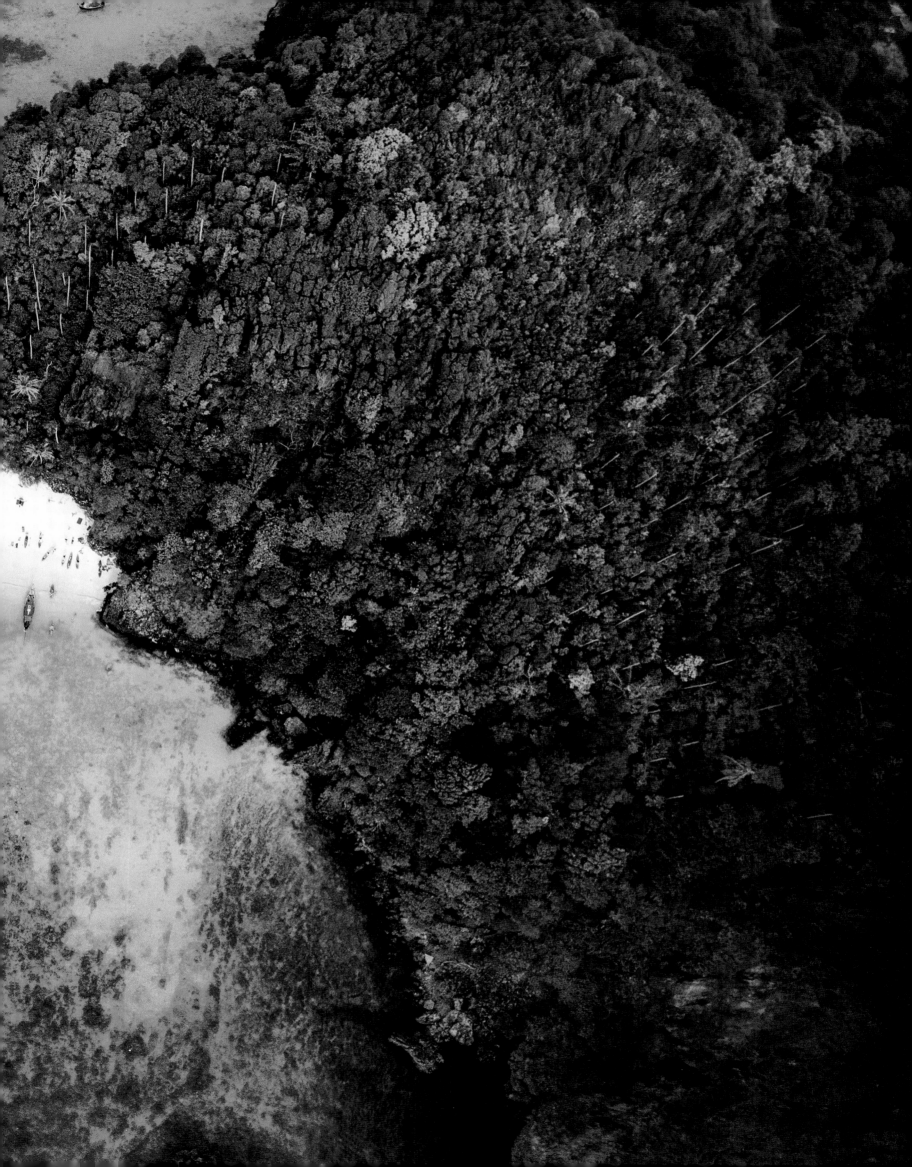

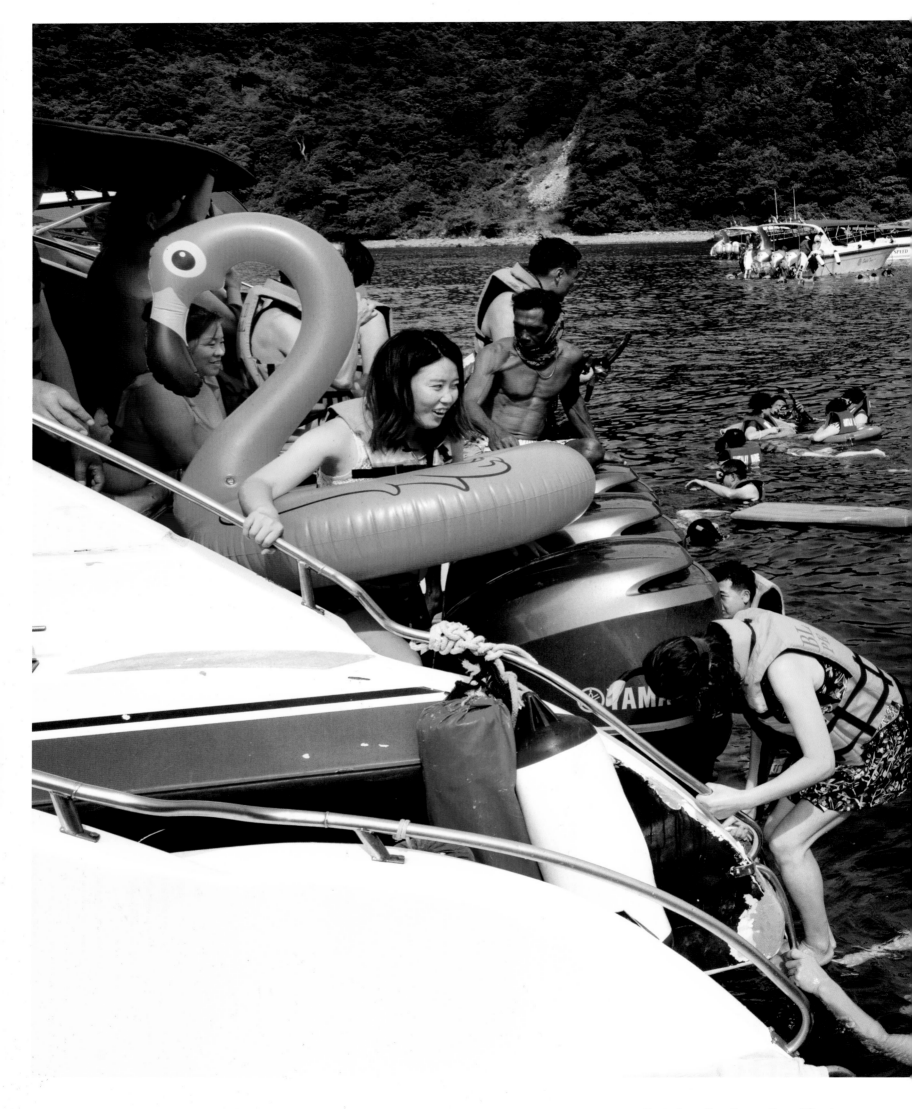

Fostering a New Generation of Coral

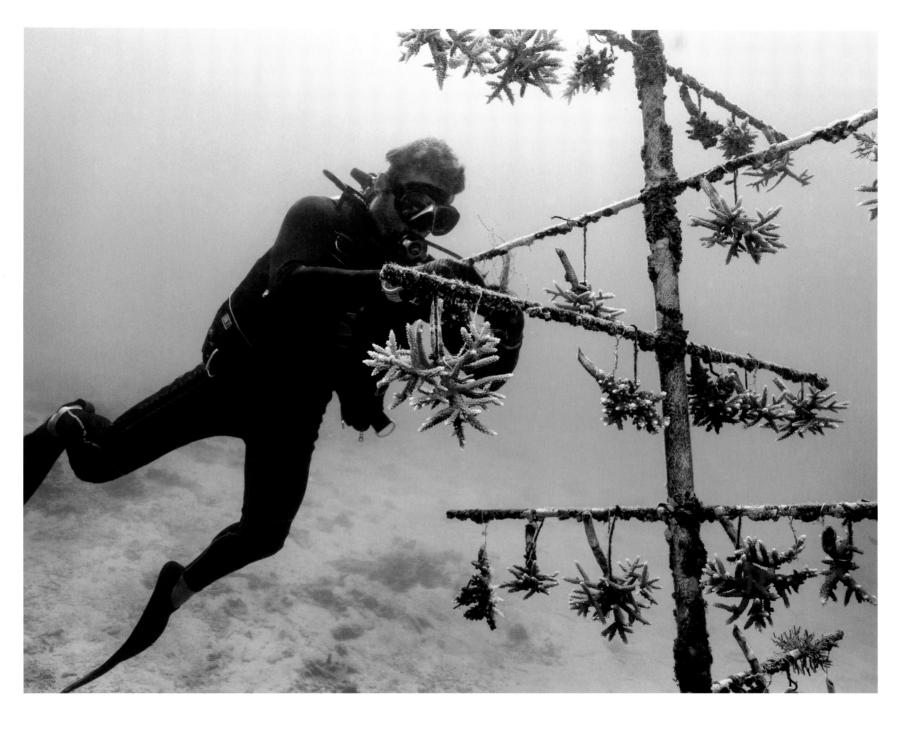

Another way of growing coral: The fragments are floating in the water, tethered to an artificial coral tree. The work is not easy, but it pays off. Each year, students come to help Andrew move the young coral from this nursery and into the wild. Then, new coral fragments are attached to the trees and nets for another year.

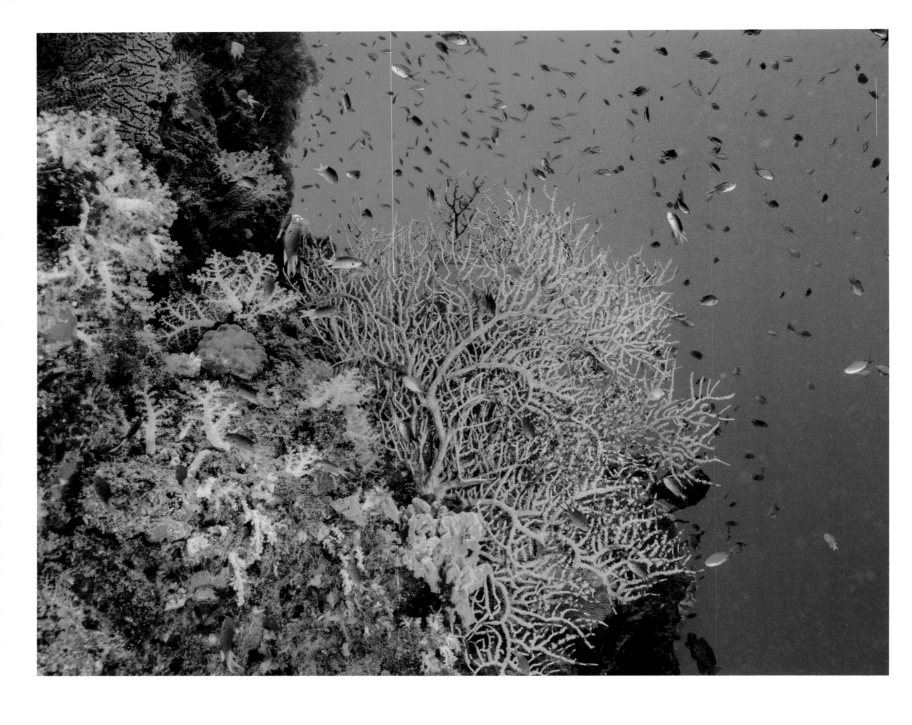

rules. Sunscreen is just as damaging to the reefs as walking around on them; feeding fish might improve your chances of getting a good photo, but the consequences for crucial natural food chains are devastating; animals that would otherwise sustain themselves on the eggs and larvae of other reef-dwellers become accustomed to humans, lose their shyness, and start adjusting to the new food source. We can pay attention to a lot of things that would help us avoid negatively affecting the environment. Foremost among these, however, is bridling our egoism and not trying, by any and all means, to get the most beautiful photograph.

Encounters of a Different Kind

The very next day we and Andrew not only are going to dive on the artificial reefs together but have also received permission from park rangers to visit a nature preserve in which all diving has been banned as of a few years ago.

The artificial reefs are our first object, and I am looking forward insanely to my chance and privilege of being able to photograph the giant steel formations under water. The dive itself is, simply put, impressive. The diversity of species that has arisen here after just a few years is stunning. Brilliant red gorgonians, all more than a meter tall, sway to and fro in the current, thronged by colorful fish. Hundreds of sea urchins, sea anemones, lionfish and other reef-dwellers have made this area their home. Nature demonstrates to us once more that life always finds a way.

INFO | BIOLOGY

Coral filter microplankton and other nutrients and microorganisms out of the water. Furthermore, coral often enter a symbiosis with algae whose photosynthetic metabolism then merges with the coral's stored nutrients. These algae also create the often luminous colors in coral reefs.

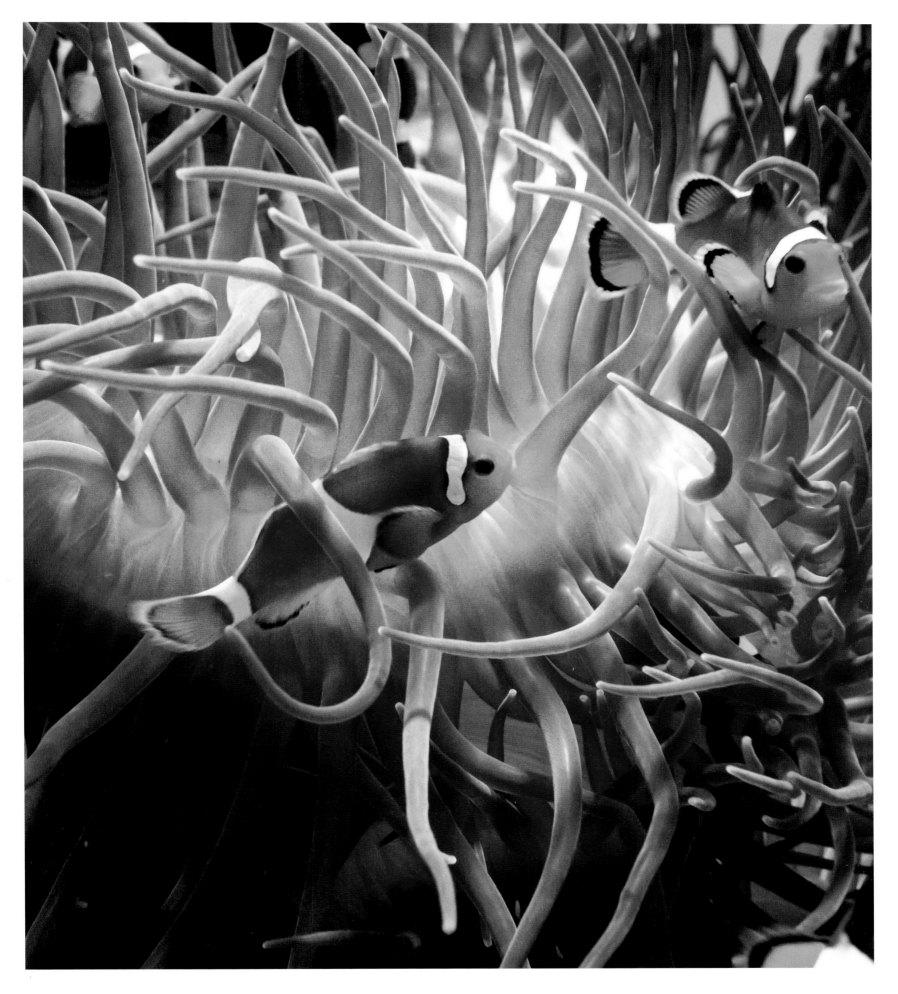

Colors like the ones we can see here in Thailand are rare now in most marine habitats. Luckily, there are still some places where negative human impact on nature has been kept in check. The colors here are unrivaled in their beauty.

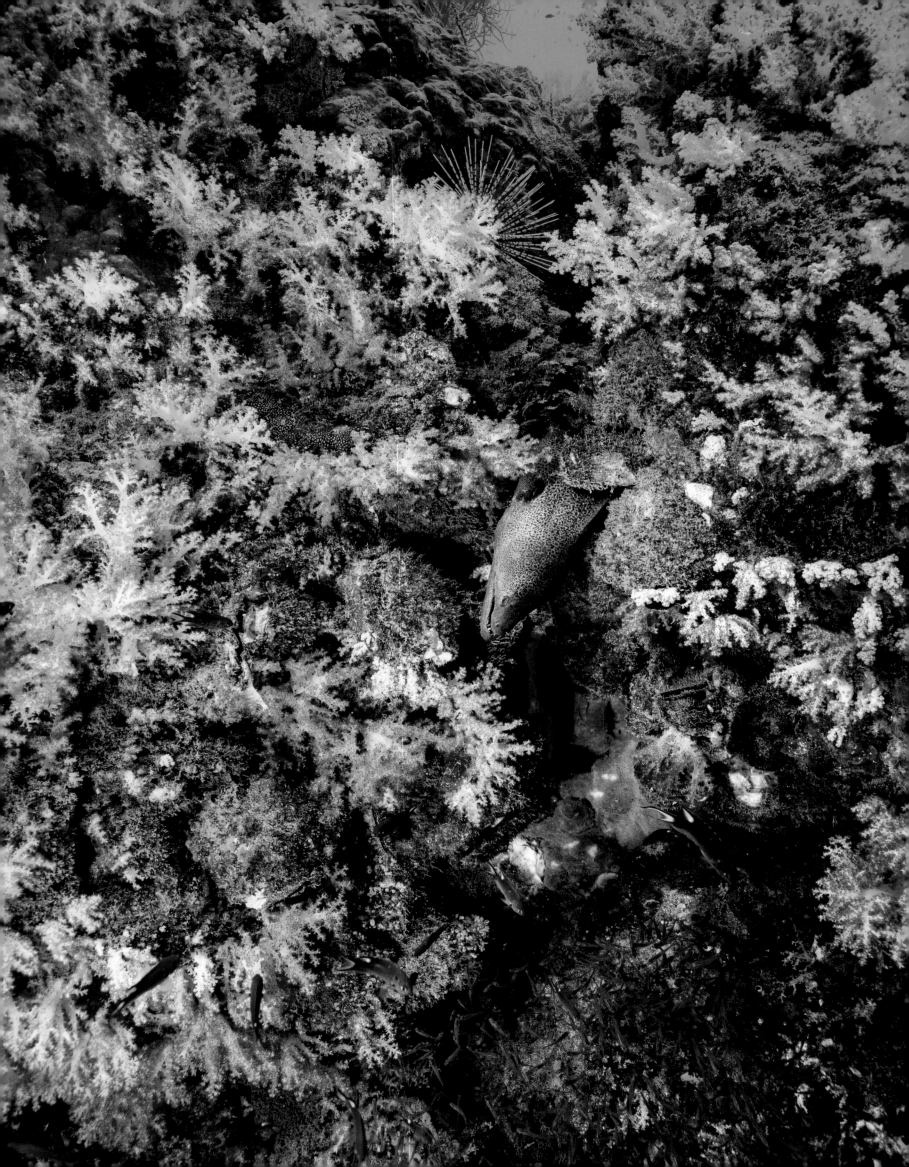

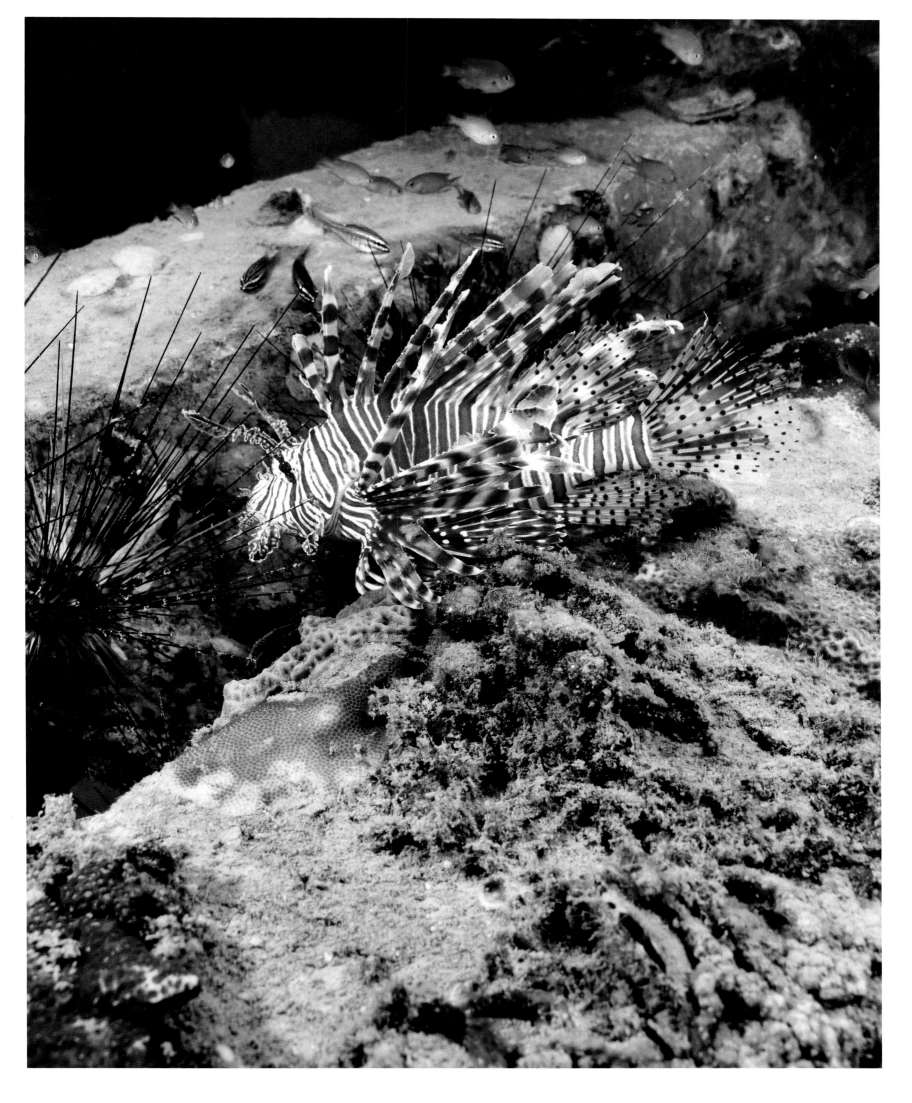

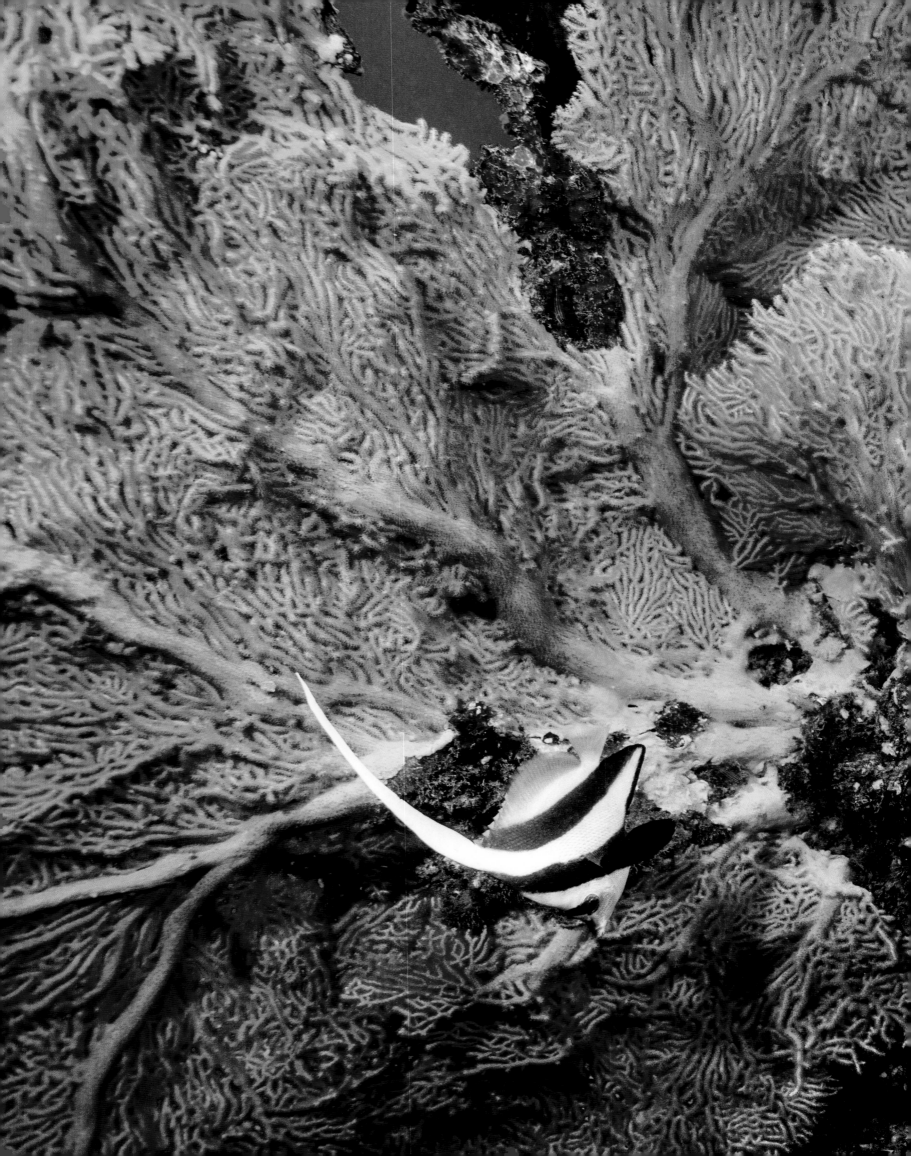

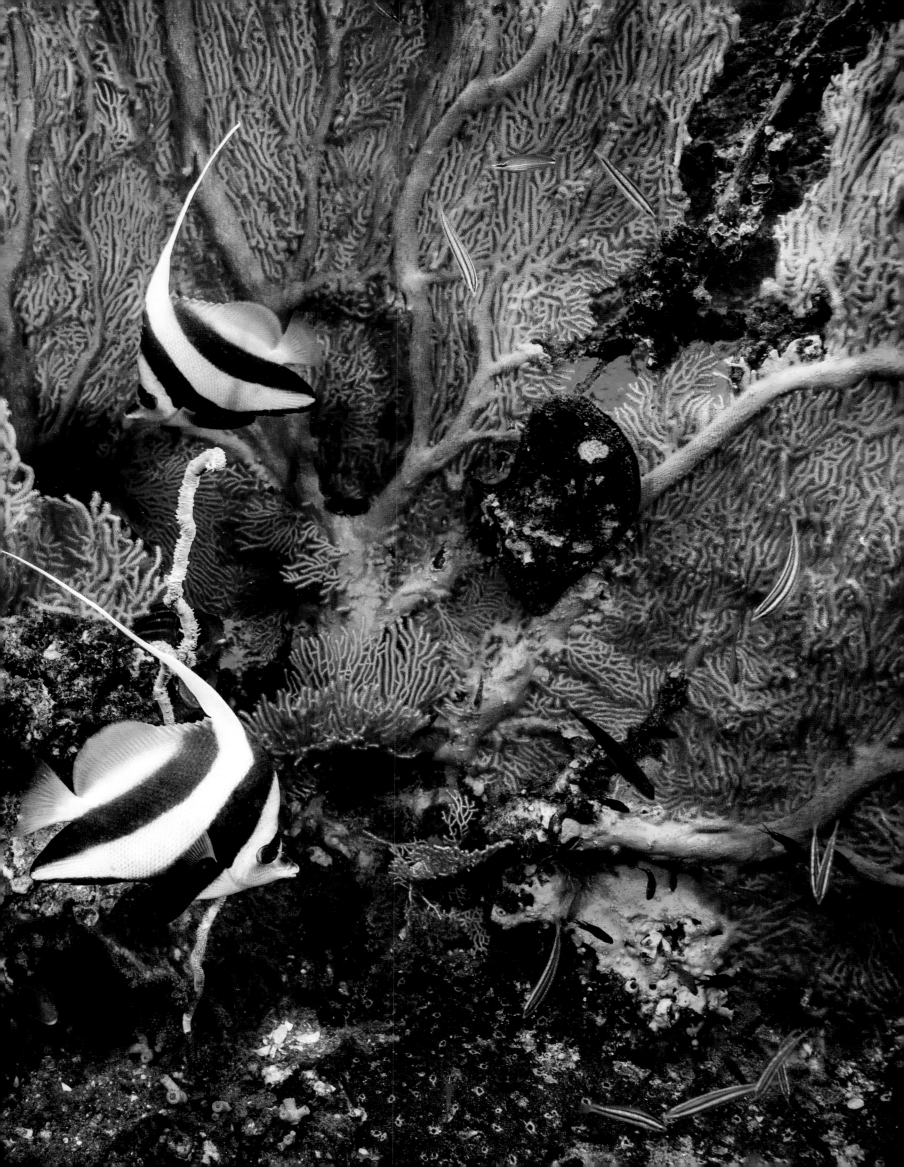

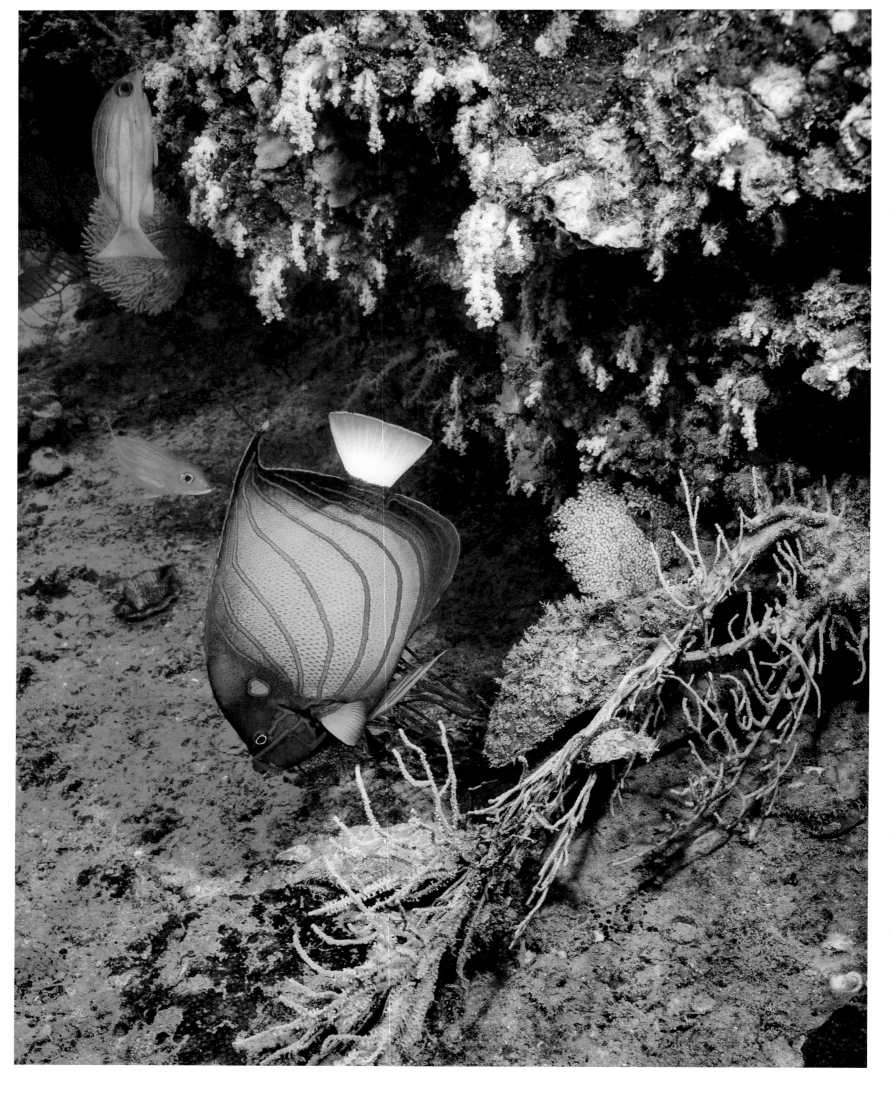

Fostering a New Generation of Coral

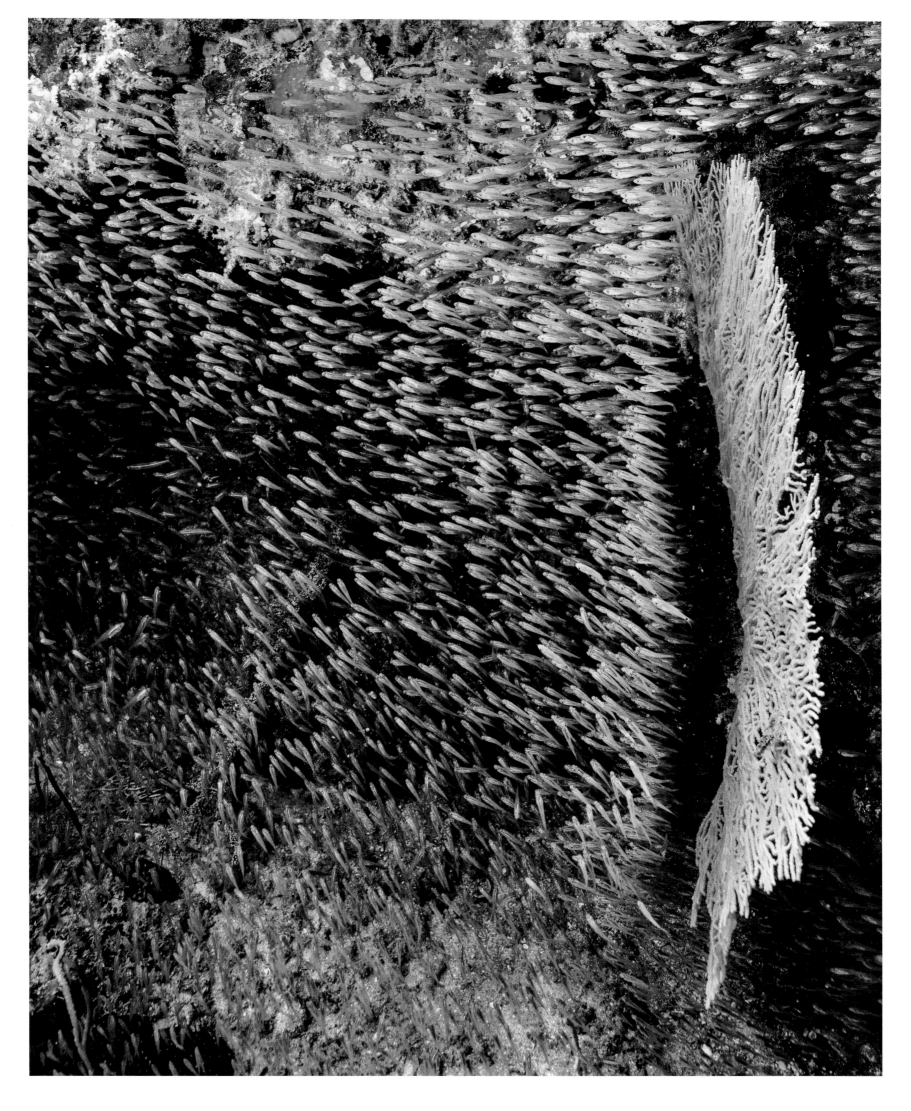

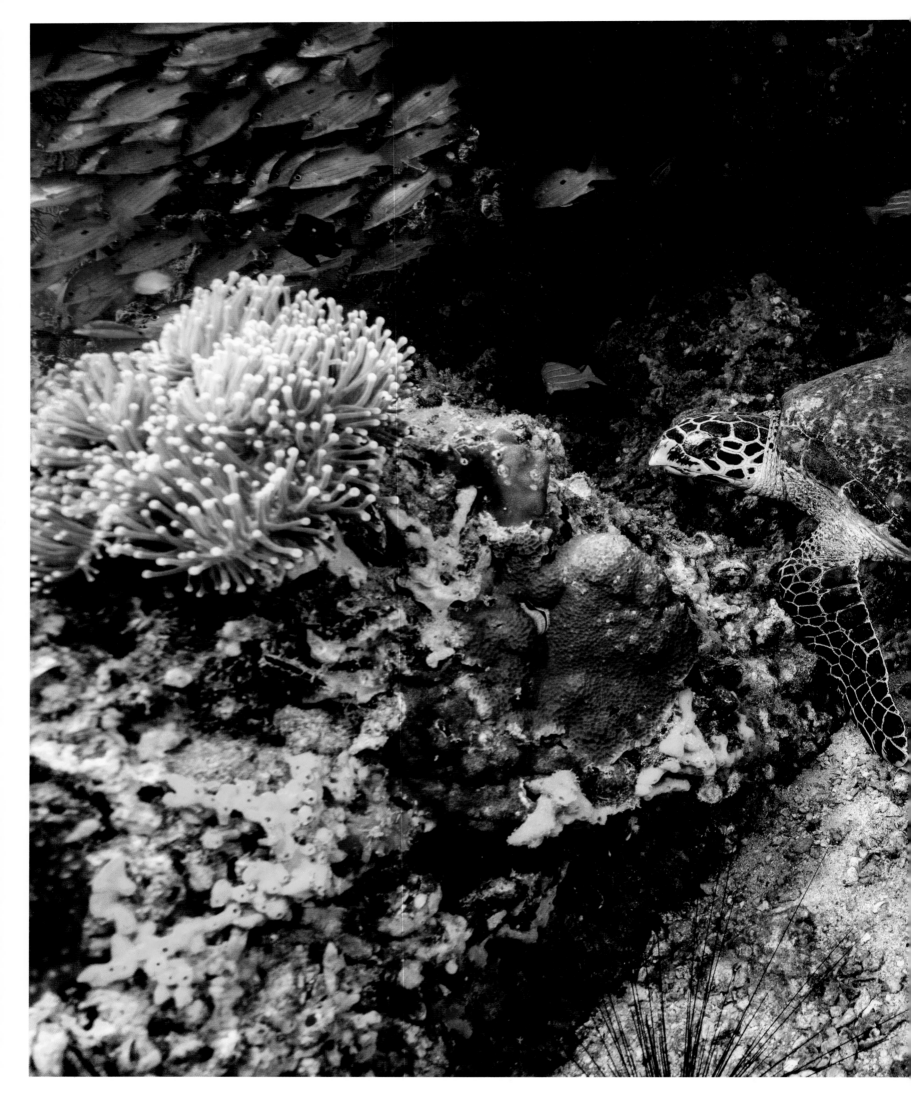

Fostering a New Generation of Coral

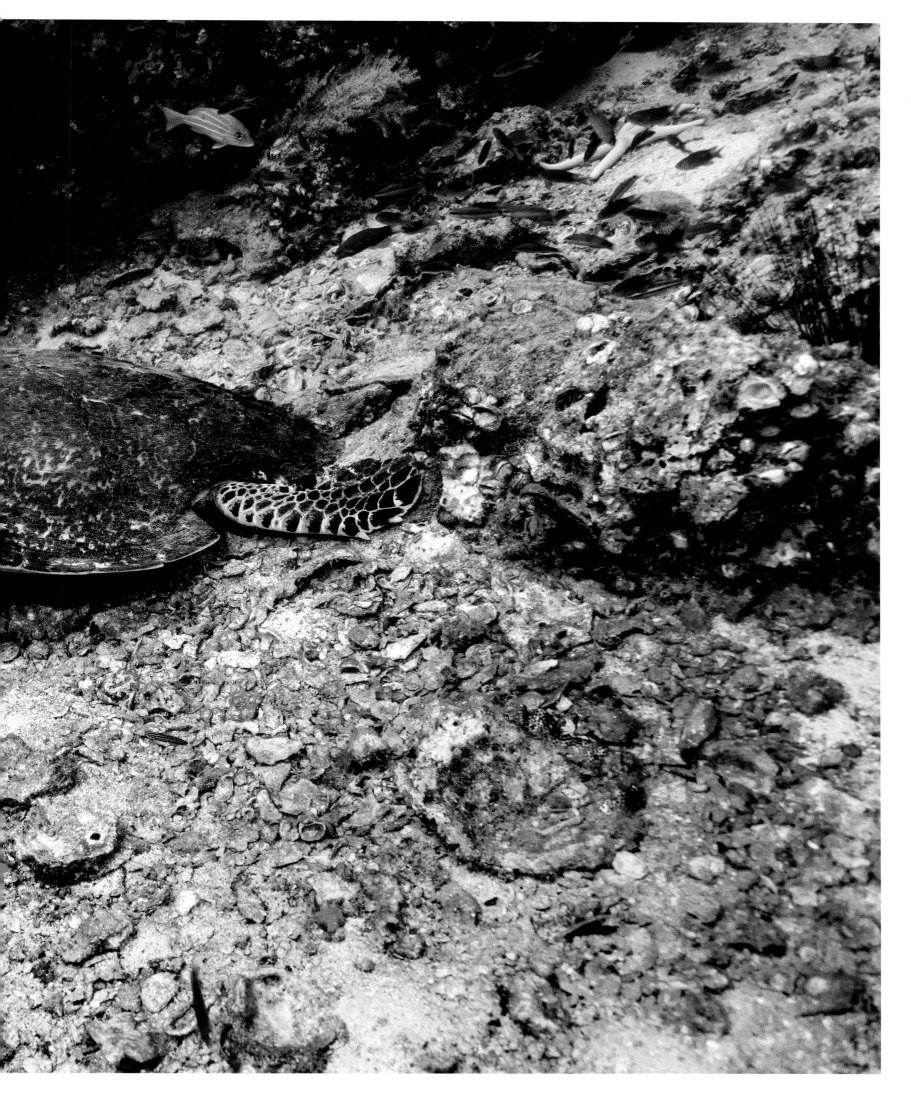

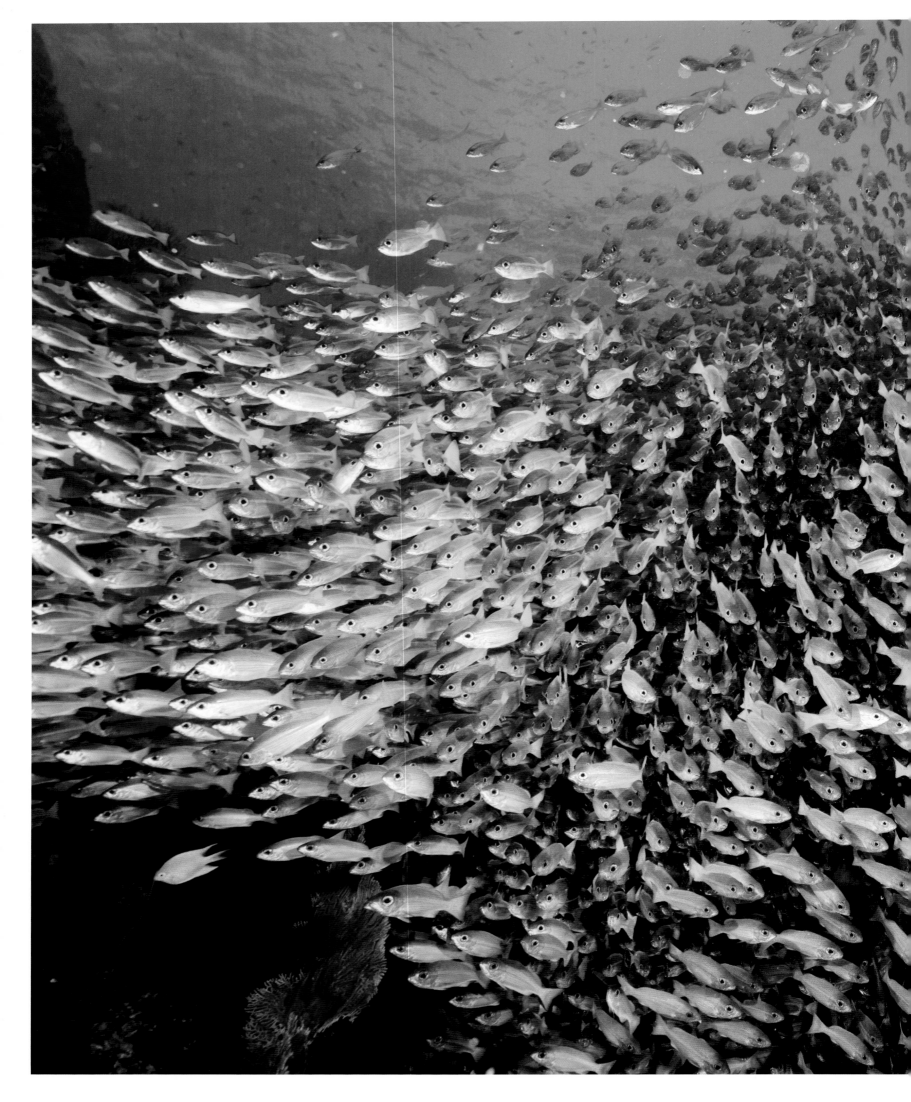

Fostering a New Generation of Coral

INFO | SEA TURTLE

The green sea turtle, also known simply as the green turtle, has its habitat in tropical and subtropical regions. It can live up to the age of 40 or 50 years old, and reach a length of up to 55 inches. Its delicate meat was once considered a delicacy, and it has been hunted close to extinction. Today this species is under international protection and its breeding grounds are under surveillance in order to make sure that as many young as possible may survive and grow into adulthood. Even so, the animals are always at danger when they swim in the ocean. Nets which are lost at sea, so-called ghost nets, are deadly traps for green turtles. Once it is entangled in the net, the turtle cannot return to the surface to breathe, and so it drowns. Each year, a large number of green turtles dies as bycatch.

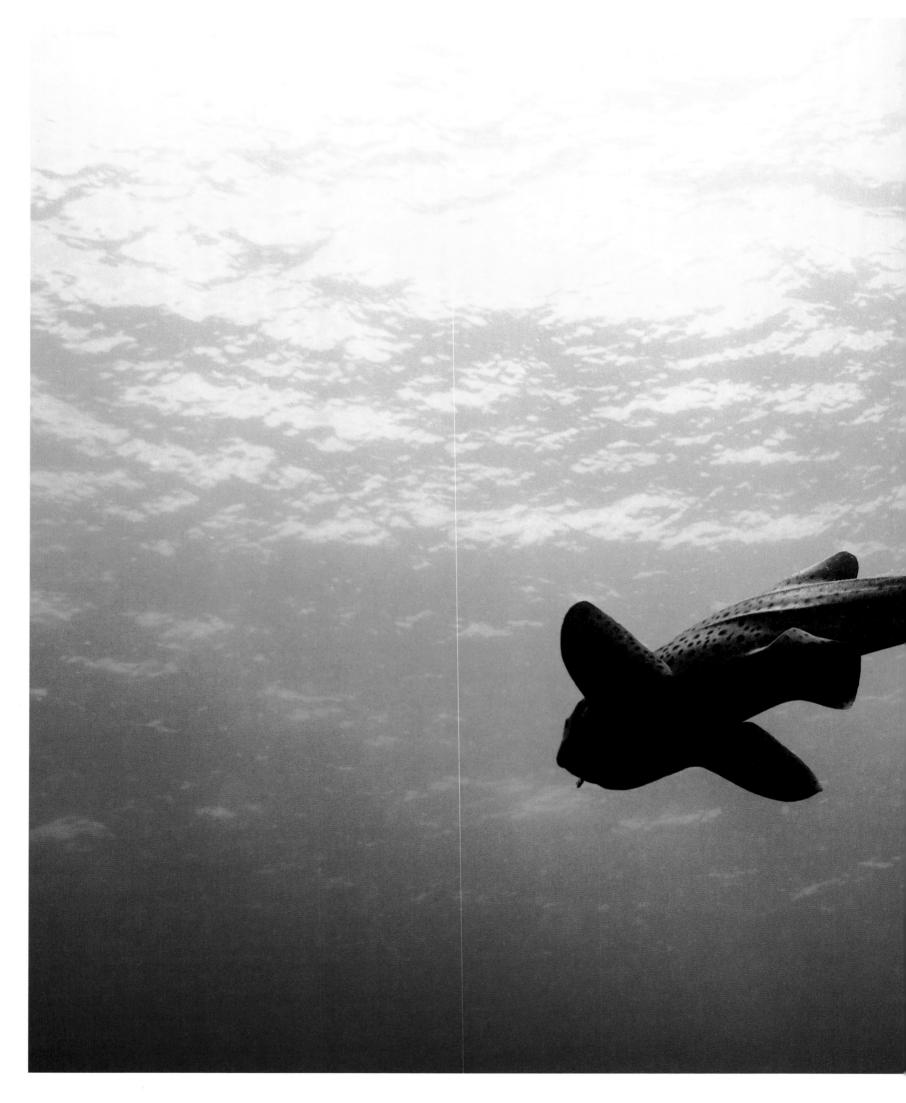

Fostering a New Generation of Coral

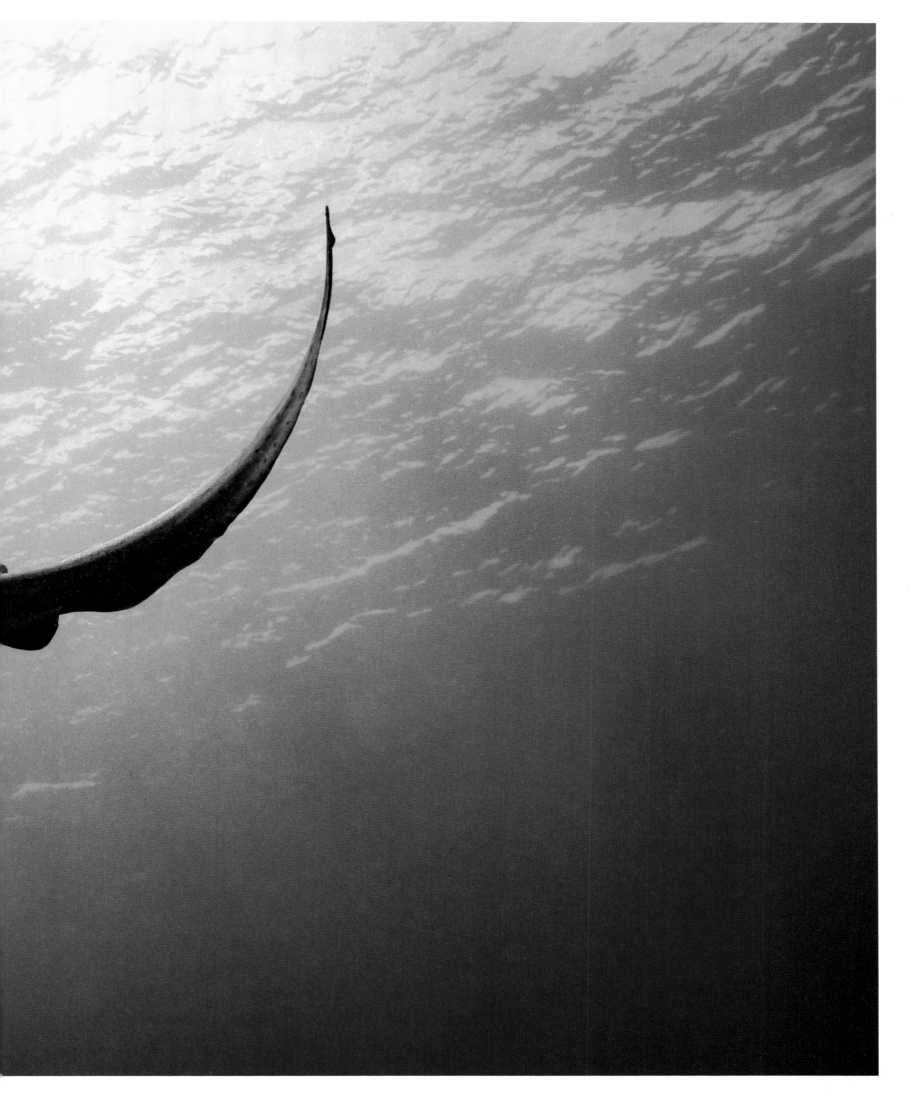

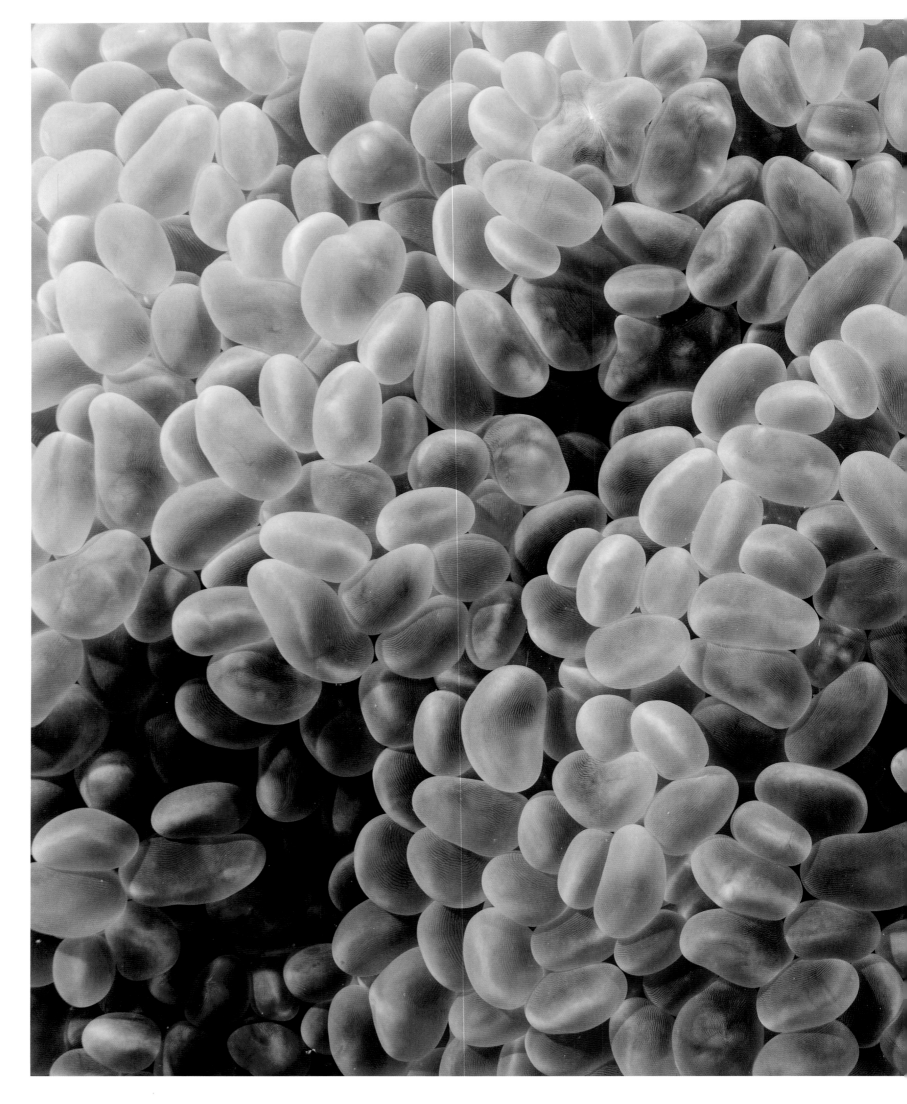

Fostering a New Generation of Coral

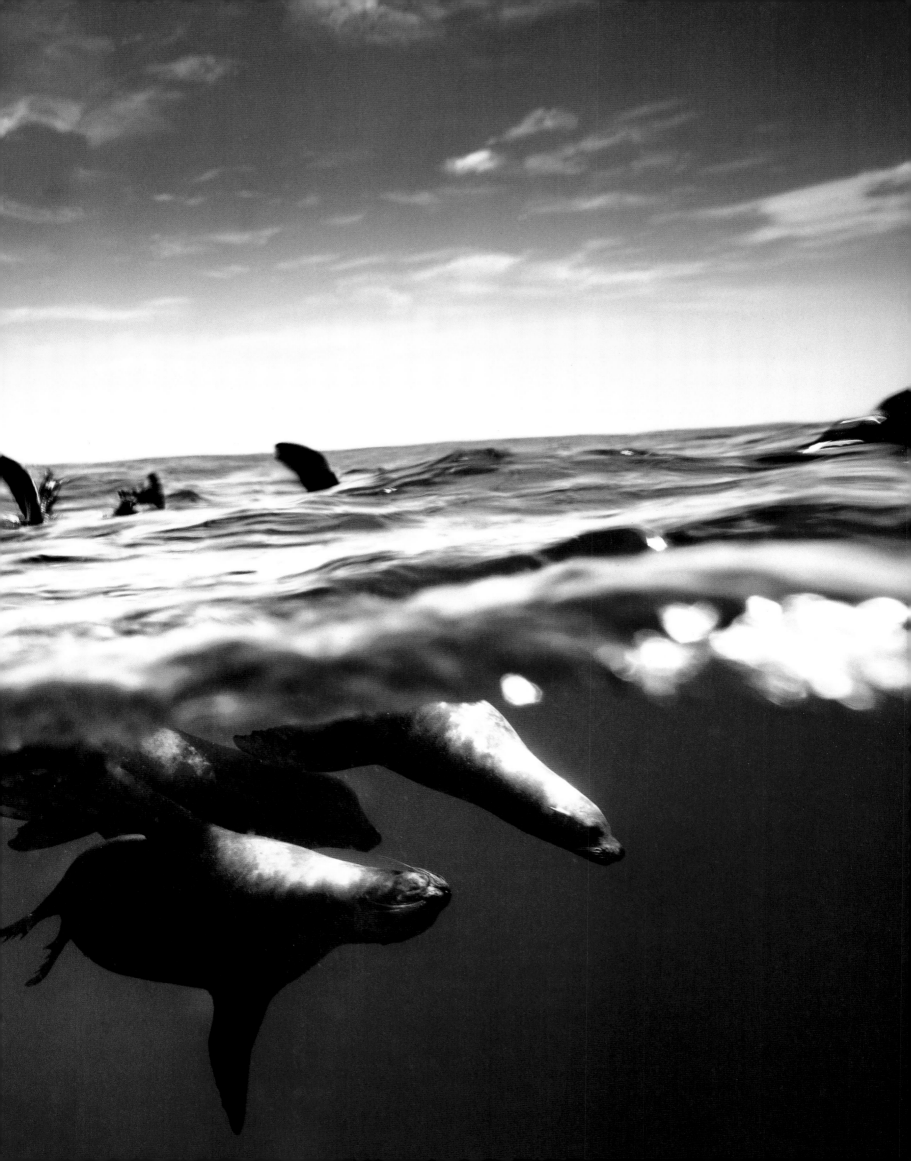

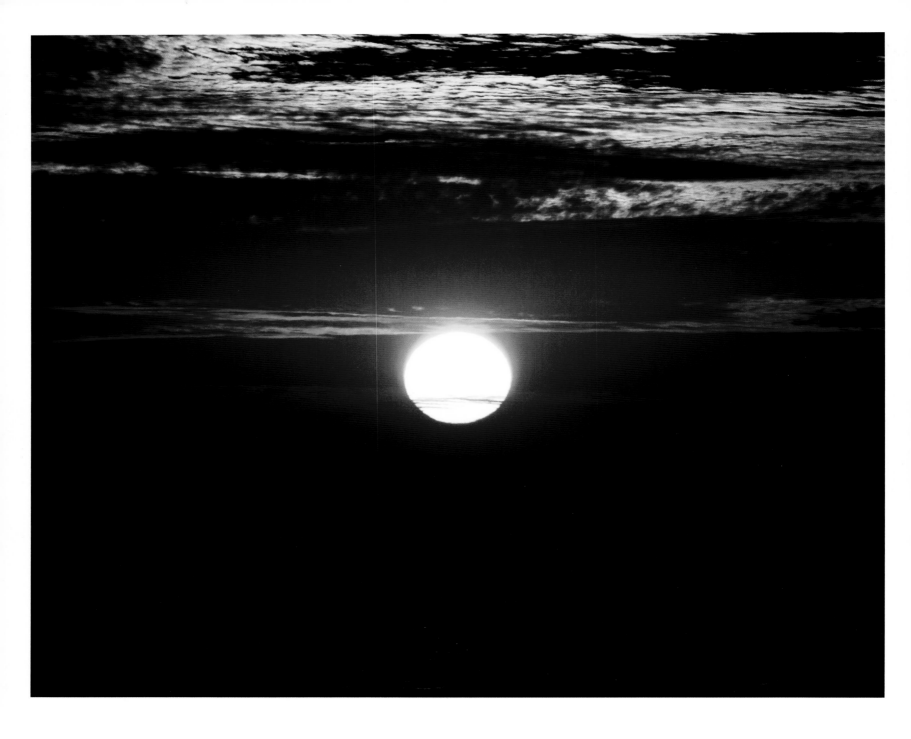

from sailing on our original route to Socorro, a volcanic island in the eastern Pacific Ocean famous for its sharks, rays and other large marine creatures, due to a hurricane. For better or worse, we will have to settle for a substitute tour. How lucky we are going to be on this alternative trip is not clear to me yet at this point in time. Had I known, I would not have stomped angrily down the quay, disappointed and annoyed to death at my misfortune.

A Momentous Decision

The alternative route takes us from Cabo San Lucas out into the Gulf of California, where we hope to find somewhat calmer seas for diving. Already, inwardly, I have said farewell to the sharks and manta rays I had been intending to photograph;

and I wait while the mainland slowly recedes behind us. For a long time, not much happens. Apart from a few jumping devil rays and dolphins, we see nothing in the blue-green expanse of the sea, which has meanwhile gotten quite rough; even here, the outer bands of the hurricane are making themselves felt—so much for those calmer seas! There is a dejected atmosphere on board that seems to be affecting everyone. But as we all know, weather is one of these unpredictable factors beyond anyone's control. And so we are left with nothing other than to keep waiting.

Only when a Cessna pilot (and friend of Jorge's) radios to tell us there is a peculiar commotion in the sea fairly close to our ship does our little group snap back to life. All of a sudden, the prospect of our first dive gives us back our exuberance. However, we first have an important decision to make as the crew gives us two options:

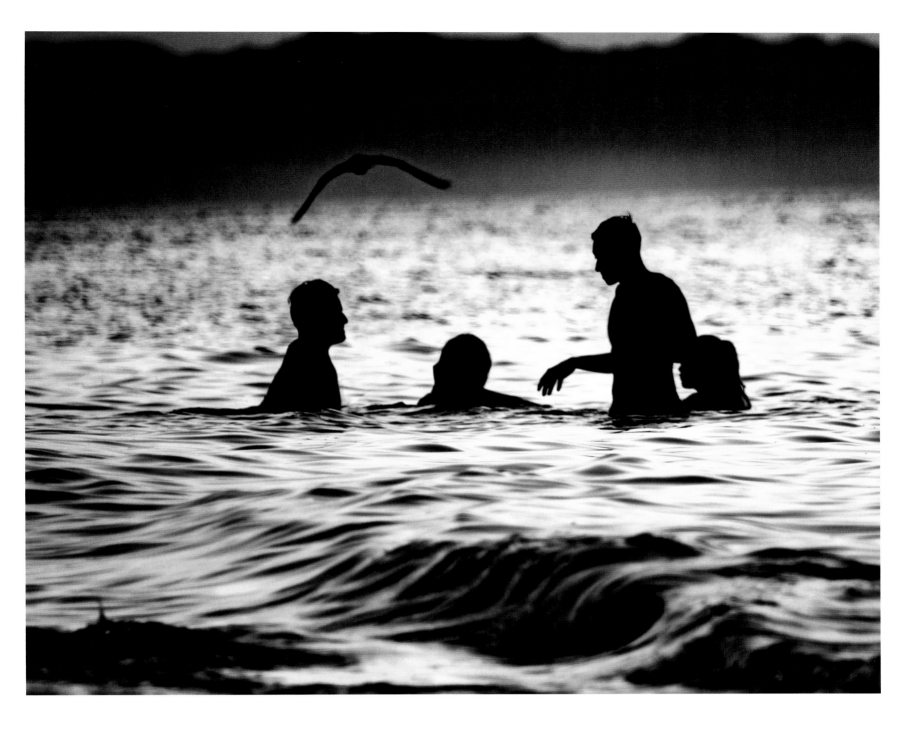

We can either dive with bull sharks that live nearby, which definitely guarantees a few exiting moments; or we can head for the unknown, that being the direction the pilot has just indicated to us. Without knowing what awaits us there, I decide quickly. I naturally choose to take a risk. For even if we find nothing, I don't even have all my equipment with me anyway; "and maybe," I figure, "after all the bad luck the last few days, fate could always take pity with me, and something big is waiting for me out there." Together with a very few other guests, I get into a small speedboat with barely room for six. Among them is Jorge—which says a lot.

An hour later, we reach the area of the sea surface the GPS coordinates of which had been transmitted to us, and we start looking. Nothing. The minutes go by, and my hopes are fading, when everyone on the boat suddenly freezes

at an exclamation: "Whales!" And then we see them: Their long, curved dorsal fins stand out black against the light grey of the sky, and I can hardly believe my eyes. A whole pod of wild orcas is coming right at us. Killer whales! We hurry to get in the water. Nobody on board is afraid; we are much too worked up for that. In the eyes of my fellow divers I only see flashes of pure enthusiasm as well as a child-like sense of anticipation that also takes hold of me and Martin. I break out my camera in a rush, and together we jump into the dark, rough water of the Sea of Cortez.

A Unique Encounter

It takes a while for my eyes to adapt to my new surroundings, but the size of the animals alone makes them easy to recognize from the very

Giants of the Seas

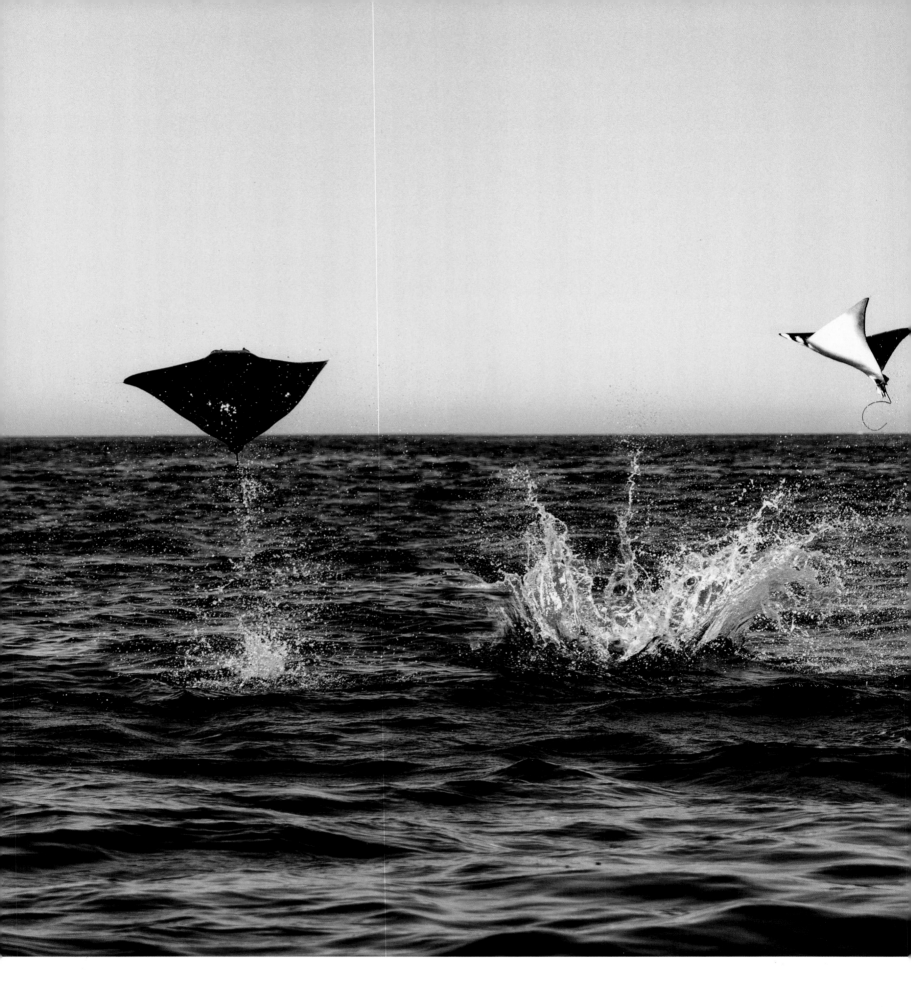

Giants of the Seas

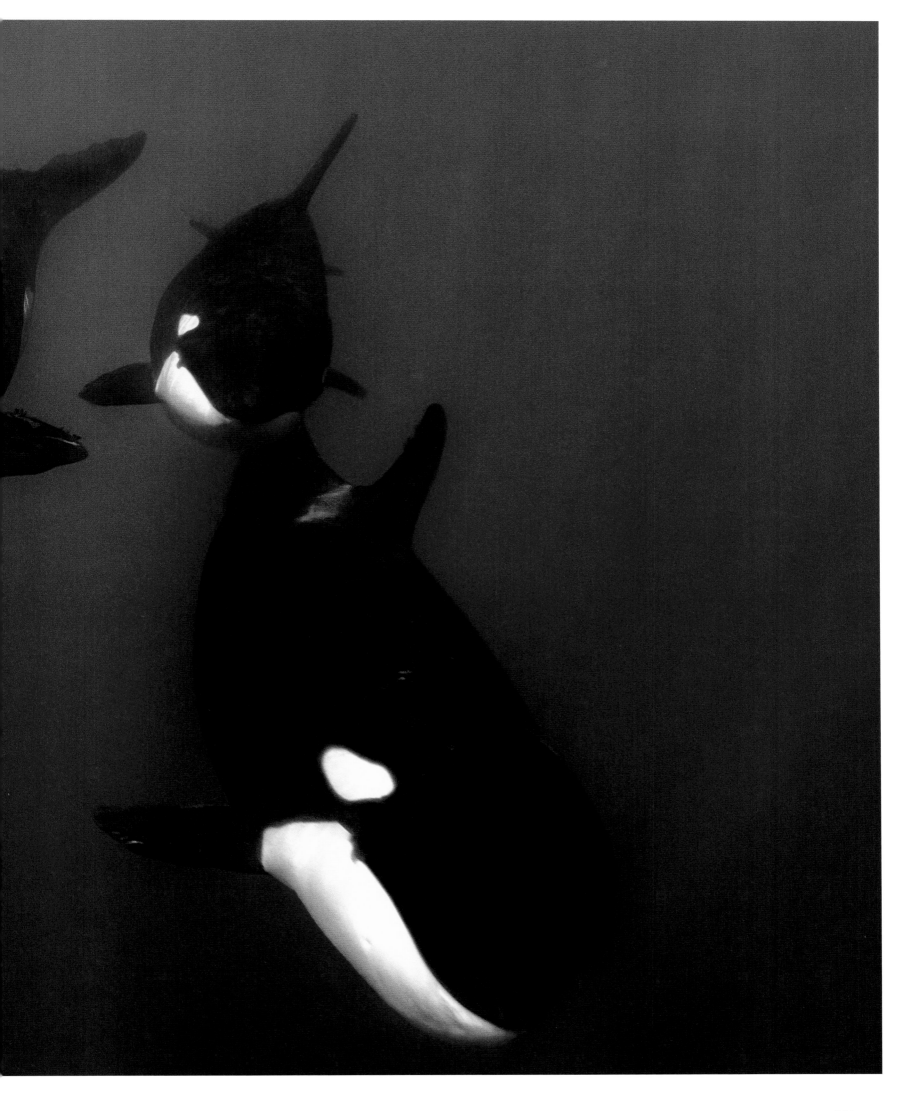

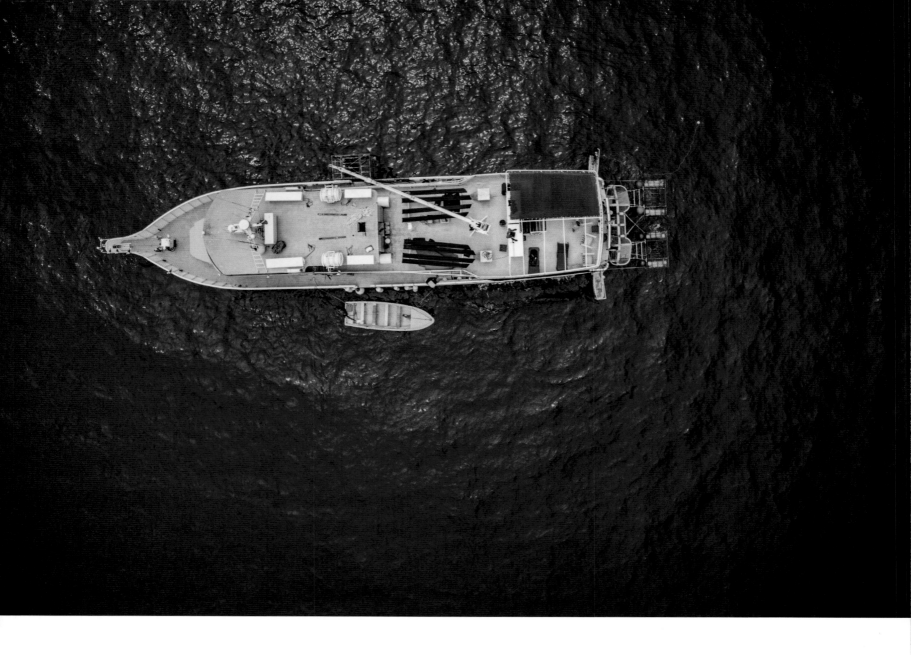

INFO | BIOLOGY

Guadalupe is an
island in the Pacific
Ocean, and it is
famous for its large
population of great
white sharks. Apart
from fur seals, which
are under protection
here, there are also
large colonies of sea
elephants on this
island—the native
great white sharks'
favorite prey.

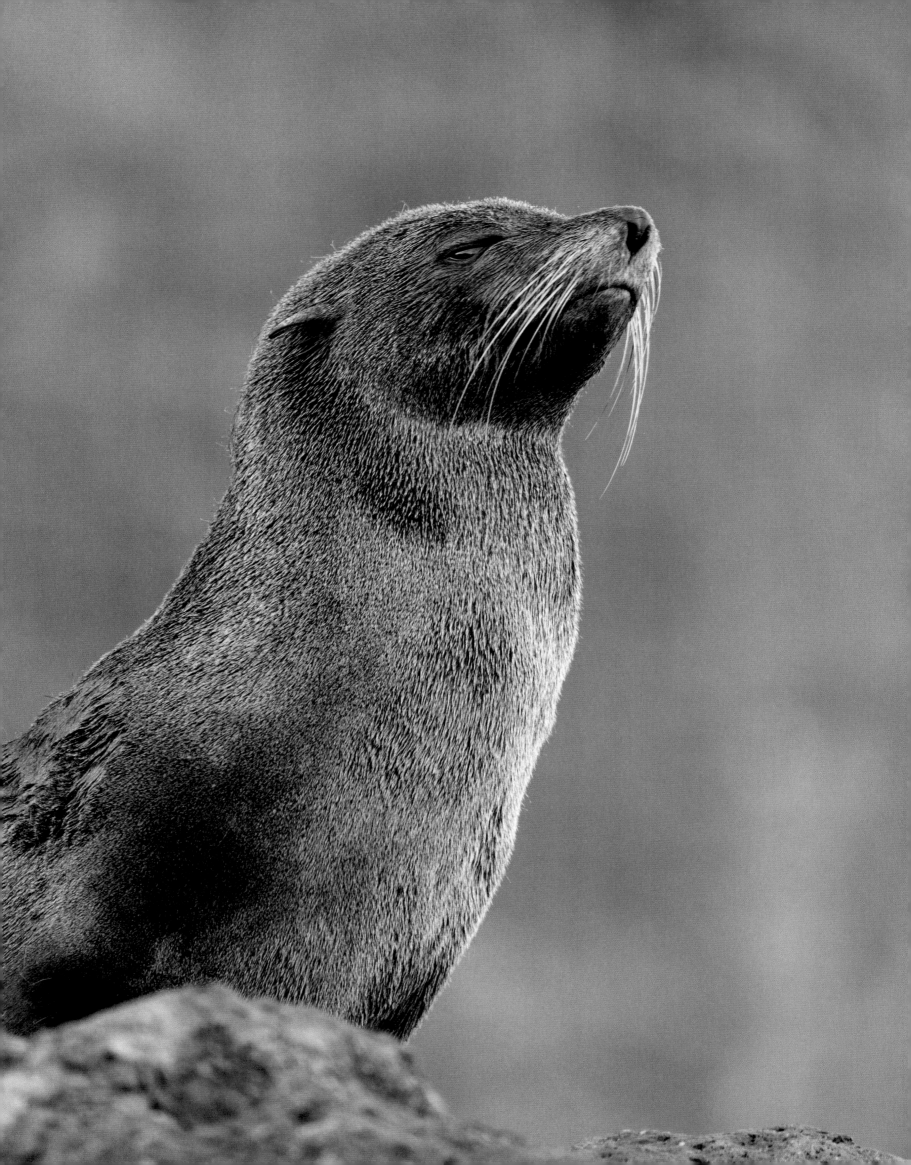

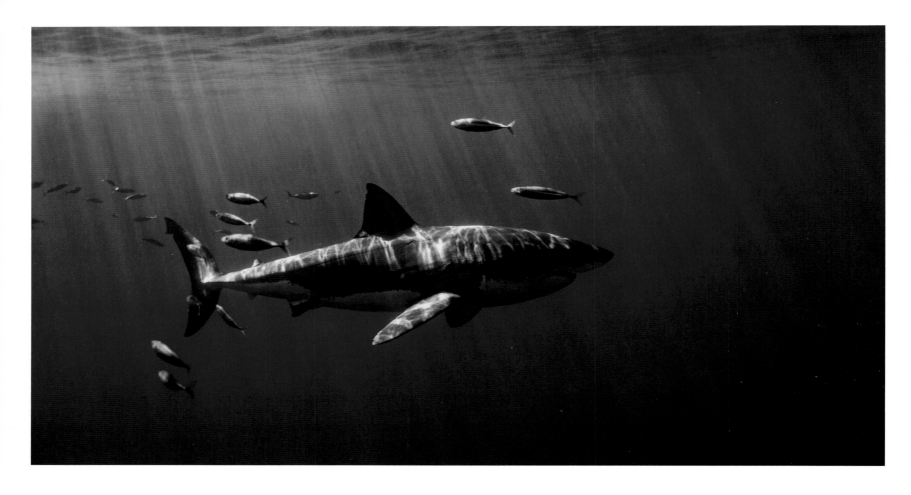

Majestic Hunters

adrenalin and enriched by the most impressive experience of my diving life so far, I am simply effervescent about it. The story sounds unbelievable; but our pictures speak volumes. In the end, I thank the hurricane for this happy turn of events, and I am sure the others who were fortunate enough to experience this with me feel the same way. Moments precisely like these are what teach us, again, how valuable our environment is, and how worthy of protecting, so that those who come after us will be able to experience these wonders too.

But orcas, members of the dolphin family, are unfortunately already highly endangered in many places. Their prey—especially fish, but also seals and other marine mammals—is gradually disappearing, and only mankind can do anything about it. This is what the organization Pelagic Life is committed to. They advocate for sustainable use of resources to preserve the diversity of life in Mexican waters. And the big predators are part of it. For their significance in the food-chain is enormous: They regulate and police the health of countless other populations of species and thus enforce a necessary balance within the ecosystem.

But orcas are not the only great hunters we are called upon to protect. There is probably hardly any other animal on this planet that flouts its reputation as much as the shark—in particular, of course, their kind's greatest representative, the great white. Feared and persecuted for decades, the great white has few advocates. But it really direly needs them.

Many shark species are already on the verge of extinction. Thousands of sharks die innocently every day as bycatch in fishing nets or are deliberately caught only to end up being thrown back into the sea, their fins stolen, mortally wounded, to die in agony. The demand for shark fins is so high that there is a huge black market; and in some countries, their exportation is even still legal. It's all just for a status symbol of a soup …

and all the while, sharks are one of the most important links in the food chain. Anyone who has ever experienced them up close knows of their beauty, elegance, and grace. I too would like to experience this; and so a few months later, I return to Mexico to set off for Guadalupe with the Pelagic Fleet.

Info | Biology

The great white shark's jaws and teeth are a triumph of nature. If the shark loses a tooth, a new tooth from the second series just behind it comes to replace it. Some species of shark have been known to shed up to 30,000 teeth in a lifetime.

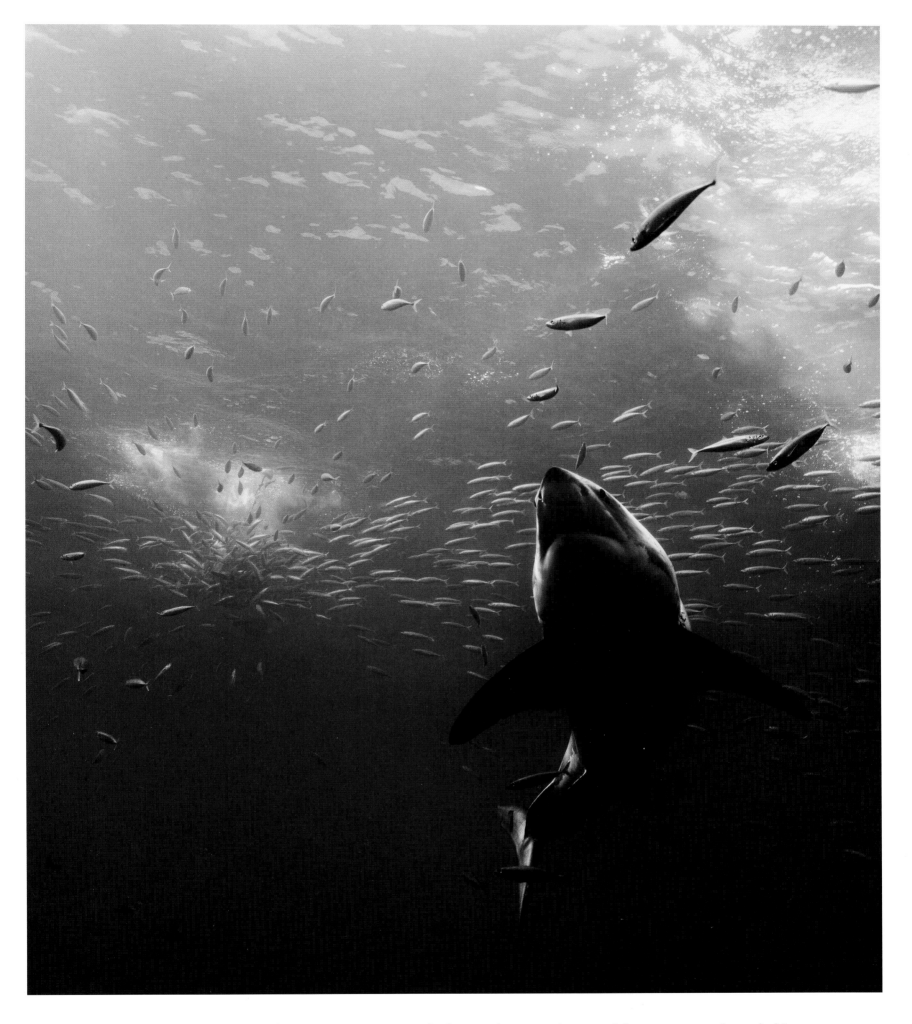

Feared and persecuted for decades, the great white has few advocates.

This image is an impressive testament to the fact that humans are insignificant when faced with the ocean's magnitude. To the diver, being surrounded by nothing but water, not knowing what is going to happen next, is a thrilling feeling.

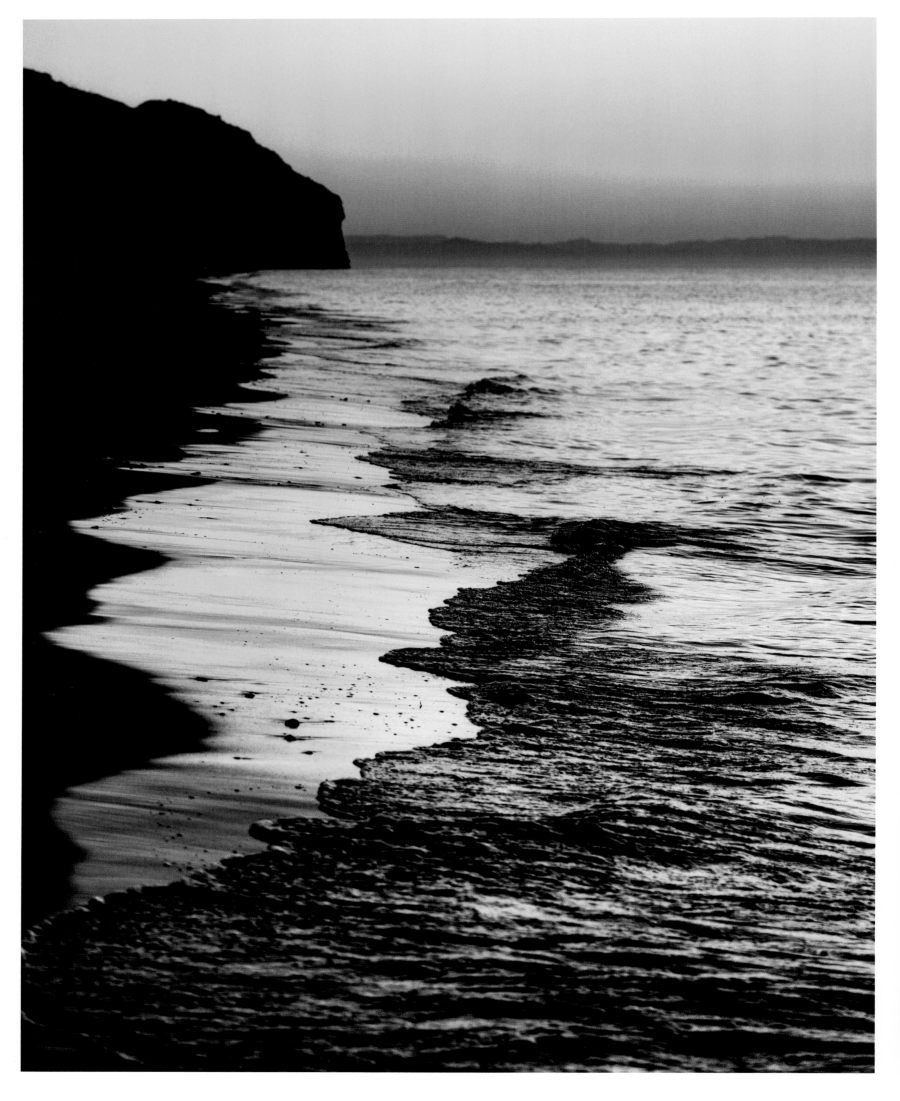

Giants of the Seas

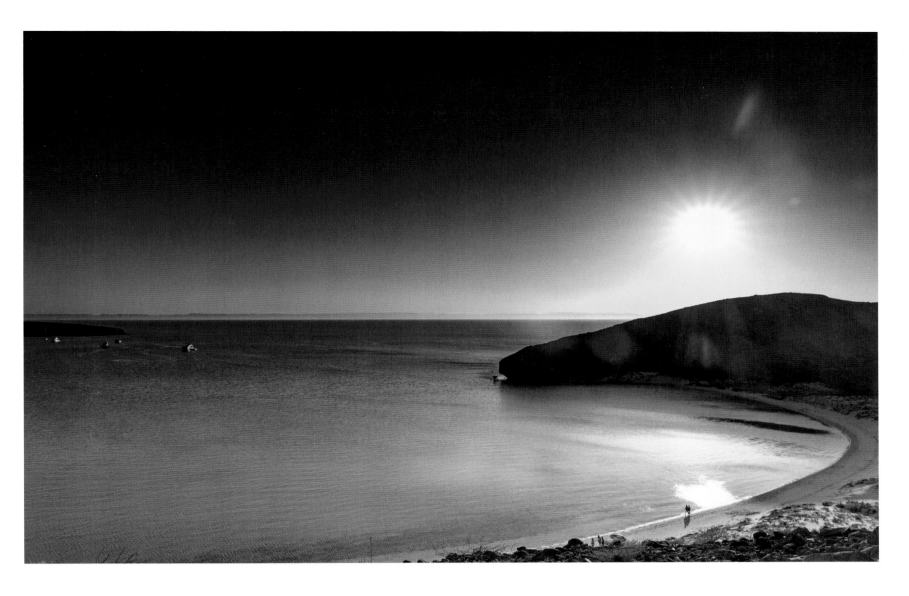

The principle is: to find enlightenment first-hand. And it is an extremely successful principle. It is how the organization Pelagic Fleet makes the animals more valuable alive than dead. Ecotourism is booming, and so support is often provided to local fishermen to switch over to the new, rewarding business. For the benefit of nature.

Once more aboard the Solmar V, we sail away from the Mexican coast and out onto the open Pacific Ocean. This time, Sabine Streich and Katrin Eigendorf are along to do the video recording. It will be two days at least before we reach our destination, and we use the time to learn more from the experts on board about the marine animals in the area. The crew gladly shares its extensive knowledge about the great white sharks with us, and we listen eagerly. There have been many scientists and camera crews on board already who have profited from the ship's modern, professional equipment.

In all there are three shark cages on board, two of which, when in use, are kept directly below the surface of the water. The third is lowered off the side of the ship by a crane to a depth of about fifteen meters so the animals can be observed better from a different perspective. Sabine and Katrin will join me in the cages such that we will be filming and photographing at the same time. I have seen smaller sharks in the wild already myself, but to see such a giant with my own eyes is another thing altogether. We are not allowed to dive outside the cages, which is something reserved for specially trained marine biologists; and, anyway, there is no point in taking too great a risk.

We anchor off Guadalupe, a small, thinly populated island in the midst of the Pacific Ocean. The moment is approaching at last. After detailed instruction on the safety rules, the cages are lowered into the water. I find myself in a shark cage slowly sinking deeper and deeper. It is not long before the first sharks appear and circle around us. Some of the individuals living here are carrying temporary transmitters on their dorsal fins. The data thereby obtained should help to better understand the migrations and behavior of the predators. Still to this day, very little is known about these animals, which, according to some scientists, are already to be considered as "biologically" extinct in some parts of the world; which means that, though the animals are still present, there are too few of them to secure the future existence of the species. Even this so-called apex

Picturesque bays and the sunset's colorful reflections on the water always make for a fantastic photograph. Here, at the Gulf of California, I always felt mesmerised by this view, unable to tear myself away.

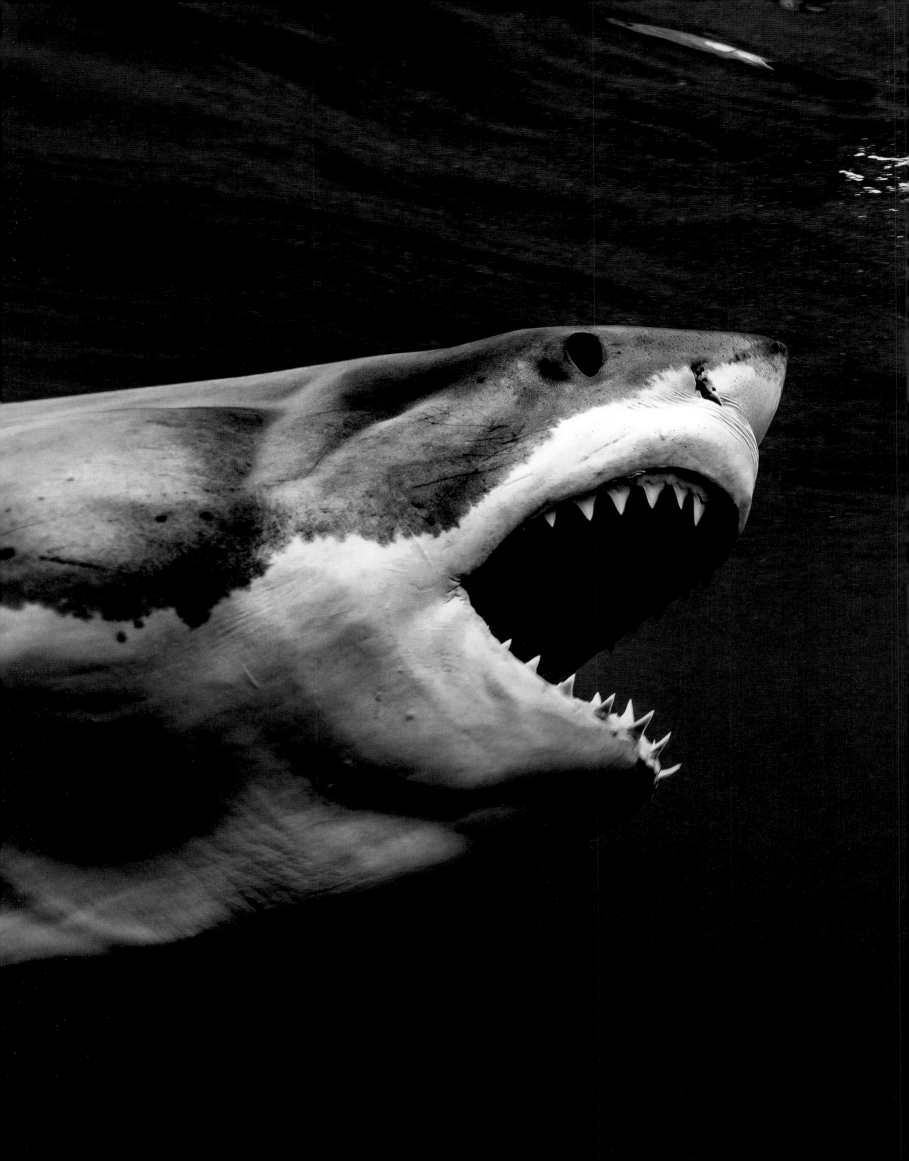

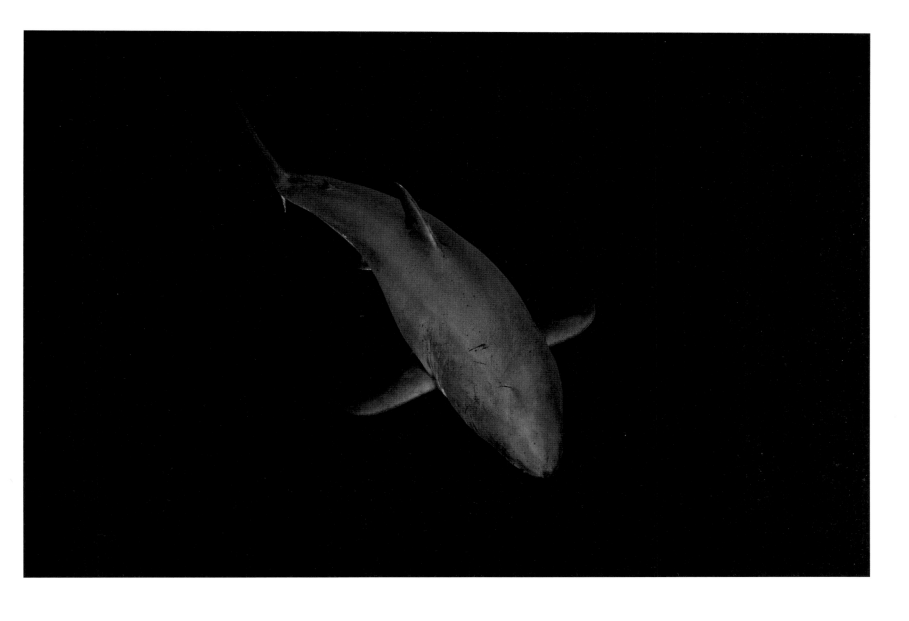

The great white shark may be the sea's most widely feared predator. Yet those who have seen a great white shark with their own eyes know that our image of these creatures is skewed. We need to distribute better and more accurate information on these animals so that people can appreciate their beauty and, most importantly, understand how essential they are for the ocean's ecosystem.

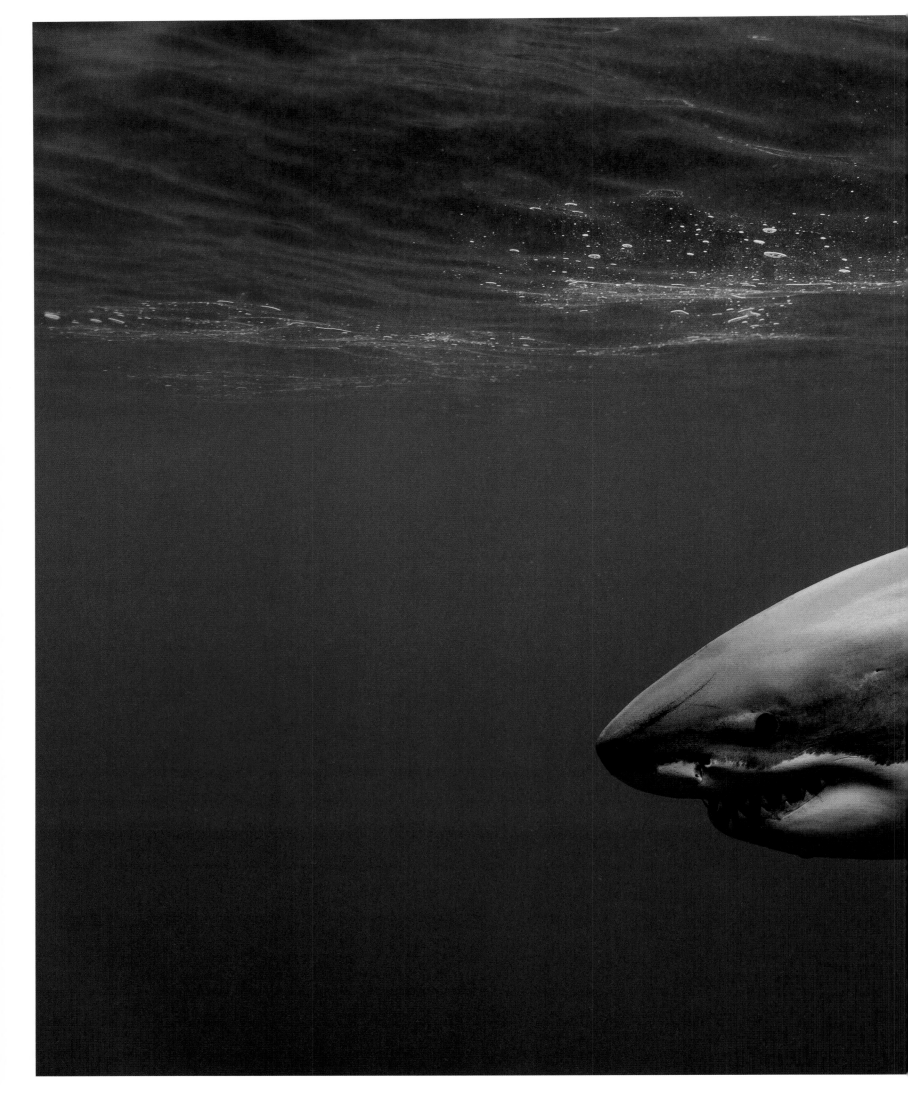

Giants of the Seas

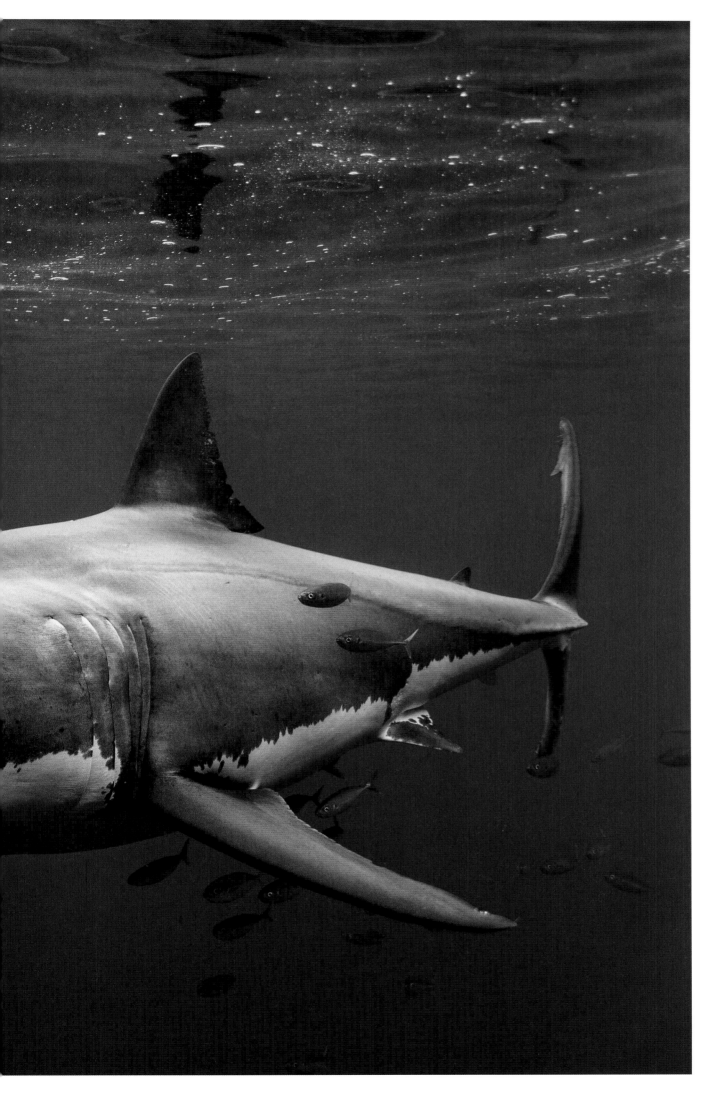

About 400 million years ago, prehistoric sharks were already living in the oceans. The biggest species was the megalodon, now extinct, which could reach a length of up to 60 feet. Some of its teeth were as long as a human's forearm.

But they still exist, these majestic hunters who sometimes even seem to smile.

predator, one at the very top of the food chain, is slowly running out of steam—or rather: out of time. For besides intentional hunting of these animals, mortality due to bycatch, and declining food sources, their slow rate of reproduction is also putting them at risk. Their natural reproduction cannot compensate the losses.

It is sad to see how humans have pushed an interrelationship of species, perfected over millions of years, to the brink of destruction in just a few decades. But they still exist, these majestic hunters who sometimes even seem to smile. Leisurely, they circle the cages, and all we can do is admire them. Their strength and size are unimaginable for anyone who has not experienced them live. Simply unforgettable.

Back on board we get another lesson about the behavior of the sharks: how we can tell them apart, and how to tell the difference between the sexes. The more we hear, the more we feel connected to the animals; and maybe that is the reason why the principle of Pelagic Fleet and Pelagic Life functions so well. Support for scientific projects paired with educational efforts and ecotourism seems to be the perfect combination. Here we find a modern kind of species conservation based on awakening people's awareness about our oceans. And exactly that is what matters!

INFO | EVOLUTION

Sharks are also setting records when it comes to age. Greenland sharks can grow older than any other known vertebrates. One animal captured in 2010 was found to be 400 years old.

Our last dive in San Diego's kelp forests. Strong currents make this fascinating subaquatic world a dangerous place for divers, yet we simply had to take the exciting opportunity to experience these vast forests of seaweed.

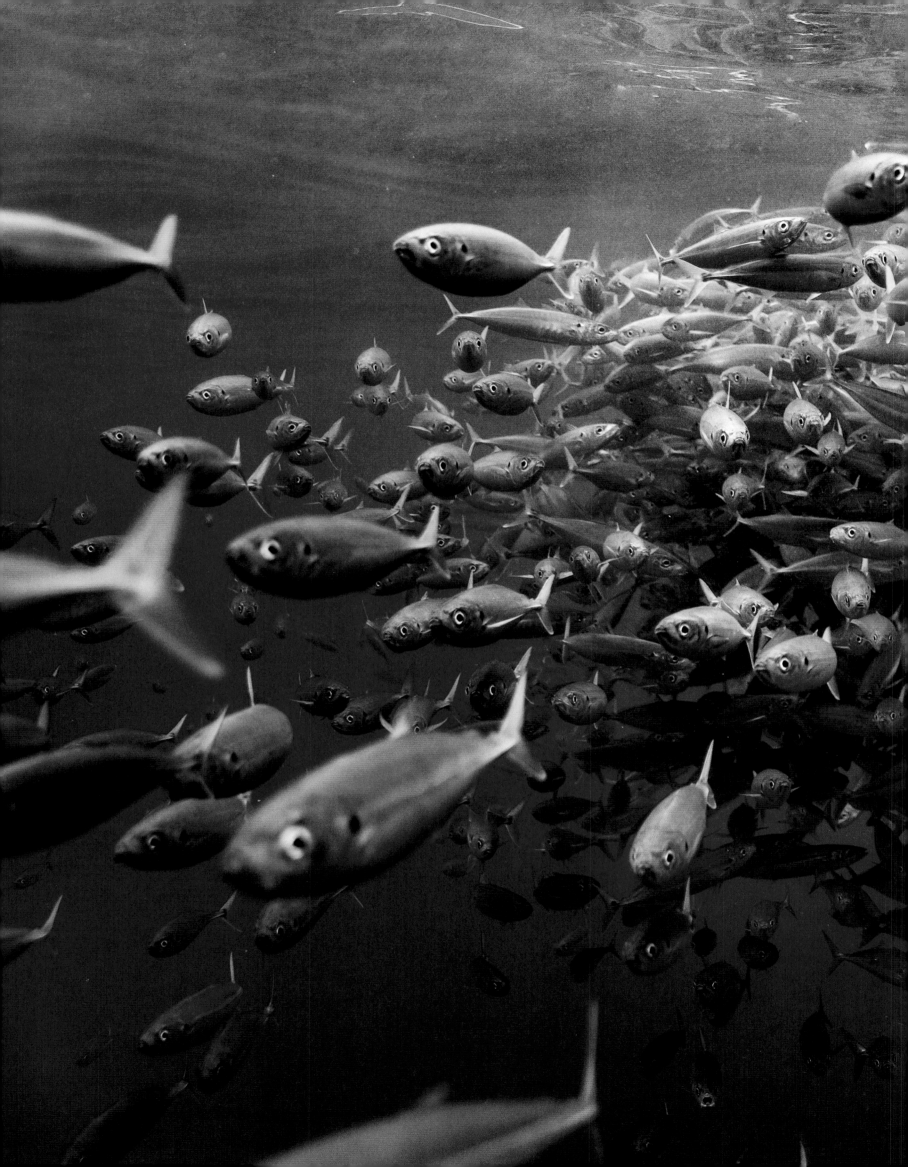

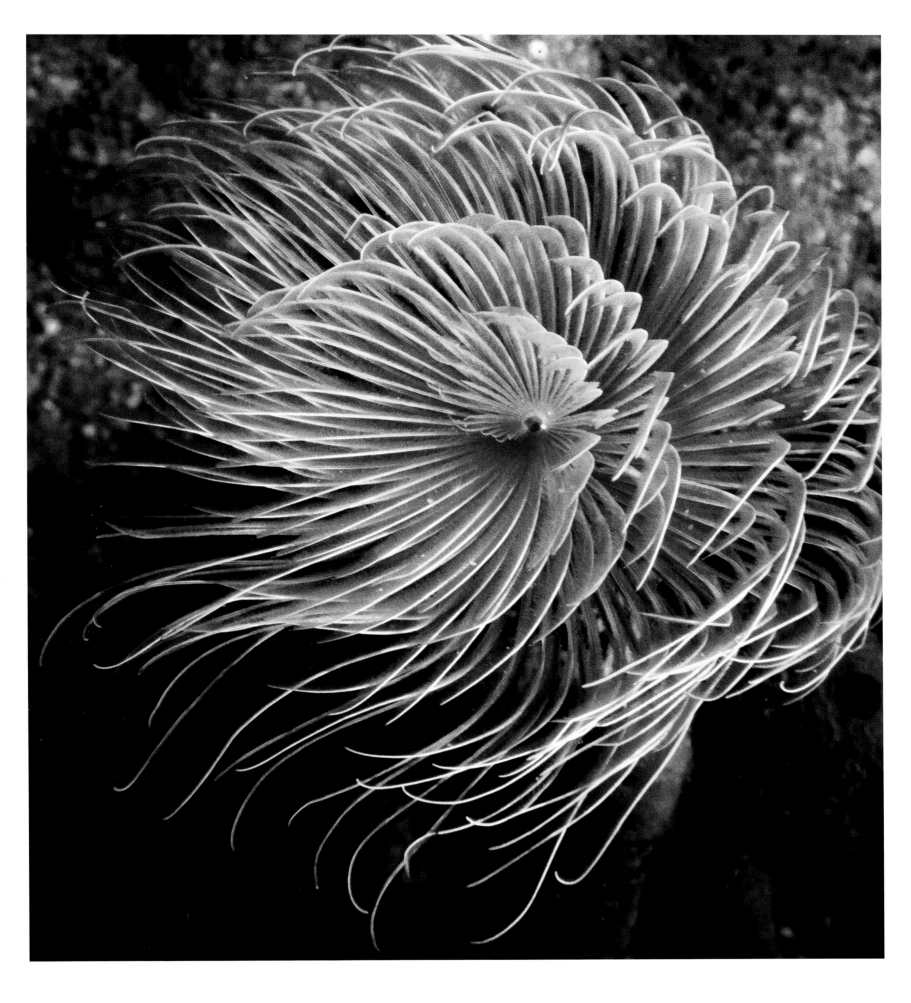

Jellyfish and sabellids—our oceans are full of fascinating creatures big and small, occurring in all shapes and forms. Even less popular animals such as the jellyfish can often be surprisingly beautiful if you take the time to observe them more closely.

Great White Shark

"I have always been fascinated with this perfect predator's grace and elegance; its powerful movements, cautious approaches, and the intelligence I see in those dark eyes. I wish more people had the opportunity to experience them up close."

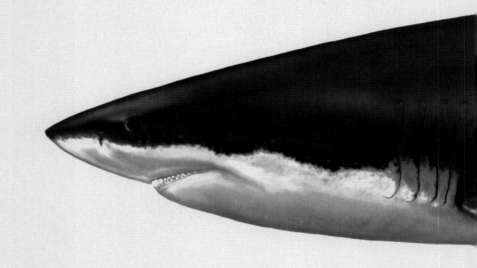

<u>Name</u>:
also known as white pointer shark

<u>Size</u>:
up to 23 feet (biggest predatory fish of current times)

<u>Predators</u>:
The great white shark's only known natural predator is the killer whale (orca)

<u>Great white sharks and humans</u>:
Great white sharks do not actively hunt for humans, yet sometimes, they may mistake humans for seals. The shark learns that it made a mistake very quickly: it can "sample" its prey by taking a so-called test bite which shows whether the animal is one of the shark's preferred types of prey.

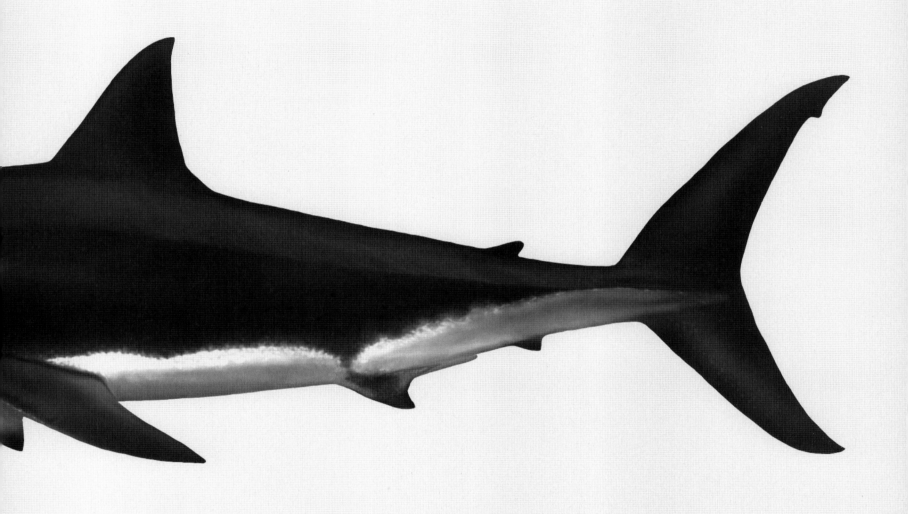

INFO | GREAT WHITE SHARK

The great white shark got its name from the light colo-
ration of underside. Looking at it from below, it beco-
mes one with the bright surface of the sea. Looking at
it from above, it is equally well-camouflaged due to its
darker back. The great white shark can reach a length of
up to 23 feet, making it the world's biggest species of
shark. Females are considerably larger than males. They
are native to almost all of the world's oceans with very
few exceptions such as the Baltic Sea and Arctic waters.
Great white sharks are now considered endangered in many
of their habitats; in some places, they are considered
biologically extinct.

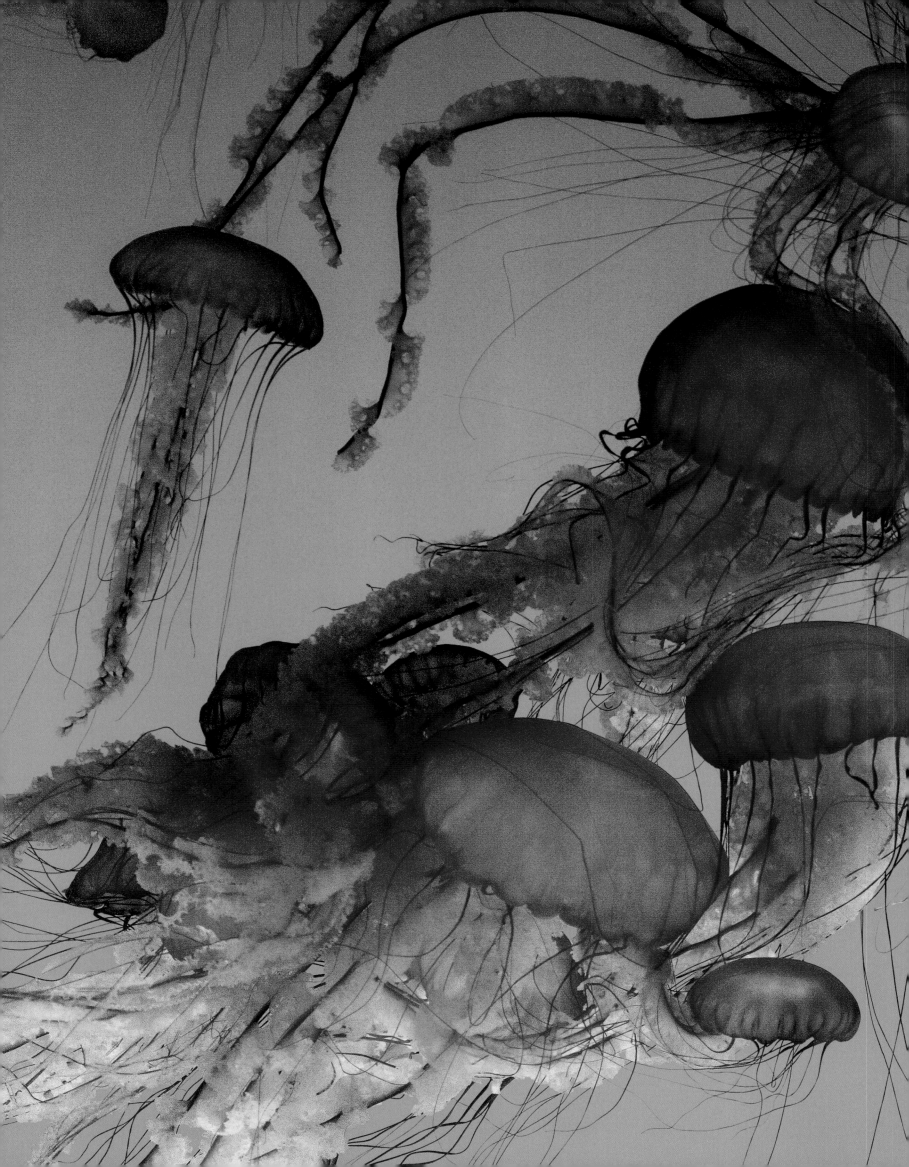

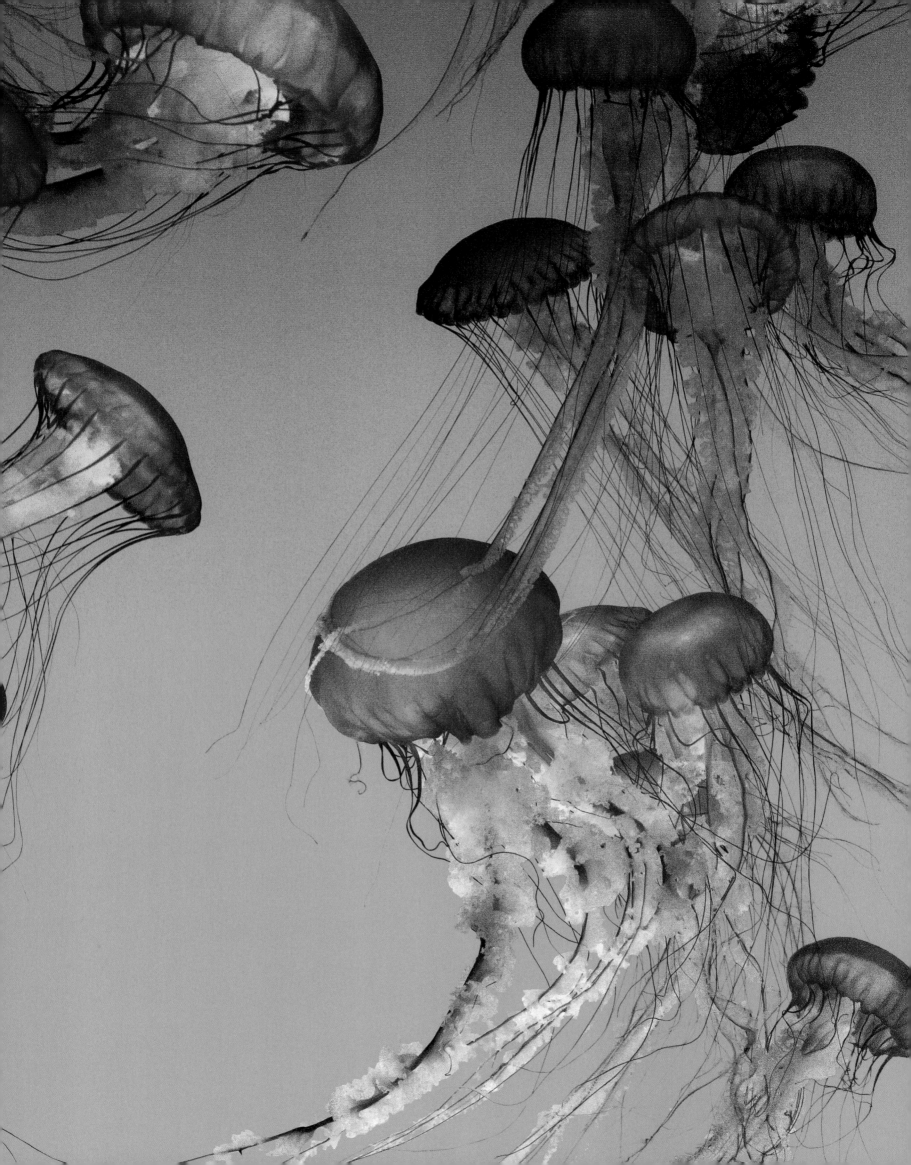

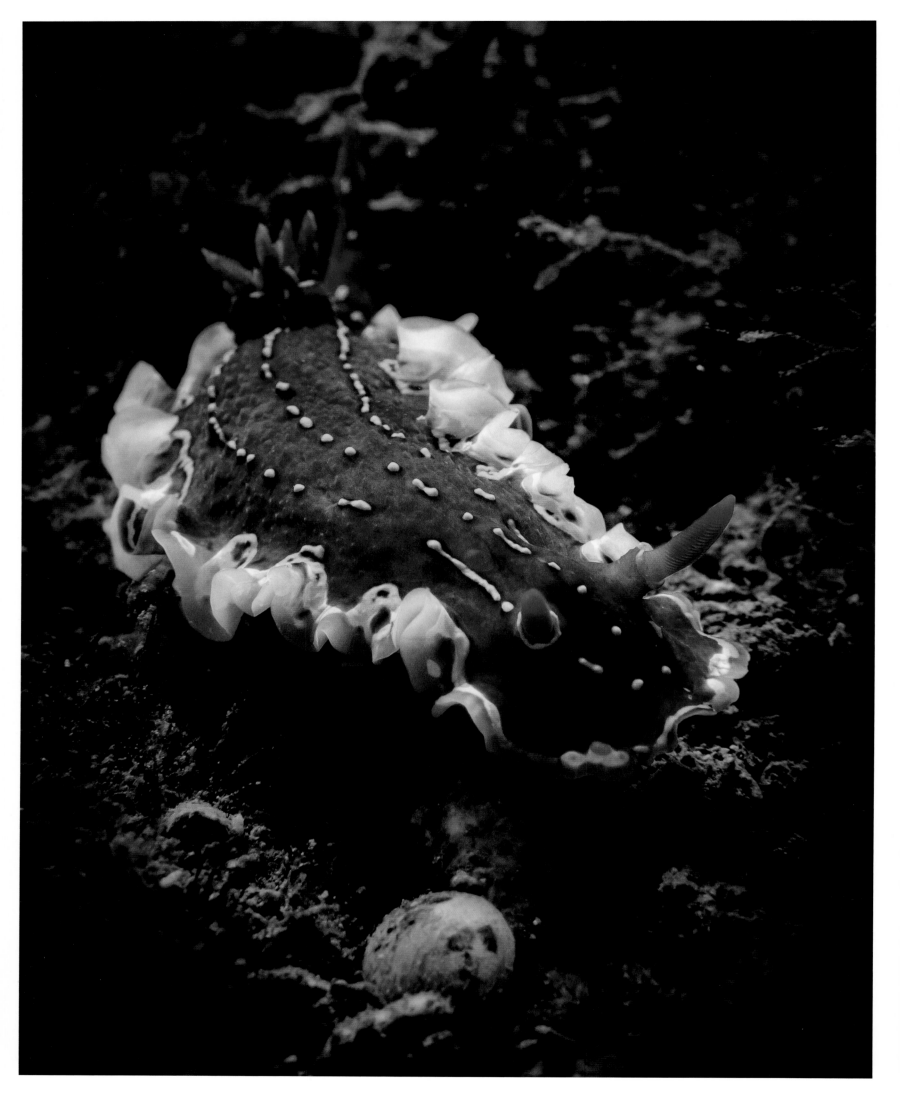

Giants of the Seas

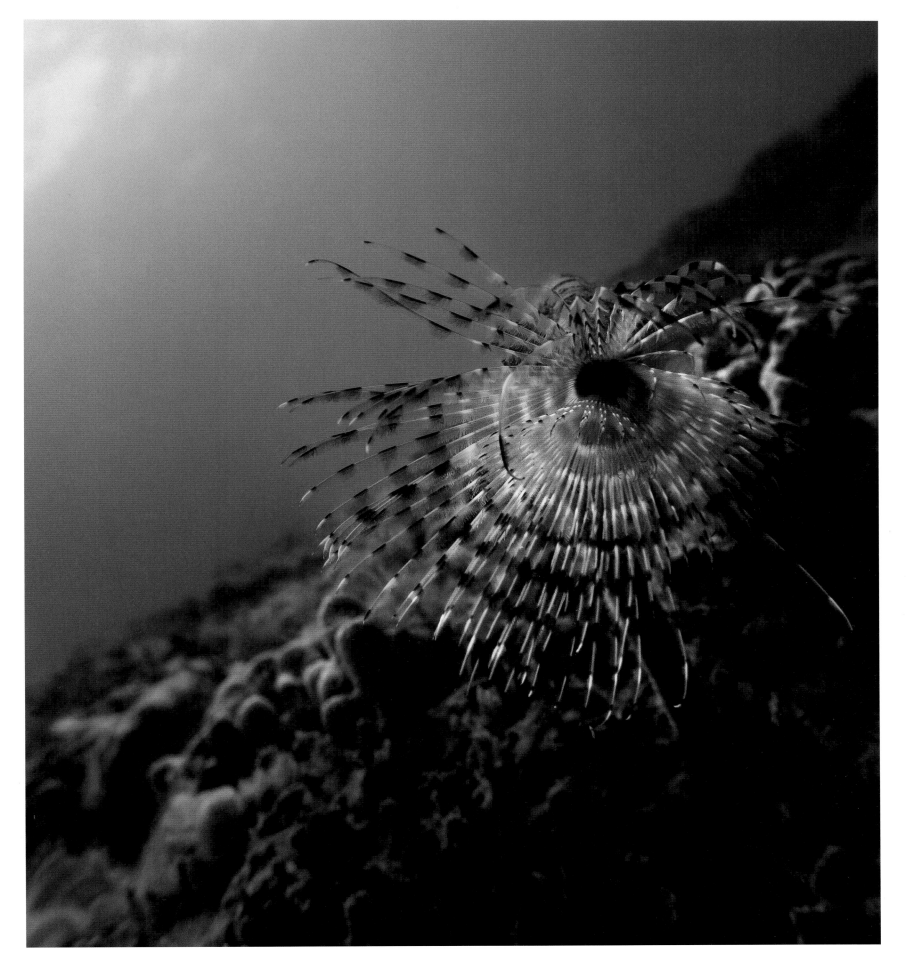

A hidden beauty. You have to approach
sabella spallanzanii, the European
fan worm, slowly and with great care;
otherwise, it will retract back into its tubes
immediately. If you wait patiently, you will
be rewarded with this sight.

Location:	Challange:	Heroes:	Mission:
Atlantic Ocean	Overfishing of the oceans	Sea Shepherd	Gabon: Monitoring and oversight of illegal, unreported and unregulated deepsea fishing
West Africa	A threat to biodiversity	Activists	
Gabon			Generally: Protection and conservation of marine habitats
Port-Gentil			

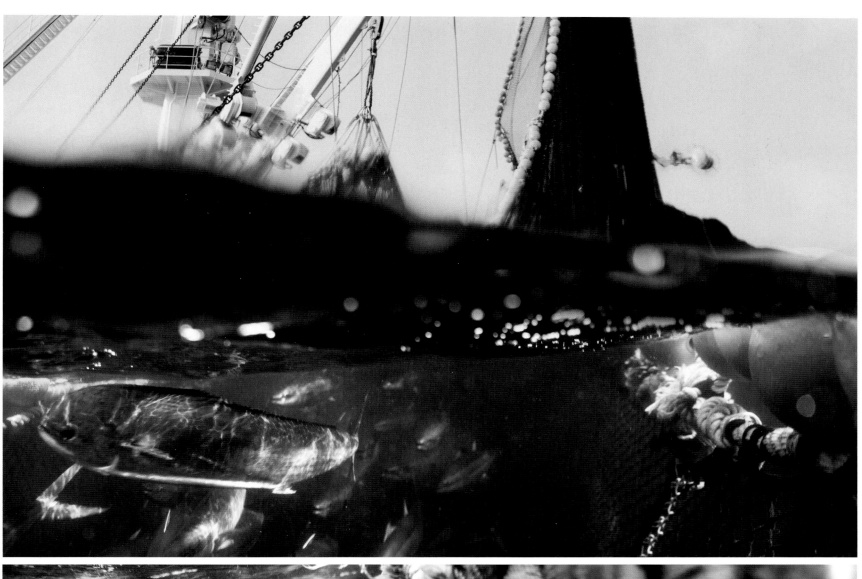
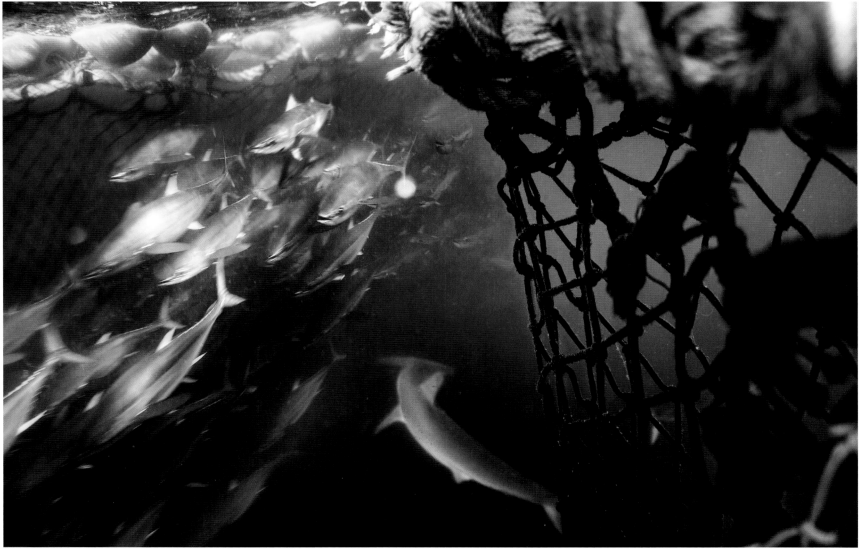

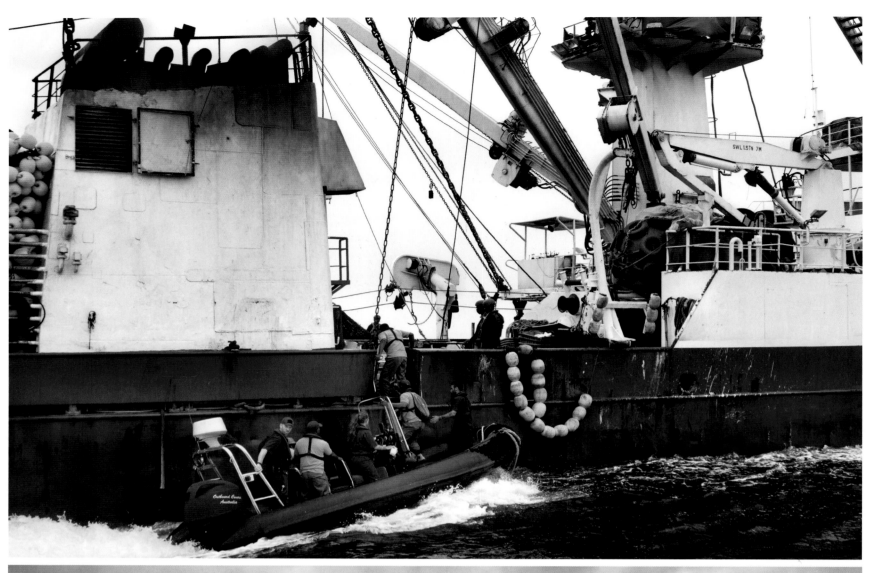

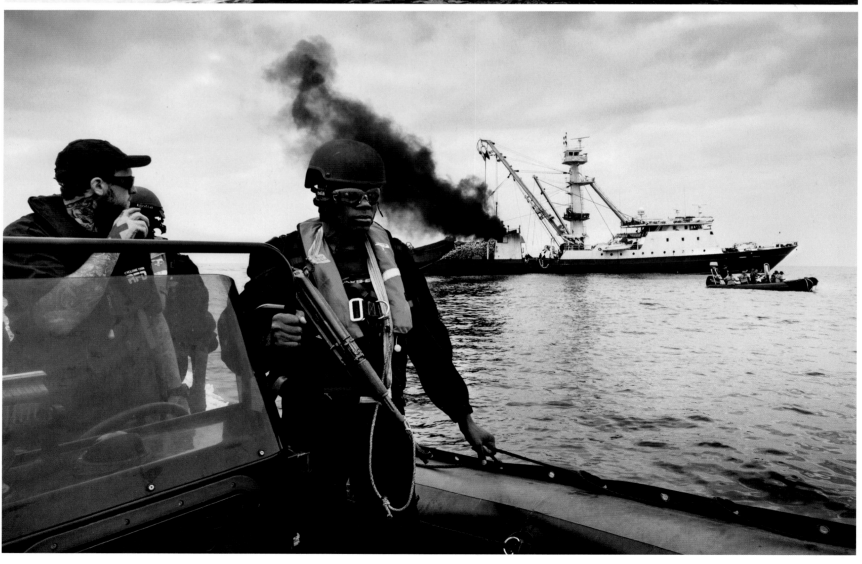

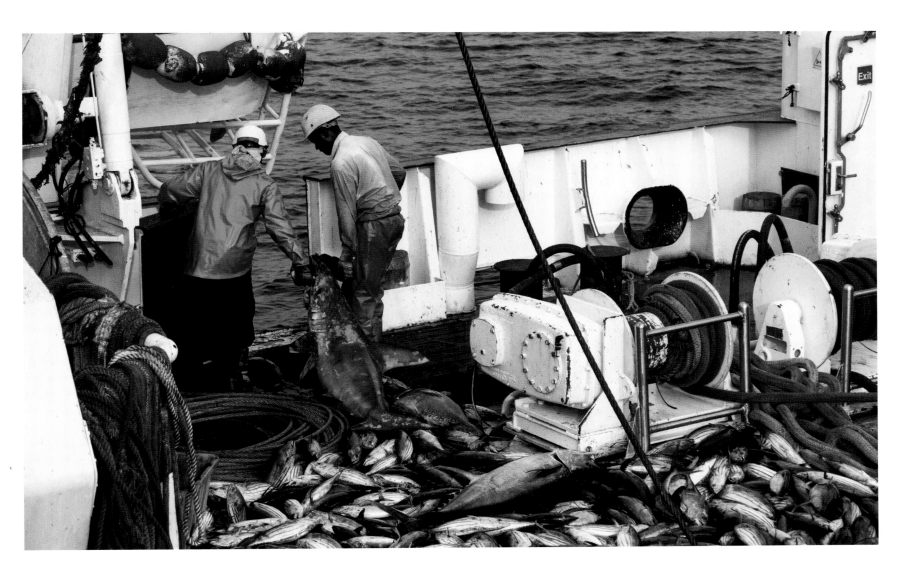

But what they may do at least is carry out their inspections as exactingly as possible: They first check to see if all the paperwork is in order and then go below deck, into the coolers. There are plenty of places here to stash away illegally caught animals or animal parts such as shark fins. But we do not discover any during our first inspection. Yet the activists know from past experience that the temptation of making extra money by dealing in banned goods is often simply too great. That is why they search a legal purse seiner with the same meticulousness as an illegal one: just to make sure.

And the fishermen know they are not to be taken lightly. By cooperating with the government, the marine conservation society can exert even greater pressure and act much more effectively against illegal operations. But the activists are present elsewhere as well, acting to secure the survival of innumerable species: from various shark species that are already on the verge of being wiped out because of the trade in their fins, to the fight against whalers; and from the diminutive Baltic Sea harbor porpoise to the cute vaquita in the Gulf of California, of which there are only around twelve remaining individuals. Their mission leads them wherever the ocean needs them. Unconditionally.

Eyes That See No Way Out

Days go by with us on the lookout for more fishing vessels. Thanks to the activists' successful first engagement here off the coast of Gabon in 2016, illegal, unreported and unregulated fishing (IUU) has already fallen off sharply. But the continued presence of the Bob Barker is necessary to make a statement. The future requires lasting change, and so we are demonstratively cruising in Gabonese waters. We pass countless drilling platforms extracting large quantities of petroleum. At night, the gas flares burning off waste gases on every one of these rusty steel scaffolds shine on the horizon like a threat: another treasure being extracted from local seas; another risk to the environment.

We pass the time with lots of exercise and various training sessions. From the crow's nest, the highest observation point on the Bob Barker, we observe the breadth of the horizon. Now and then, a huge manta ray crosses our path. We also regularly spot whales near the ship. But not until we get word of the arrival of another purse seiner does that feverish level of activity reemerge in which everyone's sole focus becomes their own role in perfect keeping with practiced procedures.

The operation is assisted by soldiers in the Armed Forces of Gabon. Each mission is planned meticulously, and when a large trawler appears on the horizon, everything happens very quickly. Each step is well-rehearsed and nothing is left to chance. Yet despite their best efforts, activists cannot stop countless sharks, dolphins, stingrays, and turtles ending up as bycatch and dying a violent and pointless death in the large trawls.

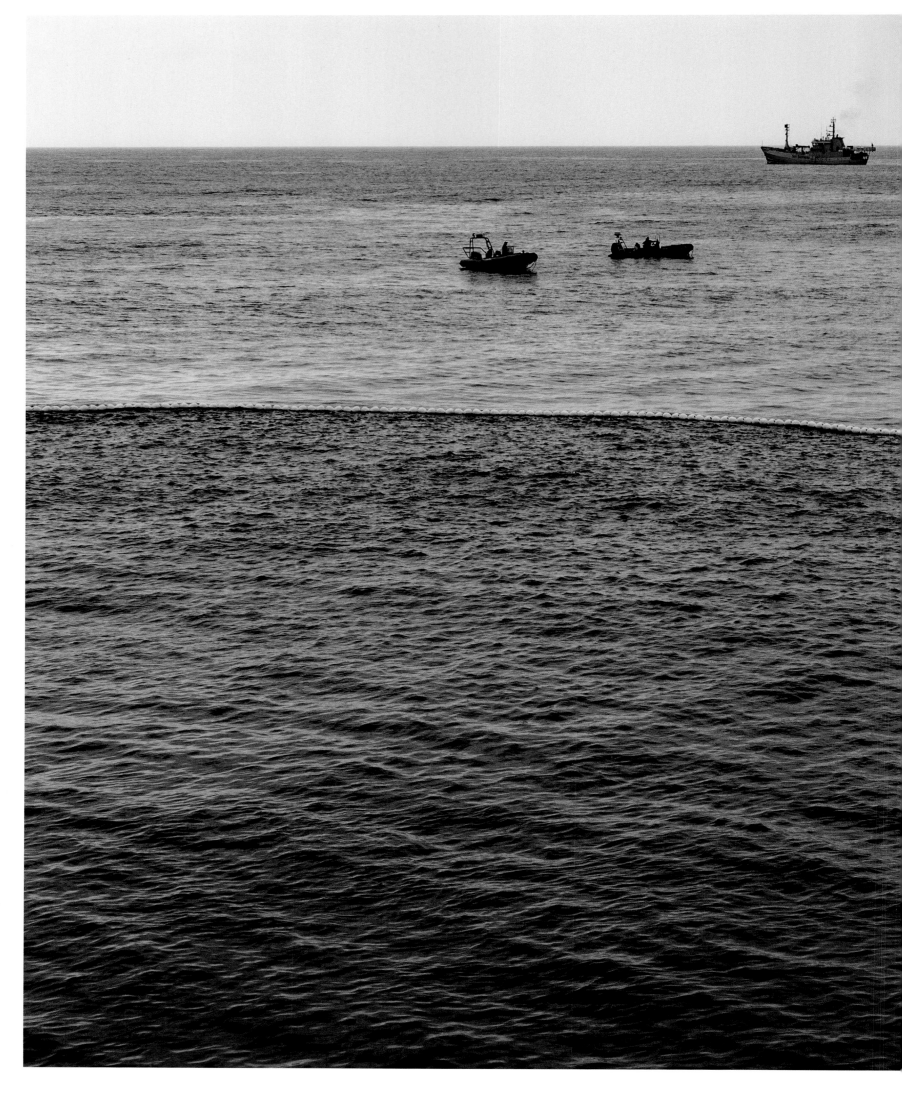

Pirates to Protect Our Oceans

The fishing vessel is busy hauling in one of its huge seines. This is an occasion I do not want to miss, and I prepare myself for my first wet deployment. I want to photograph the net below the surface, and I get a ride, in one of the inflatables, over toward the gleaming yellow floatline from which the meshes are suspended. Despite the tropical latitudes, the sea is agitated, and as soon as I enter the water, I can feel the motion on the other side of the huge net. A cold shiver runs down my spine. What awaits me underwater? I take a long, last breath, and then dive.

What I see down there jolts me within a few moments like hardly anything has before in my life. Thousands and thousands of tuna are racing around in a desperate attempt to escape. Giant, glassy eyes still not big enough to see a way out. Many fish have already got their heads stuck in meshes that hold on to them mercilessly. The noise down here, caused by the fin strokes of the fish as the ship's winch winds up meter by meter, pressing them closer and closer together, is ear-splitting. I can see several large hammerhead sharks swimming back and forth among the tuna, also in a panic, looking for a way to flee.

I toy with the idea of cutting a hole in the net to free the animals. A quick tug would set them all loose. But I know this is not allowed even for the activists: It is a feeling of powerlessness, of not being able to do anything despite having seen the cruel outcome of this drama already in my mind's eye. By now I am dangerously close to the net which is already hauled in tight against the purse seiner. The fishermen are shouting at me, and I know that I cannot remain here very much longer without taking too grave a risk. Meanwhile the water around the net has turned blood-red. I can no longer make out the tuna and sharks within it. Stricken, I signal to the Zodiac to pick me up again in order to gain a little distance. I know I will never see these wonderful creatures alive again.

In the Belly of the Ship

In under an hour, most of the tuna have vanished into the belly of the ship. A huge ladle (the so-called "spoon"), made of a steel mesh, dips into the encircling net again and again, each time hauling up fish by the ton. The bycatch gets sorted out right on deck, and so comes the inevitable. Here I see even the hammerheads again. They are long dead. Crushed by the weight of the tuna, they are thrown overboard indifferently. I am fully aware that—by now anyway, under the supervision of the fisheries agents and the soldiers armed with machine guns—the fishermen are working strictly by the book. All of this is lawful. But I also know that all too frequently, at this exact moment, the crew would be doing some very lucrative business on the side by brutally hacking off the hotly sought-after shark fins. The Asian market is a reliable customer . . . I am ready to burst into tears. But I have to keep photographing, for these are the images I want to show to impress upon everyone what is behind the diverse displays of fish presented to us at the supermarket.

Today, my respect for the activists' work has grown yet again. They, too, feel stricken and sad though they have witnessed this scenario many times before. I now understand, at least, what spurs many of them on. It is the desire to contain and regulate this dying-in-mass. For it cannot go on this way. What these people are doing for our oceans is impressive: They are bringing to light truths that once stayed well hidden; they are showing us images that make us think; and they are on the animals' side. And that makes them my heroes.

INFO | HISTORY

Hanno the Navigator, a Phoenician admiral, is said to have sailed around the Gulf of Guinea, which is where Gabon is located, as early as 470 BC. He was searching for new trade routes and wrote an account of his expedition which is still available in Greek translation.

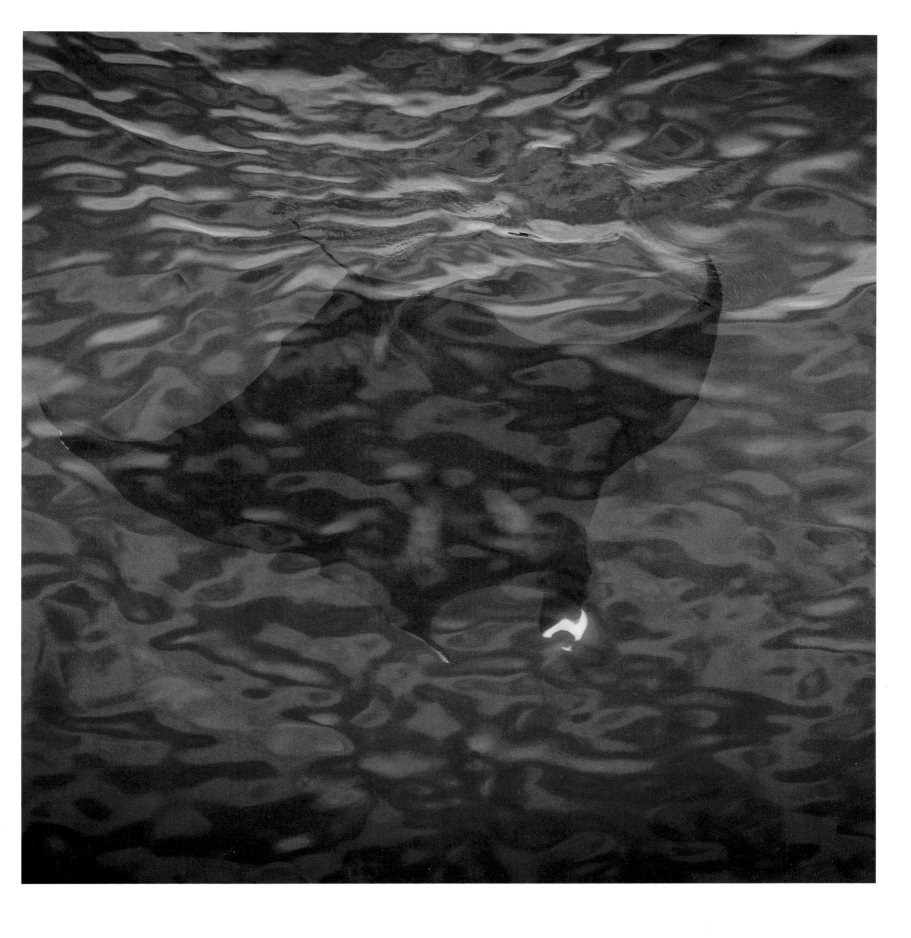

Just below the water's surface appears the silhouette of a large manta ray. It is a welcome distraction after many hours of staring at the horizon, looking for trawlers or FADs.

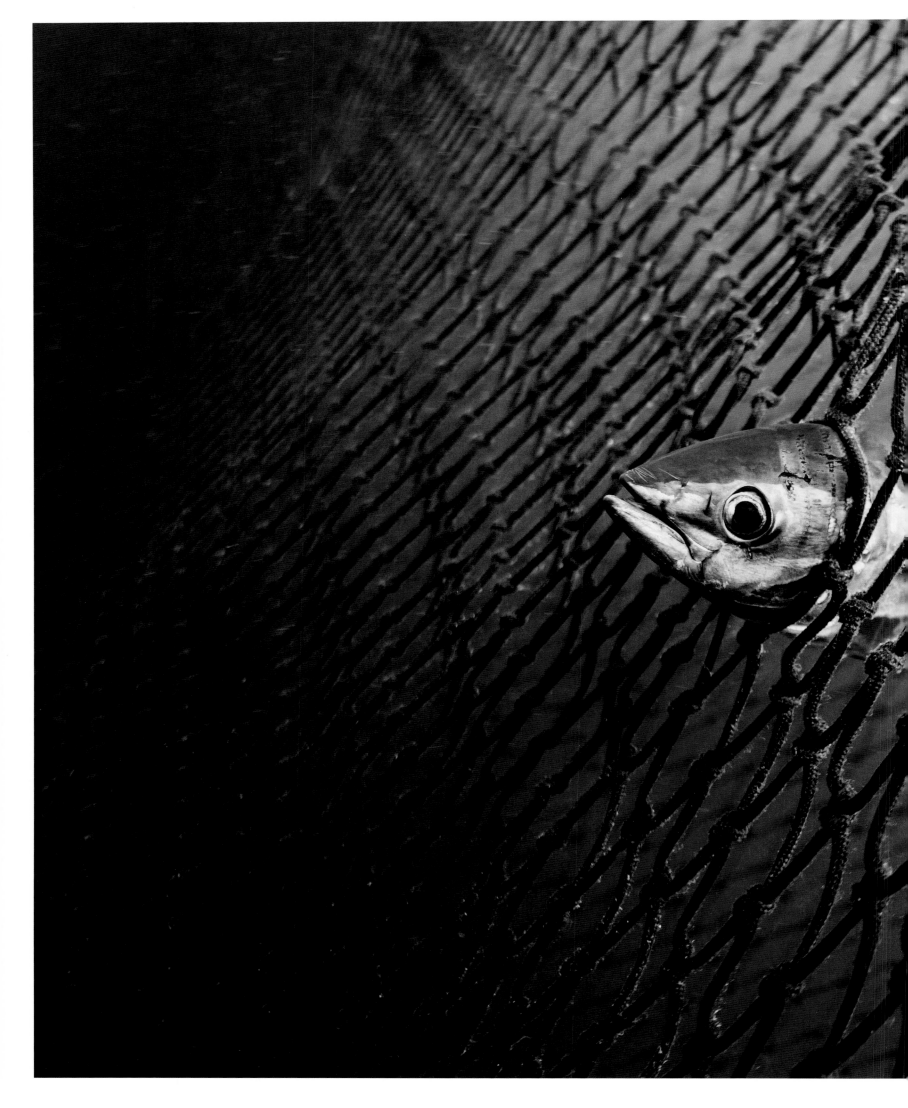

Pirates to Protect Our Oceans

This tuna's head got stuck in the large trawl's mesh. When caught, fish tend to panic and lunge themselves up against the nets. The tuna makes last futile attempt to escape. In a few hours' time, it will be thrown below the purse seiner boat's deck and disappear.

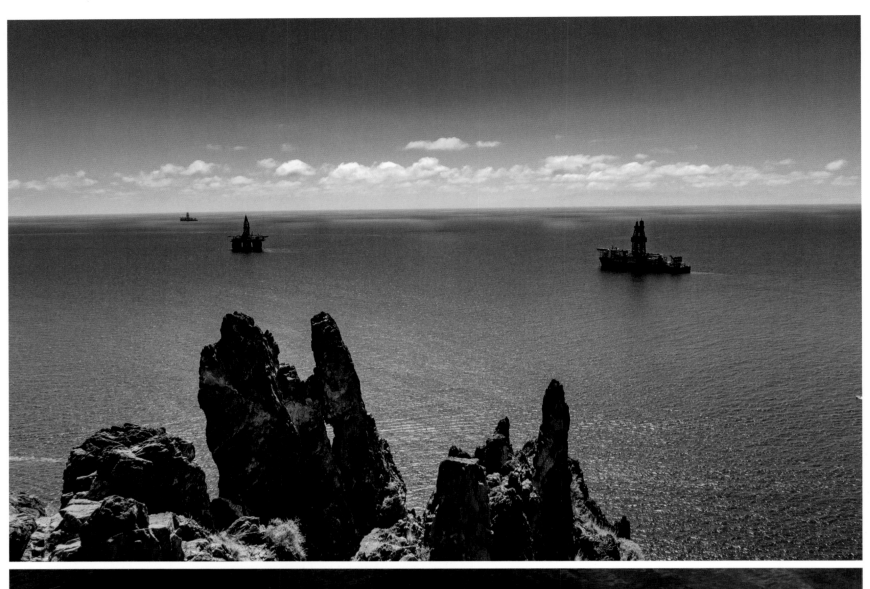

Pirates to Protect Our Oceans

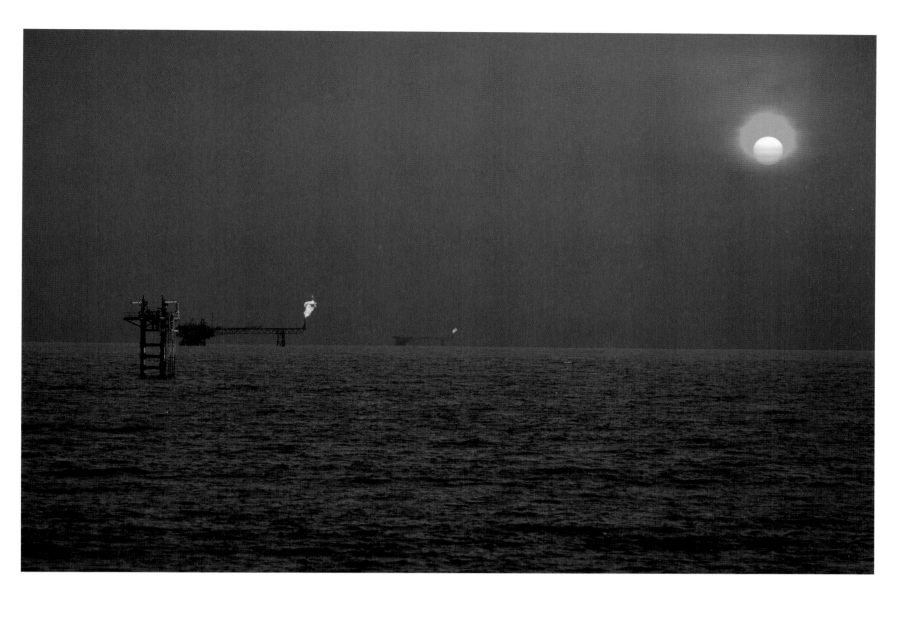

In the Atlantic Ocean, oil drilling is a very lucrative business. Be it just off the coast of the Canary Islands or at the Gulf of Guinea, oil, this "black gold", attracts industry like bees to a honeypot.

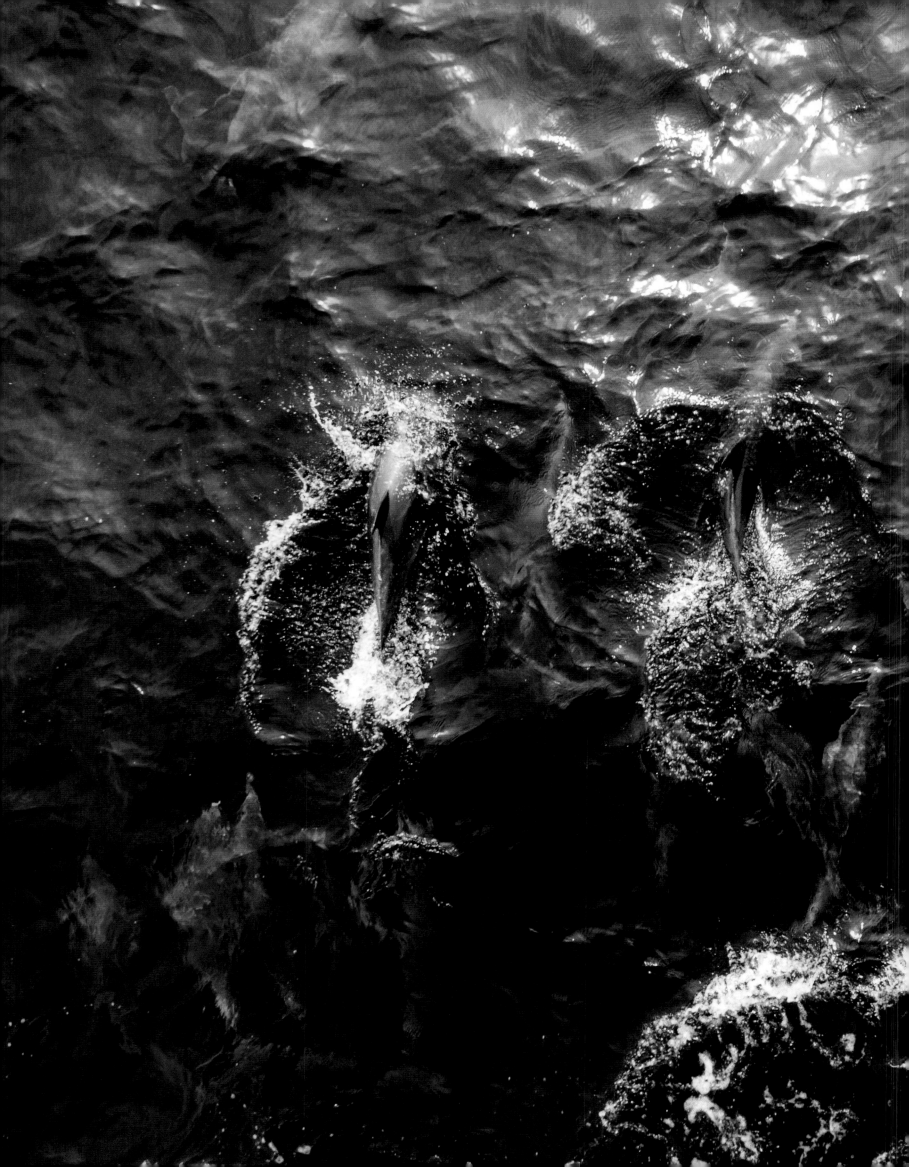

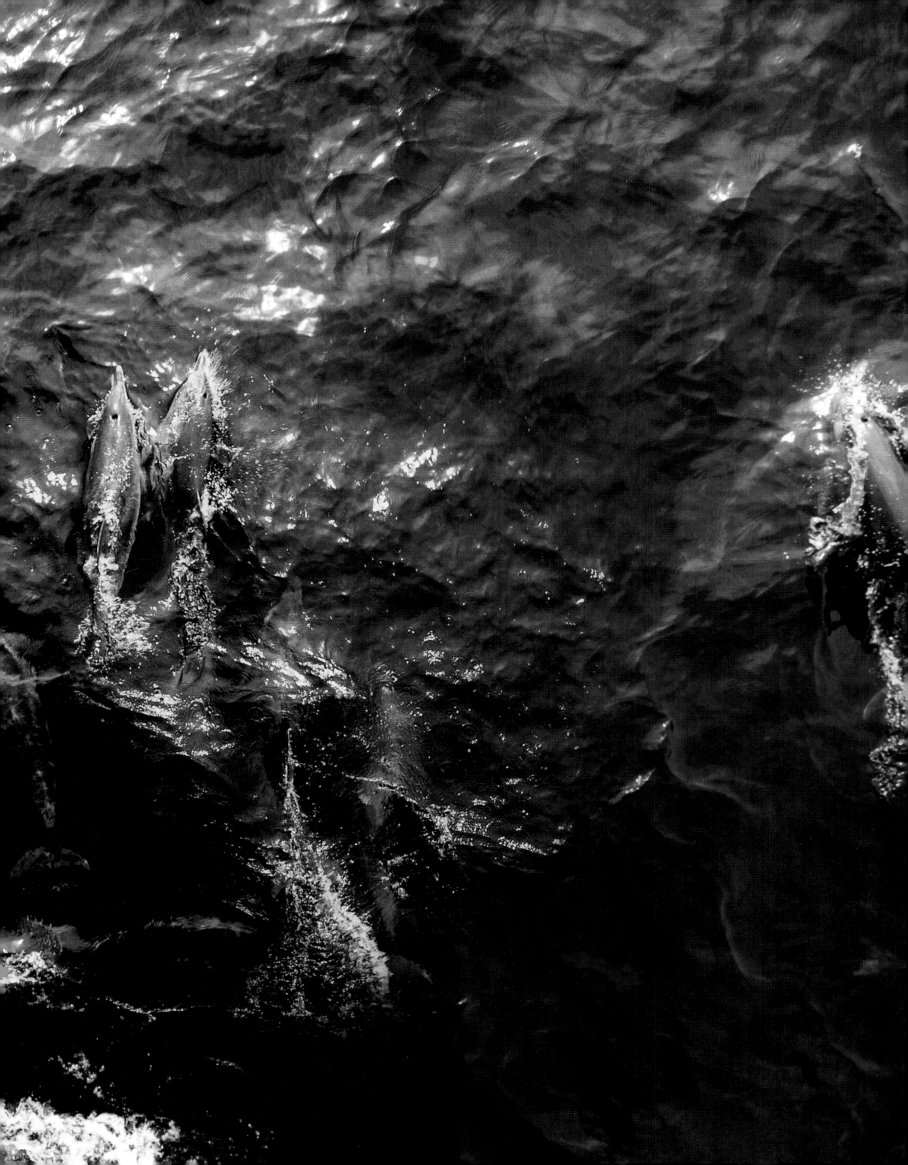

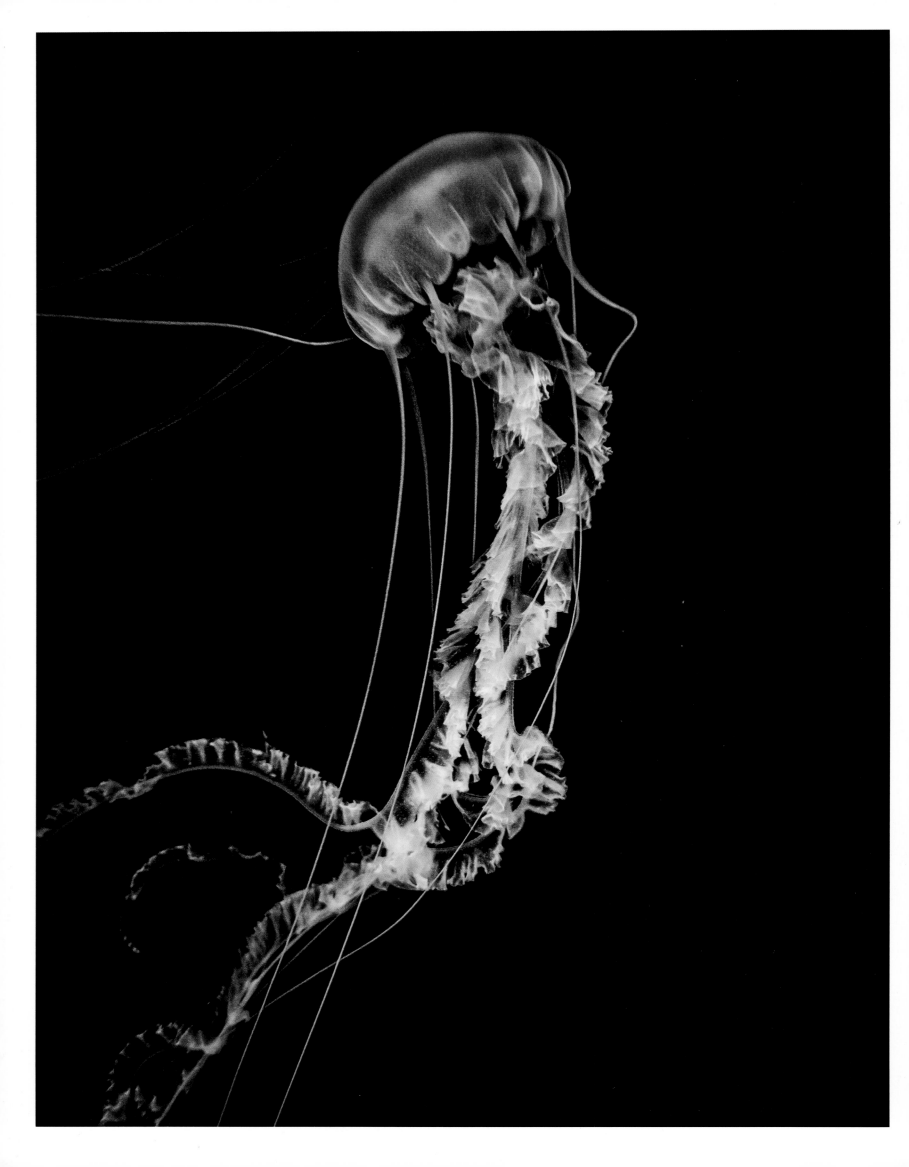

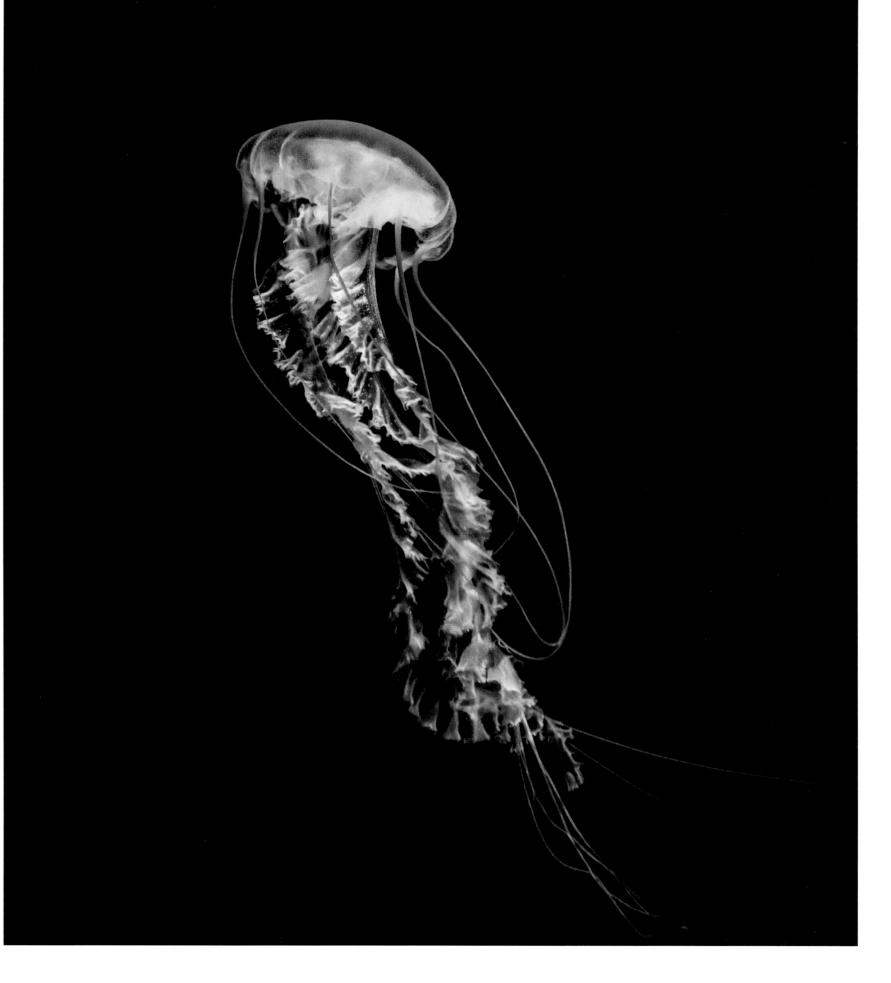

Tuna

"I will never forget the sound of tuna dashing back and forth inside the purse seiner's nets. The noise was deafening. These scenes of mass slaughter are unfolding every day in our oceans, all in order to satisfy our ever growing demand for fish."

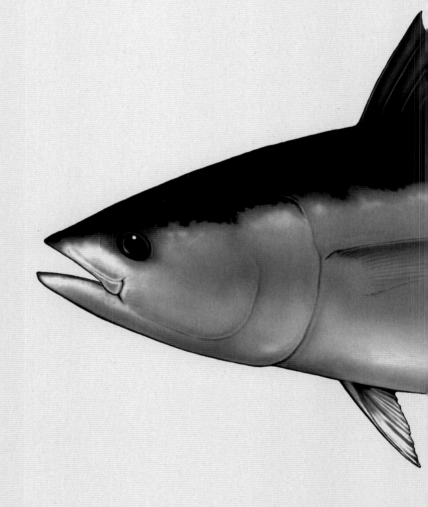

<u>Size:</u>
(varies between species)
3 to 15 feet

<u>Diet:</u>
mackerel, herring, squid, curstaceans

<u>Tuna and humans:</u>
about two million tons of tuna are caught annually

<u>Tuna in Japan:</u>
Very rare (and cricitally endangered) species of tuna fetch up to 10,000 USD and more per kilogram (roughly 5,000 USD per pound) on Japanese markets.

Our World Made of Plastic

Besides climate change, worldwide pollution of the oceans with plastic and synthetic materials is probably the most talked-about environmental issue of our time.

About 70 percent of the surface of the earth is covered in water, and there are now vast amounts of plastic waste in even the remotest corners of our oceans—and at depths of up to twelve thousand meters. Plastic is practically imperishable in the sea and will outlast all of our lives by centuries. Abrasion by waves and irradiation by the sun merely cause it to disintegrate slowly into the smaller particles we encounter as microplastic on our beaches and in the stomachs of dead sea creatures and birds. However, the greater part of it sinks to the bottom of our oceans, where it will lie for an eternity. Floating, not-yet-disintegrated and not-yet-sunken trash often collects itself into massive carpets of garbage on the surface of the sea. These gigantic accumulation zones created by ocean currents are now found in every ocean and occupy an area greater than that of all of Europe: floating continents of rubbish.

We have all seen these pictures of objects of all shapes and colors floating in the sea, from casually discarded non-recyclables that wind up as beach litter, to PET bottles, to the famed plastic bags. Microplastic—colorful little particles that animals swallow, mistaking them for food—also poses a serious danger to biodiversity in the water.

By now these images have gotten to be old, familiar impressions; and knowledge of the issue is no longer the exclusive domain of the well-informed and of scientists and environmentalists. Quite the opposite: The magnitude of the pollution nowadays is plain for all to see. Whether we walk along the coast near our homes, vacation at expensive luxury hotels on remote atolls, or spend time at the north pole—even in these places, the problem of plastic waste is omnipresent.

The Autobahns of Trash on Our Planet

I have repeatedly asked myself whether it would be possible to collect all of this trash. Would it even be doable? How many times would we have to start from scratch when it feels like every wave carries more trash onto the shore? A Sisyphean job, unavoidably pervaded by setbacks. Would the bay cleared of plastic today not just fill up with it again tomorrow?

As I now know, however, this question does not get at the heart of the problem.

It is now estimated that eight million tons of plastic end up in the oceans every year. Ninety percent of it is carried into the oceans by ten large rivers alone: the Yangtze, the Yellow River, the Hai River system, the Pearl River, the Amur River, the Mekong, the Ganges, the Indus River, the Niger River, and the Nile. The dimensions are barely imaginable.

I went looking for a solution to this global problem, the source of which is on land. Human waste, as well as agricultural and industrial waste water, additionally transforms earth's major rivers into poisonous autobahns of trash that terminate in our seas. From there, it is only a matter of time before tides, wind, and marine currents carry the waste into every corner of our oceans—and up against our coasts.

But what might a solution to this drastic situation look like? In search of an answer, I found a man who has begun his work where the trash starts accumulating: on land.

INFO | ECOLOGY

Plastic pollution is one of the most pressing current issues for marine ecosystems. On average, there are now more than 46,000 pieces of plastic in every square mile of ocean. In 2013, up to 150 million tons of waste was drifting in our oceans.

Our World Made of Plastic

A black cloud of plastic debris and excrement is making its way into the Caribbean Sea. Aerial photography shows the vast extend of the pollution. We can only imagine what will happen to our oceans if we do not change our habits and act more responsibly.

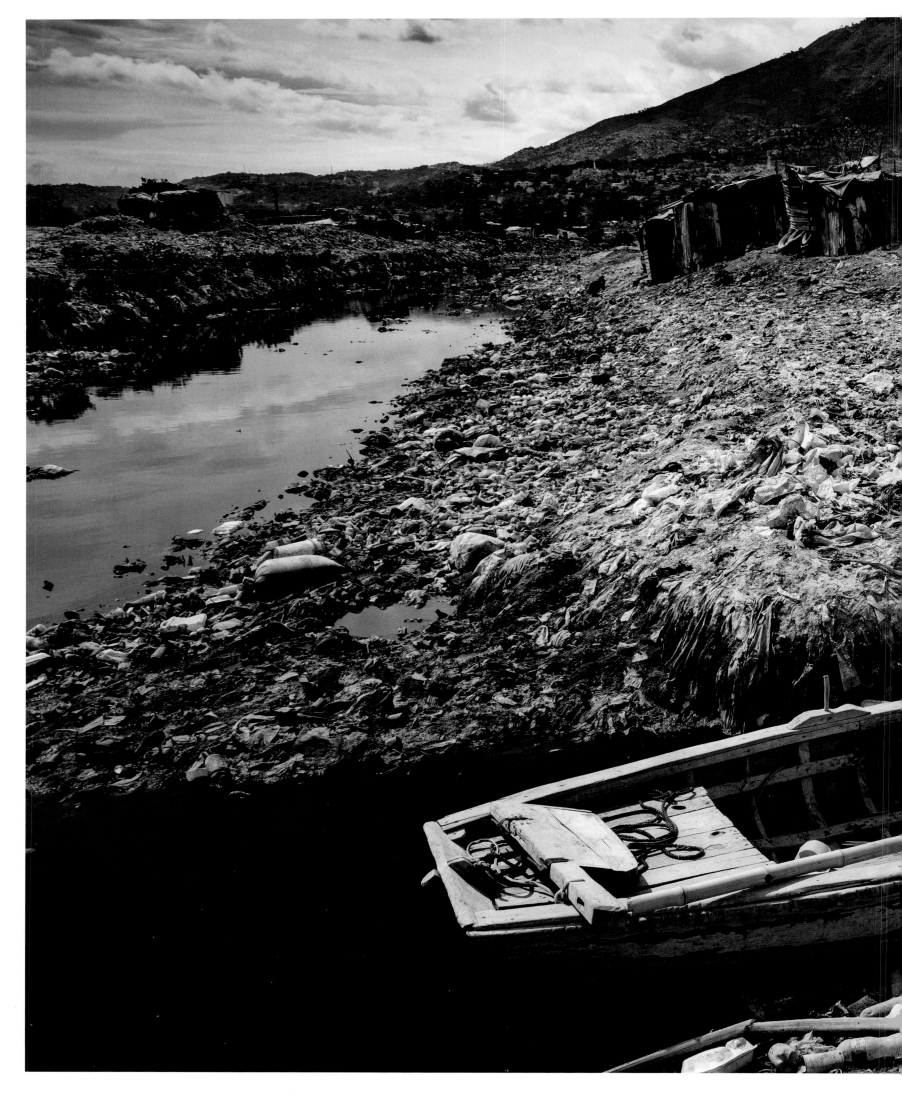

Unsere Welt aus Plastik

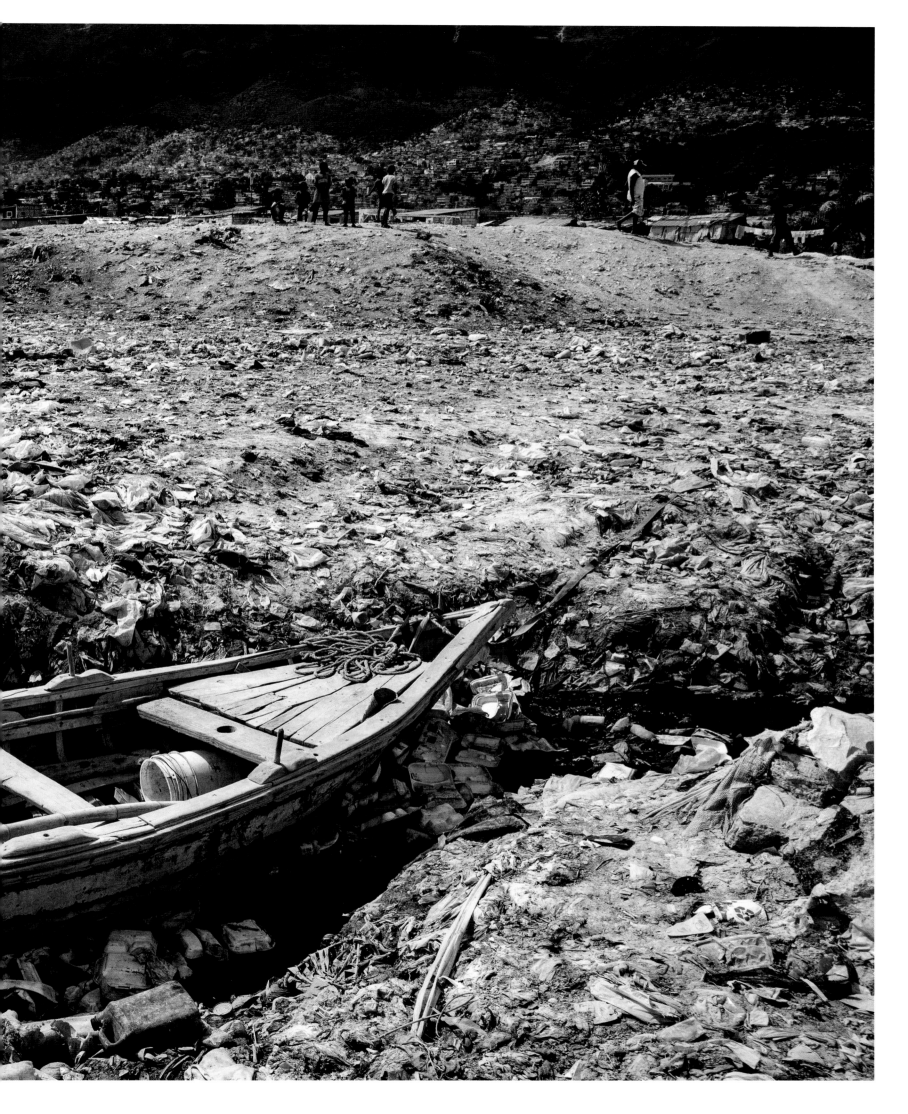

But what might a solution to this drastic situation look like? In search of an answer, I found a man who has begun his work where the trash starts accumulating: on land.

A Bank for Plastic?

To see him at work, I travel to the Caribbean island of Hispaniola with Sabine Streich, who is this time along to do the filming. Here in Haiti, a hotspot of plastic pollution, we are going to meet David Katz, who, through his company Plastic Bank, has created a system that, for the first time since before the devastating catastrophes of recent years, has given the local people new hope. Haiti was rocked by a once-in-a-century earthquake in 2010 the epicenter of which was directly beneath the capital Port-au-Prince; hurricanes and cholera epidemics followed. The people here live in abject poverty, without a functioning sewage or waste removal system. But how bad it really is here can only be experienced first-hand.

En route from the airport to the hotel, we already get a first impression of the magnitude of the accumulated garbage, which is the most obvious problem the people of Port-au-Prince face. Everywhere you look, there are mountains of piled up single-use plastic and polystyrene foam packaging along with typical household waste and feces. The stench is so miserable that we can't open our car windows.

At the hotel, we are immediately apprised of the city's personal safety situation. Nothing will go on without the driver from the Plastic Bank and a couple of armed bodyguards. It is recommended that we do not move about on foot outside the hotel. Everything is thoroughly planned, and as such, locals and interpreters are going to accompany us out to every appointed interview over the next few days.

Photographers and camera crews are not welcome guests in Haiti, especially not in the poorer districts. The media's lewd sensationalism has walked all over the goodwill of the population; and so we, too, have to render a few explanations about what we are intending here. But happily, we are with the team of David Katz. With the Plastic Bank, he has established an institution that directly helps and gives people the prospect of a better life. Over the next few days, David takes us to a few collection sites for plastic waste and explains to us the principle behind his operation that up-values plastic as a raw material here.

Like a bank, he tells us, the Plastic Bank either gives people a virtual credit for the plastic they collect, which they can spend on purchases at certain shops; or people can exchange the plastic directly for money, goods or services. People no longer see the raw material merely as the trash that threatens to suffocate them but rather as an opportunity for a better future. At the same time, they are helping the environment—and above all: our seas. For what goes back into to the industrial cycle has not come to rest in the ocean.

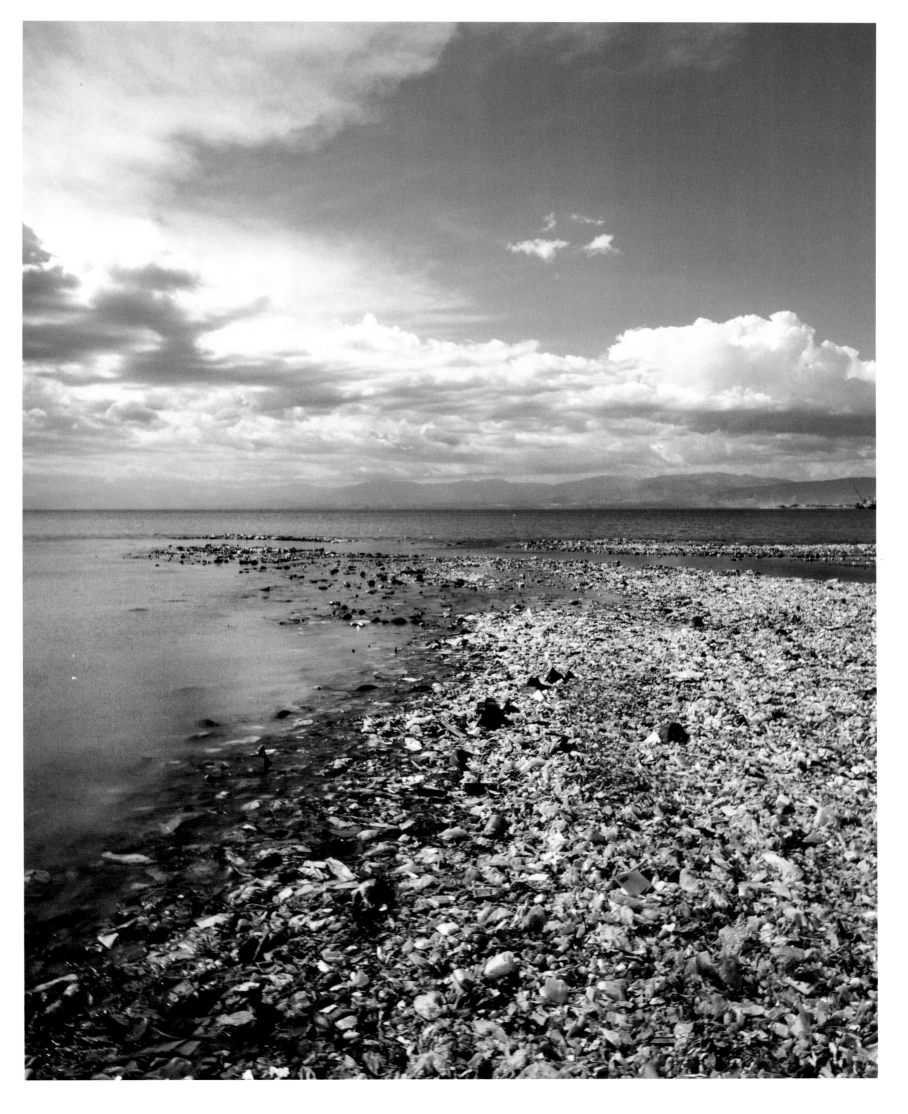

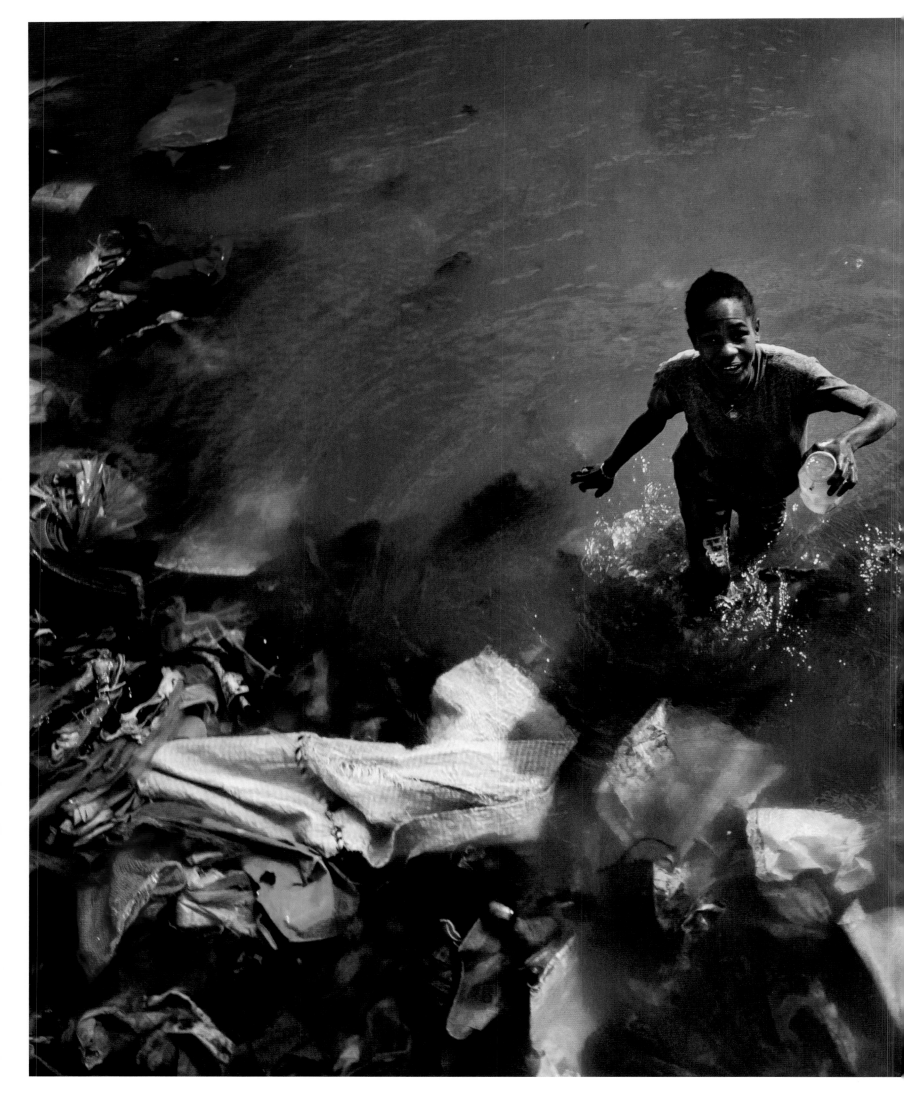

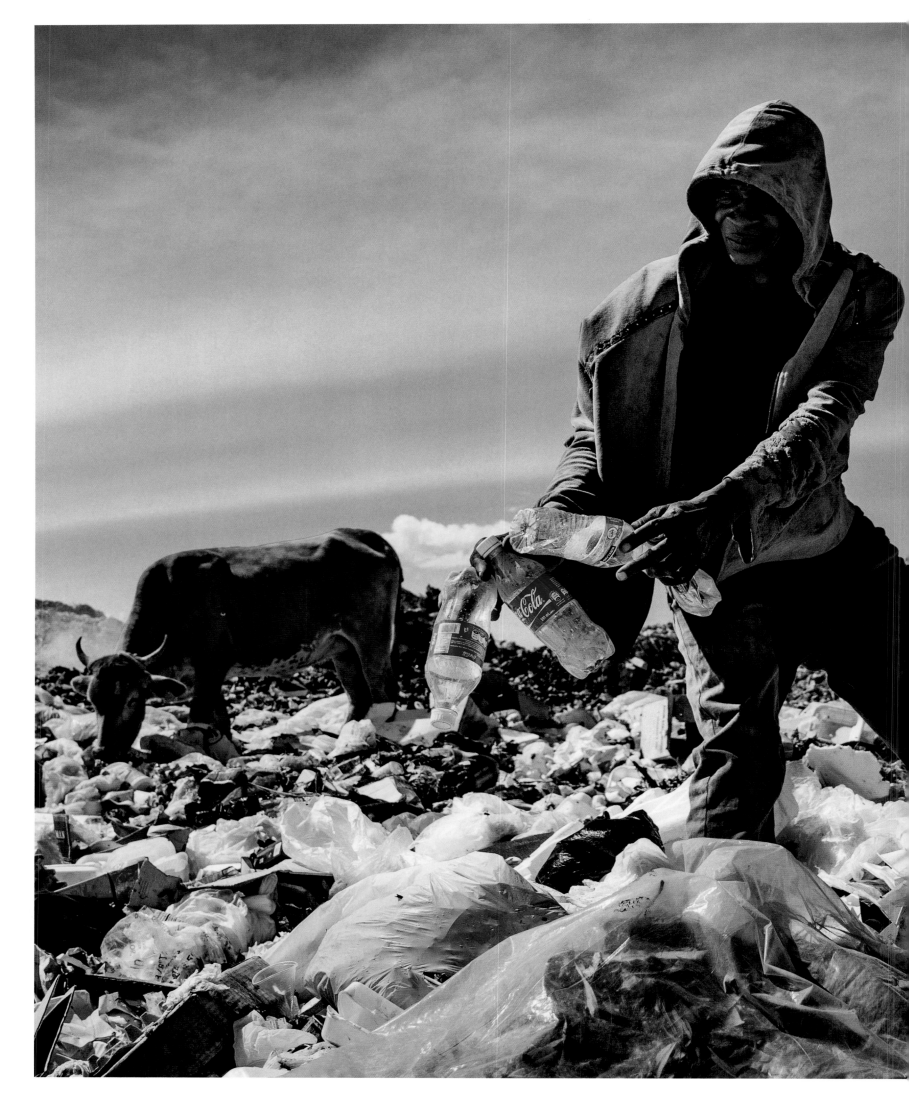

Our World Made of Plastic

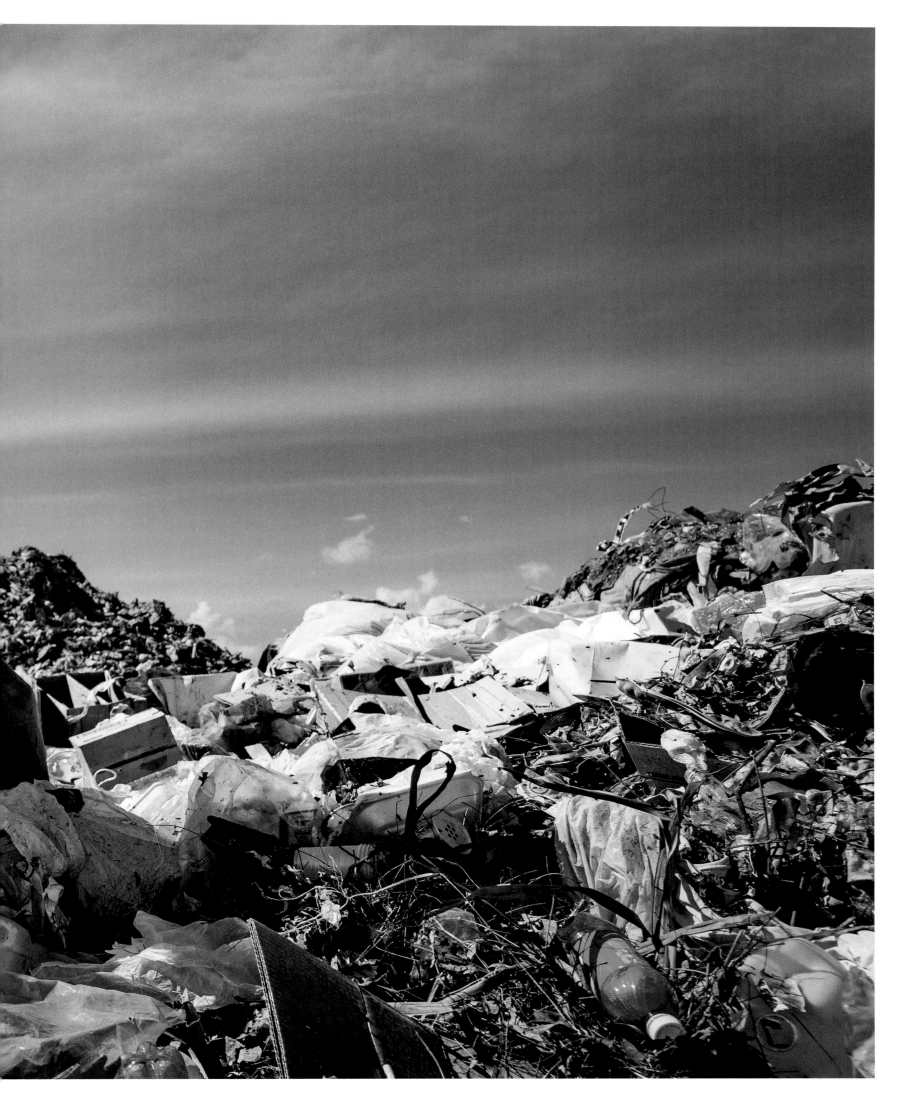

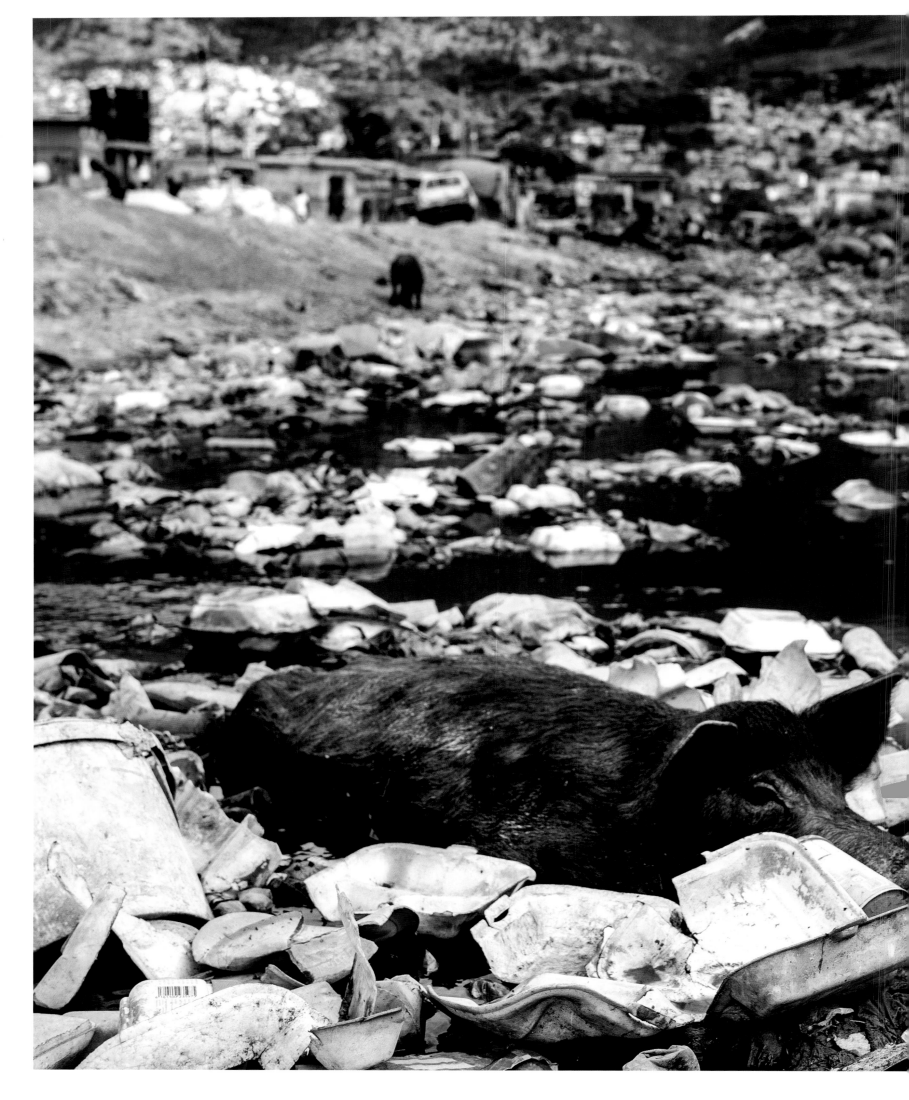

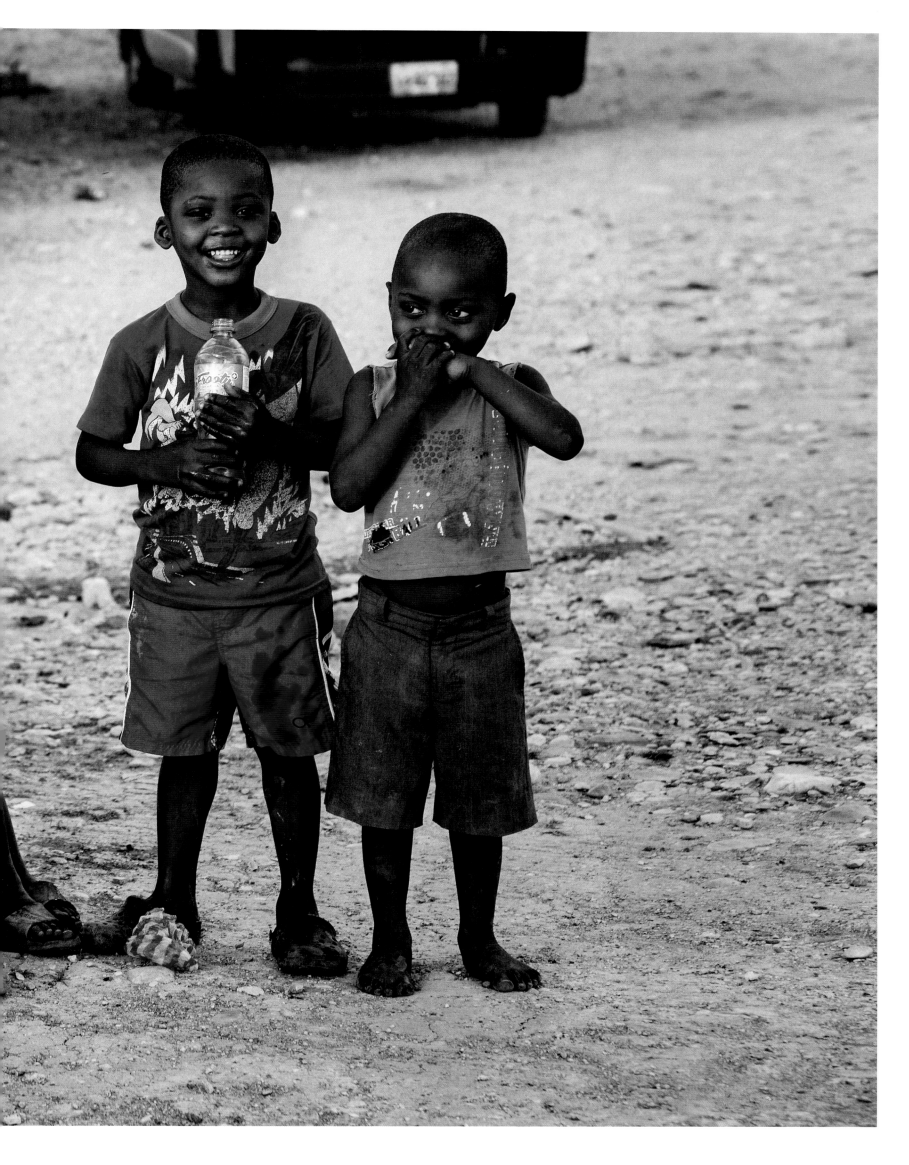

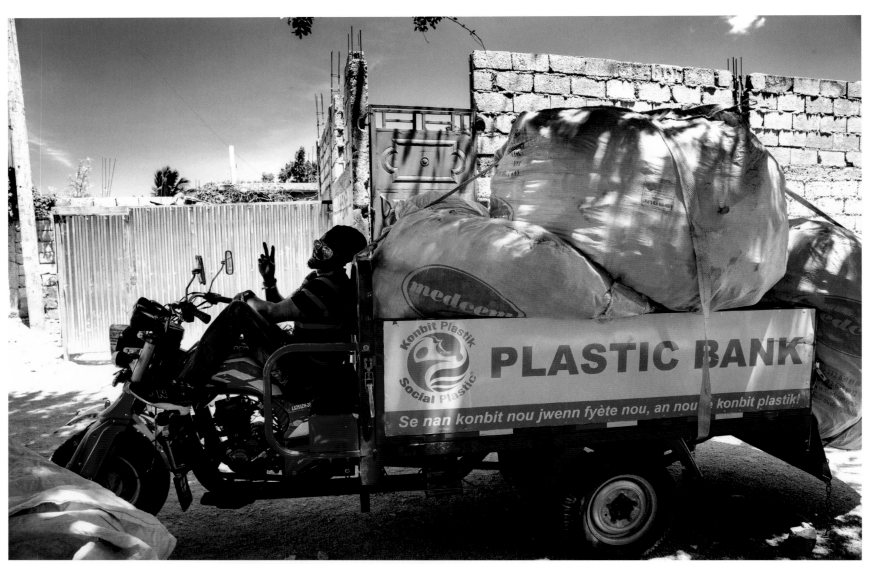

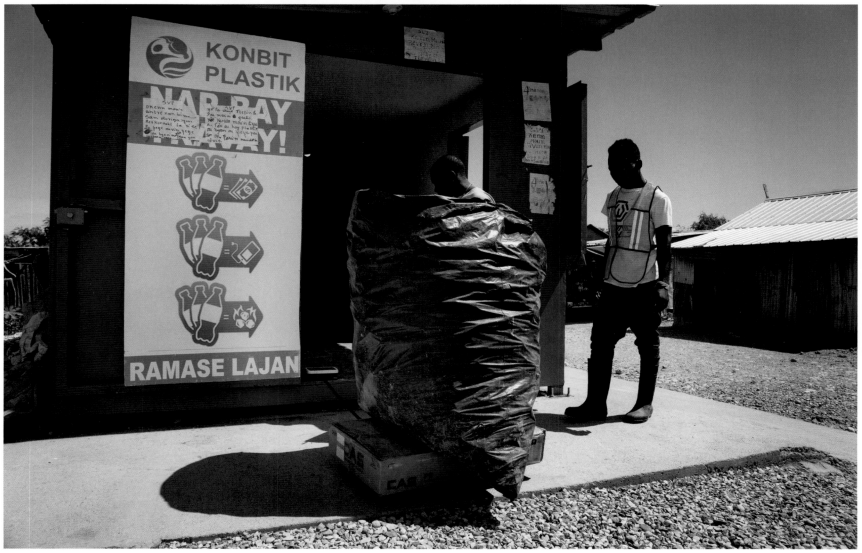

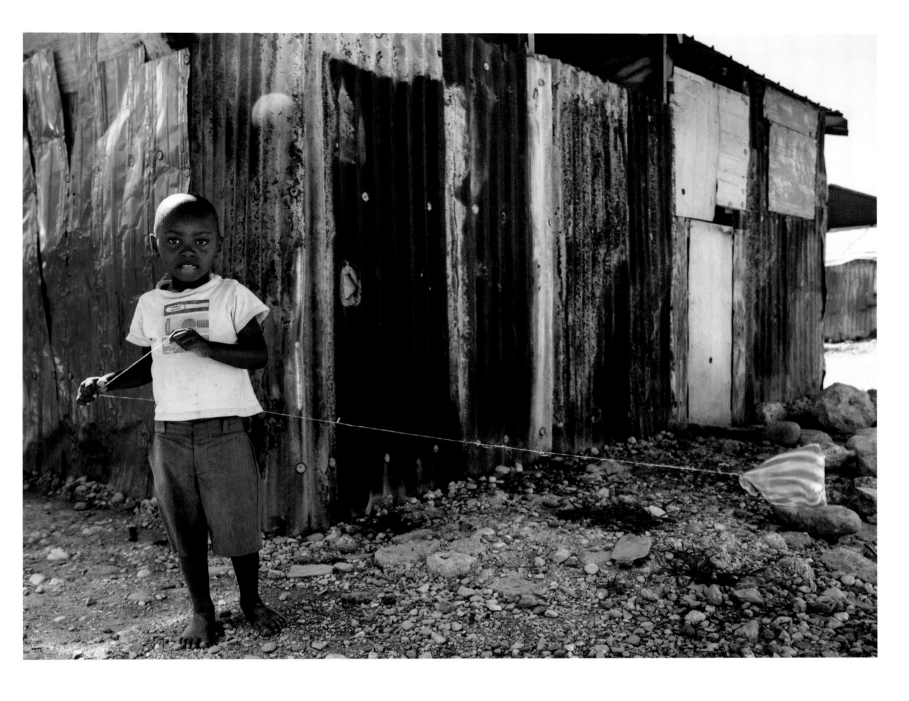

"The only way to stop ocean plastic," David continues, "is to reveal the value in plastic by transferring as much value as possible into the hands of the collectors. We are stopping the flow of plastic trash into the oceans and fighting poverty at the same time."

David Katz and his partner, Shaun Frankson, have managed to develop a solution that both helps the people in poor regions as well as gets at the root of the problem of trash accumulation.

Where Once There Was a Caribbean Beach...

The amount of garbage accumulated over the years in and around Port-au-Prince becomes particularly clear in the slums, on what used to be the city's beaches. We can only enter these areas under extreme security measures. We are told not to underestimate the high levels of gang activity.

But what awaits us here simply defies description. This one beach, which must at some point have had a Caribbean feel, is now covered in a meter-deep layer of reeking garbage. There is no sand—no ground—to be seen. The trash stretches out over the water, a wobbly mass, until it eventually dissipates. Not far from us, a small river empties into the Caribbean Sea. Black water, stinking of feces, stains the once-clear blue a greyish brown and gives us an idea of how very unhealthy it would be to go swimming here. These are frightening images.

But in the midst of this catastrophe, a glimmer of hope is germinating: There are people working as trash collectors for the Plastic Bank. They are collecting the various types of plastic, to be sorted and delivered later. The raw material is sorted into categories, and the collectors are doing it the same way. Some of them pile up incredible quantities of colorful PET bottles before taking them to the collection stations where the huge bags are

INFO | GEOLOGY

On January 12, 2010, Haiti was hit by the most devastating earthquake in the history of America. More than 300,000 people lost their lives. The economic damage was estimated to be eight billion USD, which is more than the country's annual GDP.

171

weighed. Payment is by weight. The trash is then turned back into a granulate that is sold as the raw material for plastic production to The Plastic Bank's partners, who can produce new packaging from it. Going by the name "Social Plastic," it has become a positive symbol for recycling.

„Monsieur le président"

From the beach we continue our journey, into the middle of the slums, to meet a man known here as "monsieur le président," who is going to personally show us around. There is hardly any room left for people to live here. Small, corrugated tin stalls and sheds that house entire families on just a few square meters are crowded closely together.

There is no sewer system, much less waste removal. Gangs control the area and have long since driven the local police from the streets.

But "monsieur le président" Joseph Dieufaite, who is blind, is a permanent fixture for the people here—a kind of spiritual leader, always ringed around by children whose helping hands guide him through the narrow confusion of dusty alleyways. They cluster around him, whirling, whispering things to him, and not leaving his side. Sabine and I, with our cameras, are in tow. We can feel the looks that follow us along the entire path, but we apparently are actually safe here. For any friend of David's is also a friend of the people.

Our tour takes us past voodoo shrines with dead chickens on the walls and burning barrels giving off toxic aluminum vapor, to what they call

INFO | ECONOMY

Haiti is the poorest country in the Western hemisphere. About 80 percent of its roughly 10 million inhabitants survive on less than two USD a day. About two thirds of the adult population are unemployed.

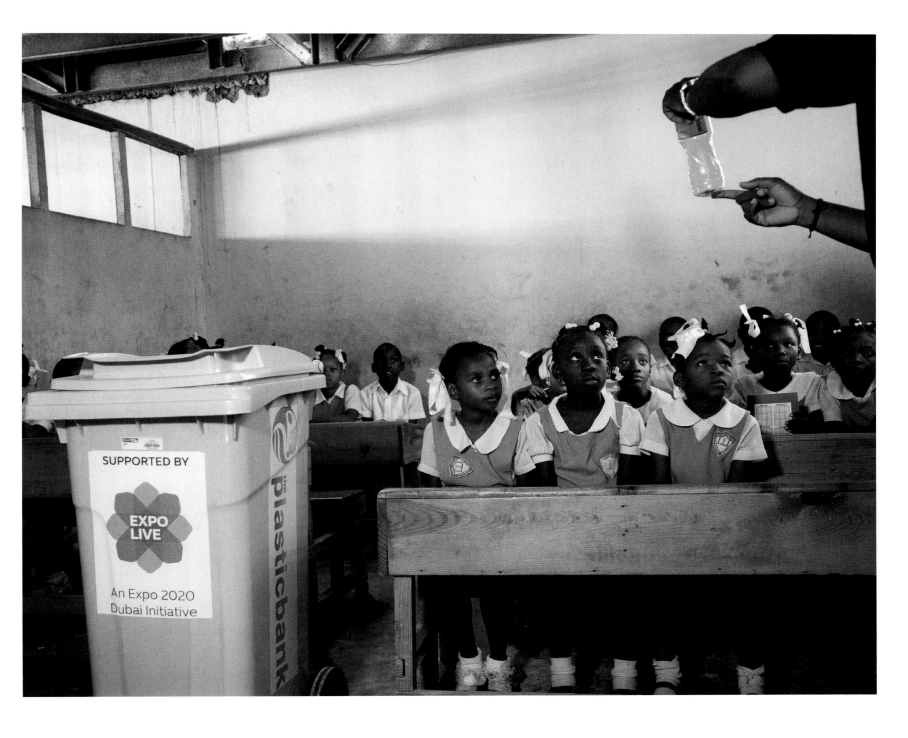

"the Styro River": Unbelievable but true, it is a moving stream of polystyrene trash. We have really never seen anything like it. It is one extreme after another in this city. Just when you thought it could not get any worse, it proves you wrong.

Sending Signals

It really does seem like a never-ending nightmare David is battling against here with the Plastic Bank. But successes thus far have proved him right and given him the courage to keep going. For everywhere in the world, there are people like those in Haiti. And there is plastic everywhere in the world. People like David are the ones who can ultimately move the needle, even influencing industry. If it is true that we cannot completely do without this raw material, then as consumers we still might as well consciously choose products made of recycled plastic when we shop. At least that way, we send a signal to other businesses so that they, too, at some point, will feel moved to switch to "social plastic." Each and every one of us can have a role in solving our oceans' global plastic problem, and we can decide for ourselves how big our contributions should be. There are countless options for us to take small steps in the right direction: starting with the switch back to natural soap; moving on to renouncing plastic bags and straws; and then consciously doing reduced-plastic shopping. Sending these signals is up to us.

At school, children in Haiti are already learning how to deal with plastic debris. People in Haiti try to raise awareness of ecological issues in the younger generation; it is an important step towards the continued positive developments in this country.

Our World Made of Plastic

It is up to our children to continue positive developments which are only now beginning to emerge. We must rely on the next generation to adopt and realize new solutions to current issues. All we can do is to prepare the way for them and to hone in them an environmental awareness that will help them correct the mistakes we have made.

Seabirds

"Every day, countless seabirds die due to marine pollution. Pollution in the ocean has an impact that goes far beyond aquatic life and the sea itself."

Habitat:
anywhere in the sea (penguins, guillemot, ...) and above the sea (seagulls, albatross, sea swallows, ...)

Appearance:
Unlike most other birds, seabirds are not very colorful. Predominant colorations are black, white, grey, and brown.

Age:
Seabirds often live longer than other types of birds. The king albatross can live to be up to 60 years old.

Seabirds and humans:
Each year, more than a million seabirds die due to plastic particles that they consume with their food.

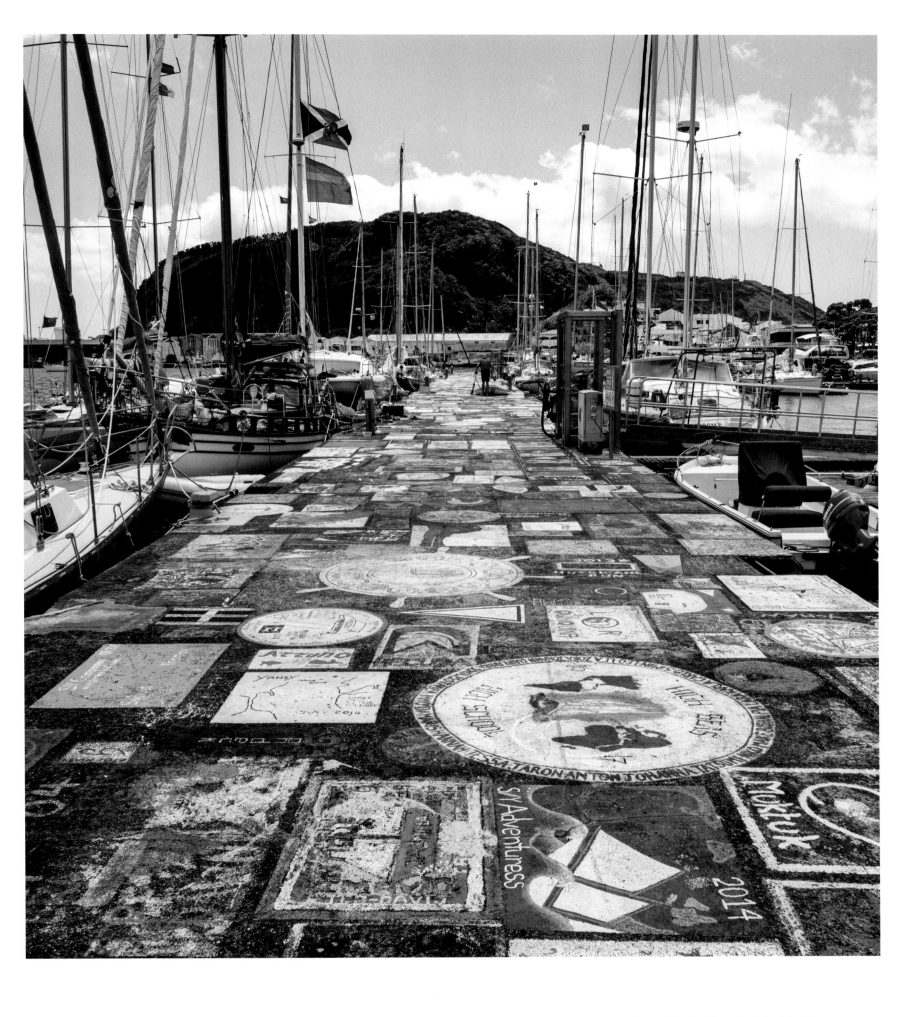

Any sailor who ties a knot in this harbor gets to leave a trace by painting a picture onto the concrete. As a result, you can now spend hours reading and looking at traces left by people from all over the world.

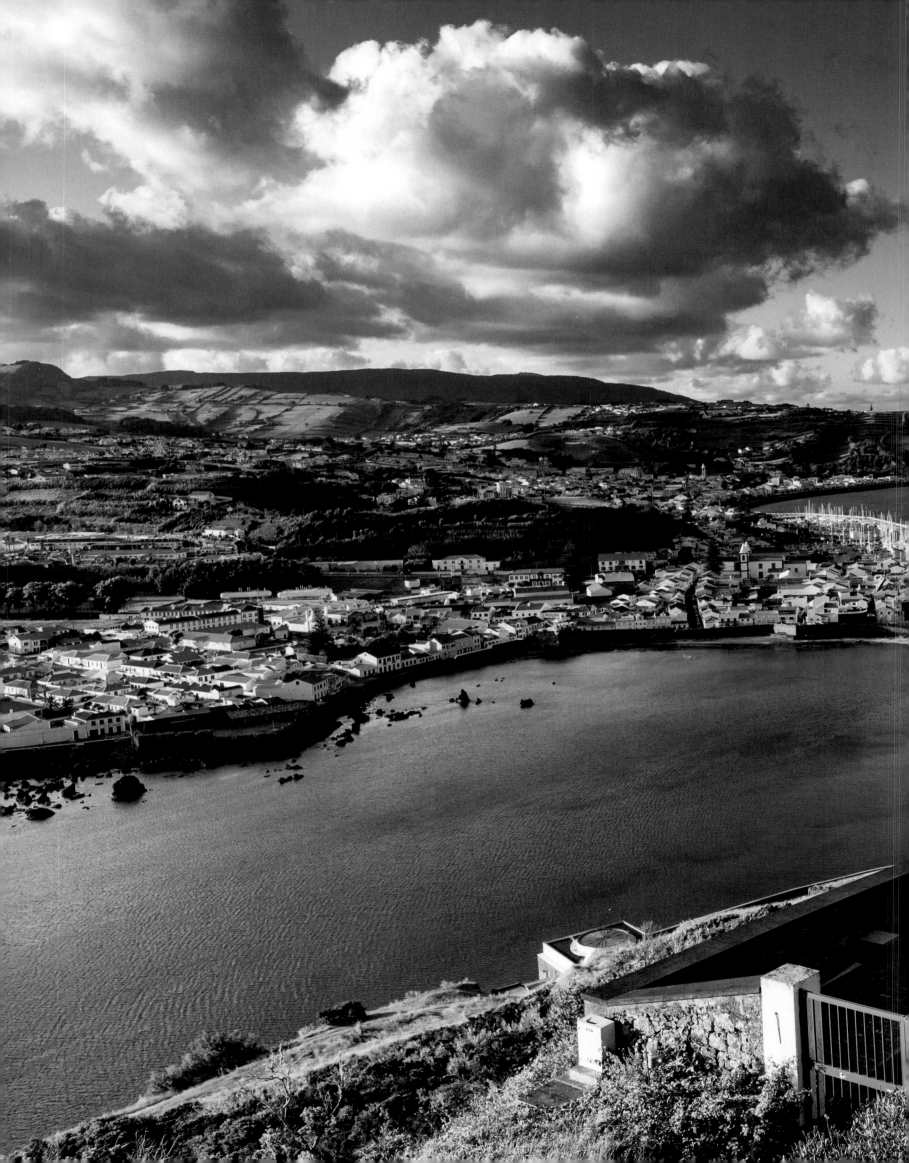

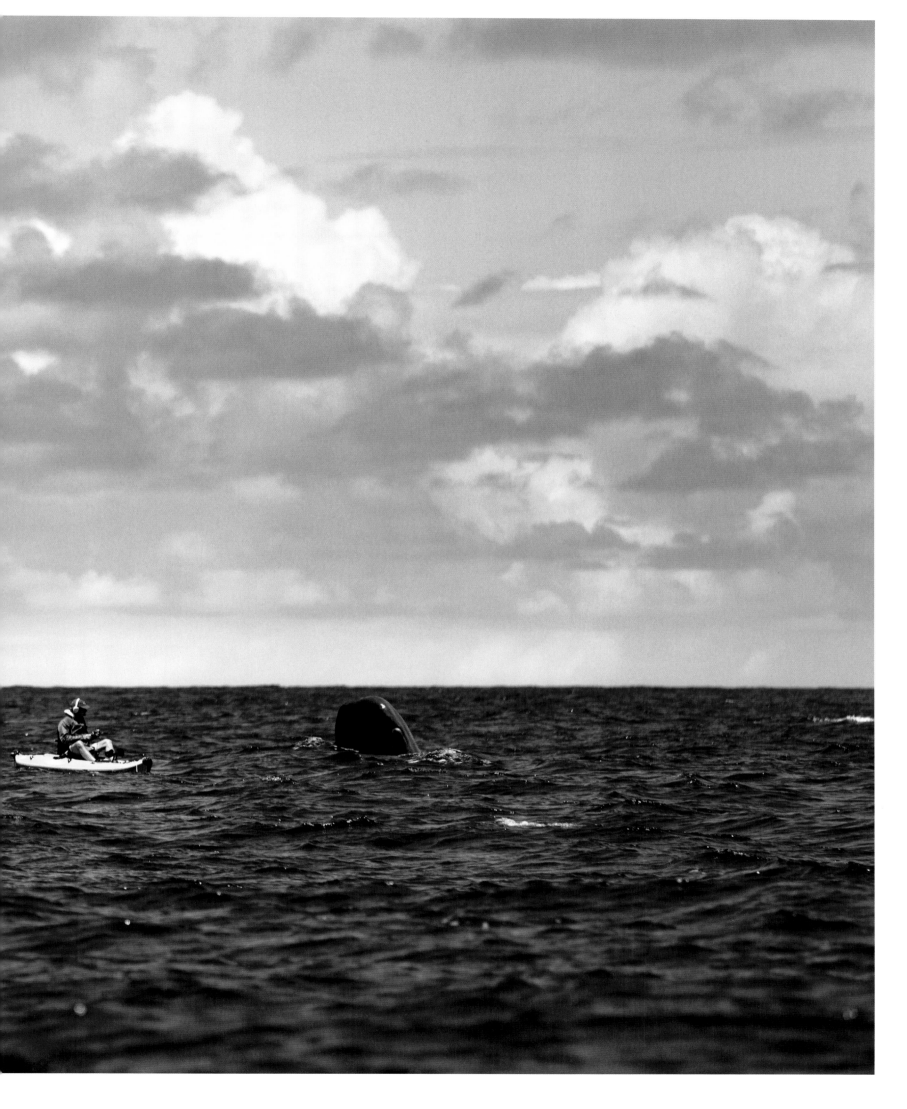

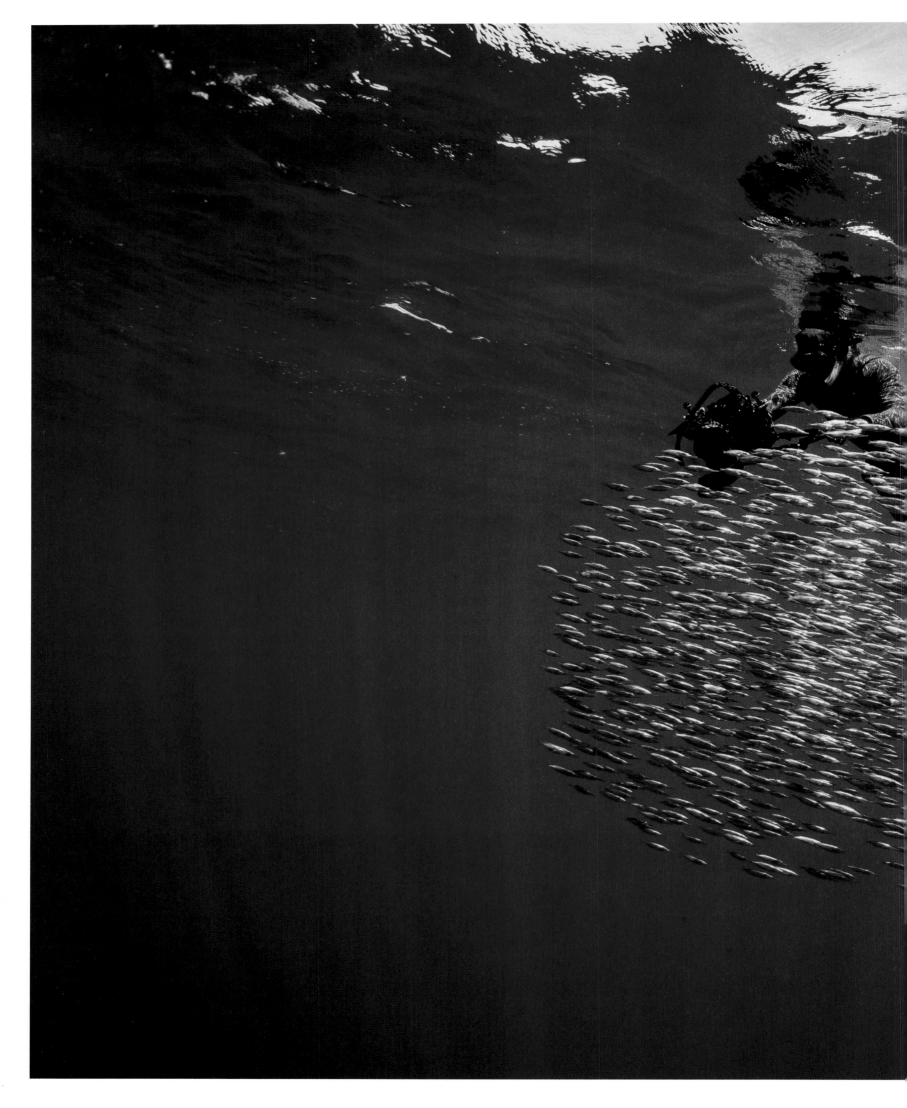

Our Planet's Biggest Predator

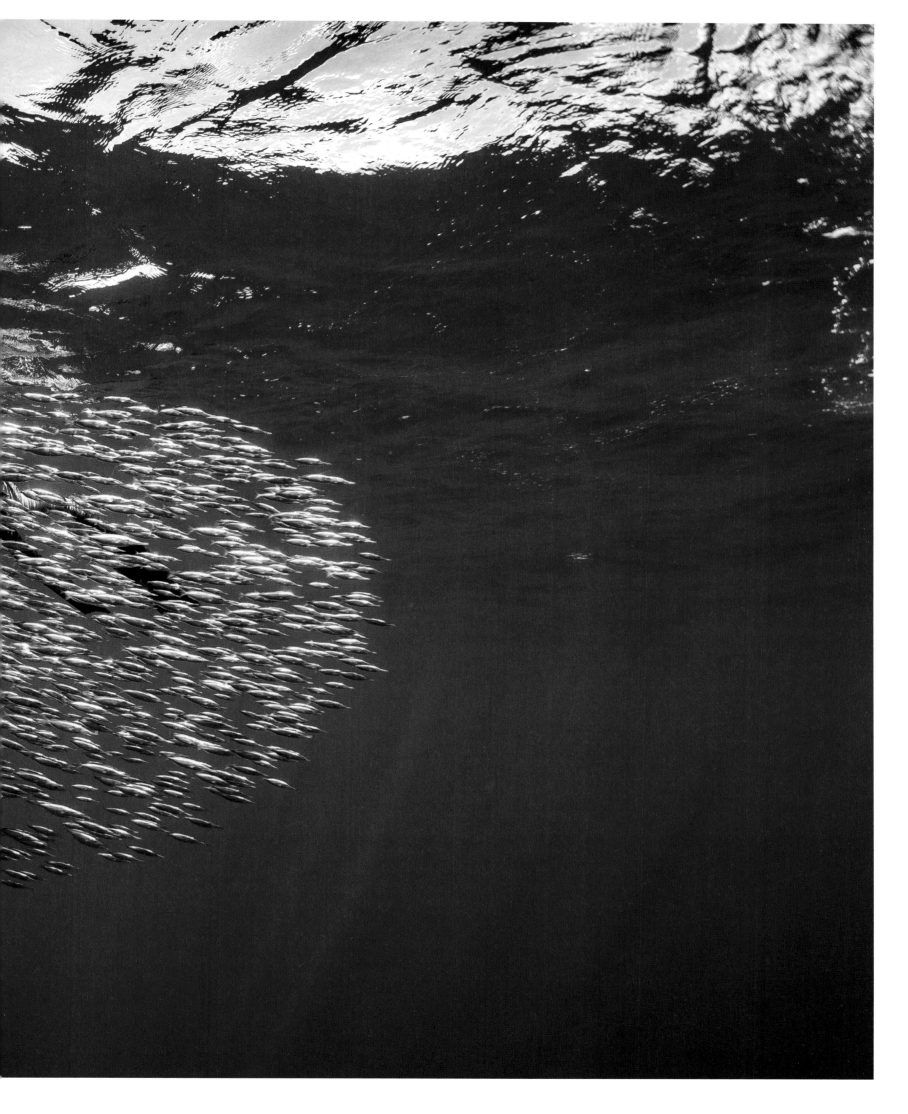

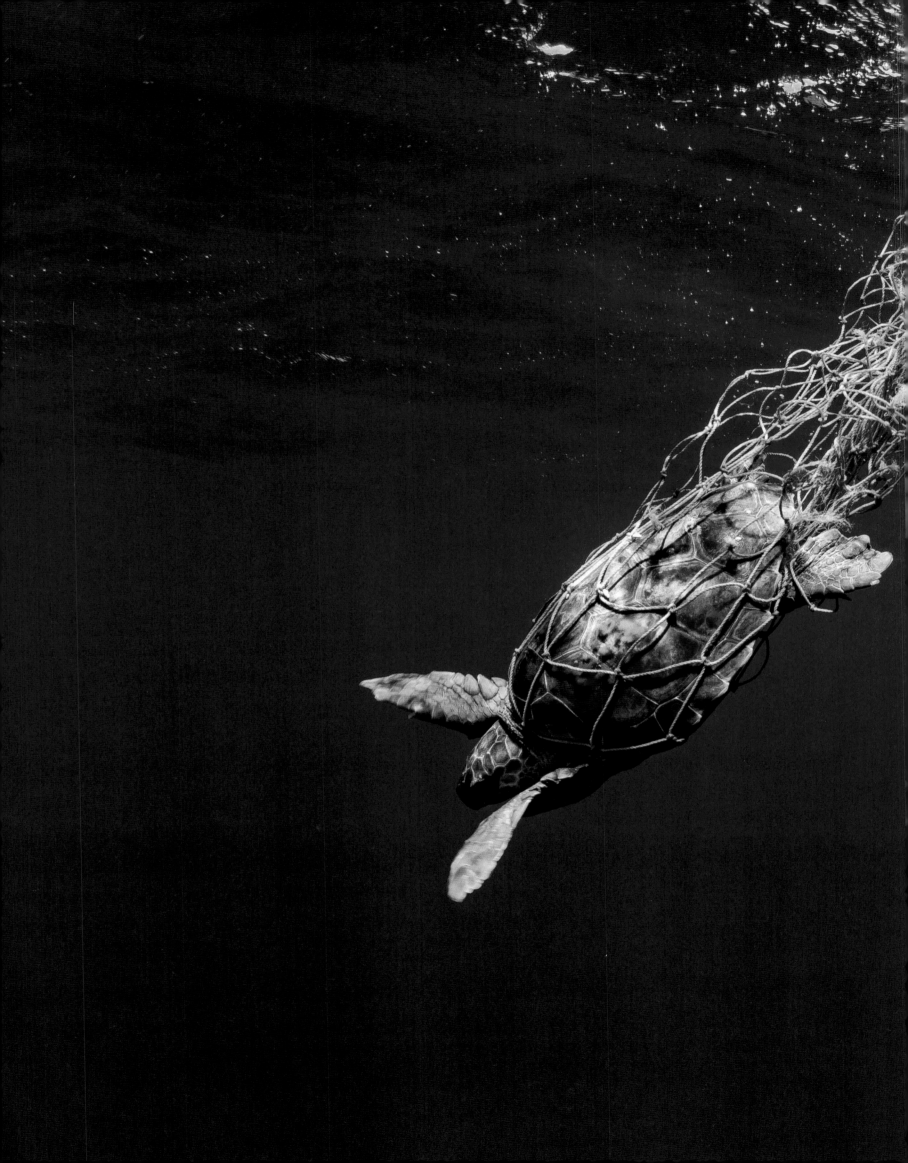

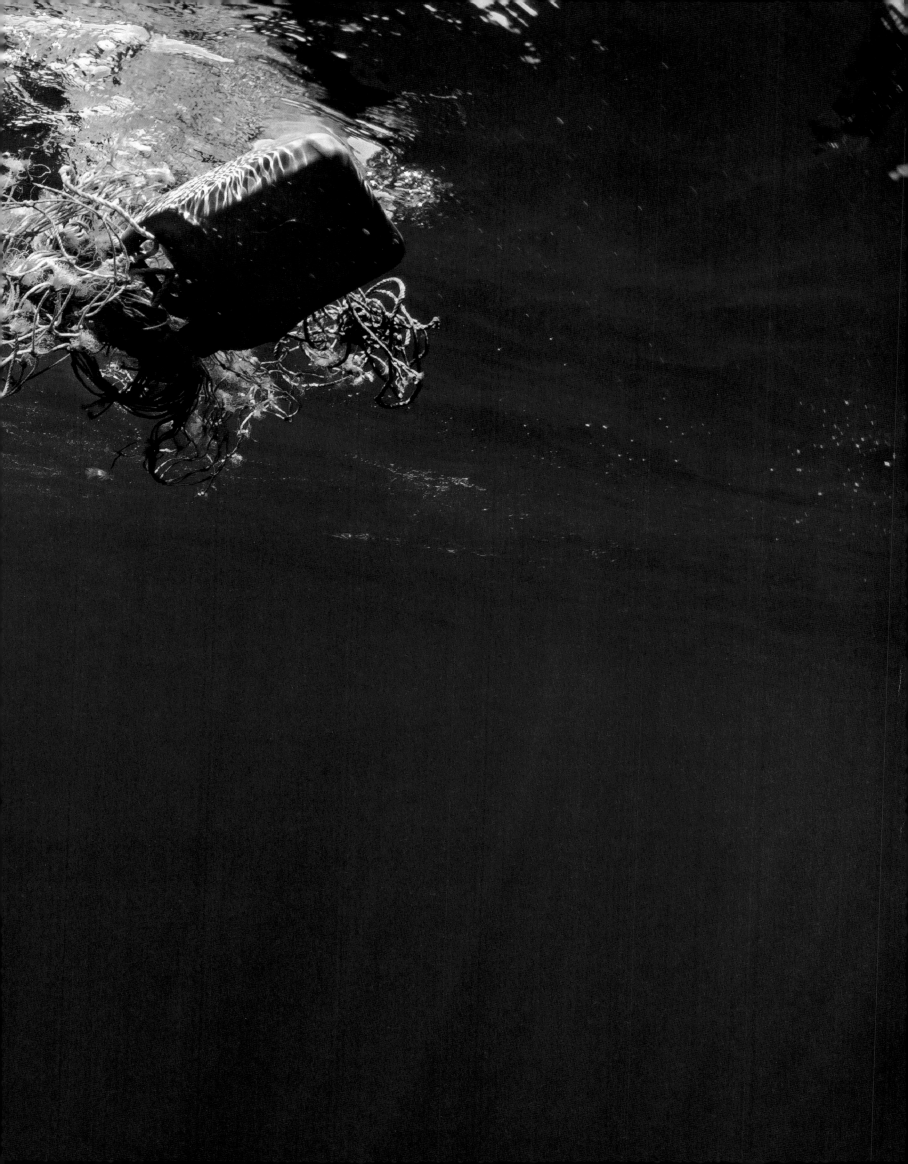

some hump or spout or the like. Rick meanwhile paddles towards the presumed whale sounds he is able to follow through his headphones, armed only with goggles, snorkel, fins and camera, so he can act quickly and with the least possible effort above as well as below the surface.

The Big Moment

The first half-hour belongs to Rick alone. He paddles far out among the whales, which I have meanwhile also spotted. I won't enter the water until he gives the signal so as to avoid startling the animals. I would never have dreamed of one day getting this close to a sperm whale. I am pervaded by a sense of awe when Rick at last signals me to get in the water too. I try to cover the two hundred meters between us as fast as possible.

Slowly, I approach the group of whales that seem to be dozing just below the surface of the water. One of them is resting in front of me, almost vertical, with its belly facing the sun in the infinitely glowing blue.

I dive down toward it, carefully pushing the heavy underwater camera in front of me. Closer and closer, bit by bit, as if in slow motion.

Then comes the moment I will never forget as long as I live: The enormous hunter slowly wakes out of sleep and fixes me with its giant eye. Motionless. It rests its gaze on me. For a brief moment, it is as though I am frozen, but I quickly get a grip on myself. For me, our very short encounter seems never-ending and sears itself into my memory forever—the fulfillment of the dream of a lifetime for which I've been yearning for so long now.

The enormous hunter slowly wakes out of sleep and fixes me with its giant eye.

This gentle colossus—elegant and beautiful beyond belief—enchants this moment, turns suddenly, and then makes an exit, silently moving down into the depths of the ocean below me. Beyond my reach—but what an experience!

Physically exhausted but radiant with happiness, I swim back to the boat, one fin-stroke at a time, where the crew is already waiting for me. All of Rick's crew's shots worked out. These images are the vehicle filmmakers and camerapeople use to bring us nearer to things we never get to see ourselves. Without them, there would be no way to spread the knowledge scientists have been accumulating about our oceans. For it has to be done through imagery: through emotion-laden pictures that, like the way the sperm whale's look affected me, strike us so deeply that they penetrate our consciousness.

It has always been my dream to experience these colossal animals in real life. Despite their immense size and weight, they are moving gracefully in the water. Watching them play and relax in the sun has made them seem all the more charming and docile to me.

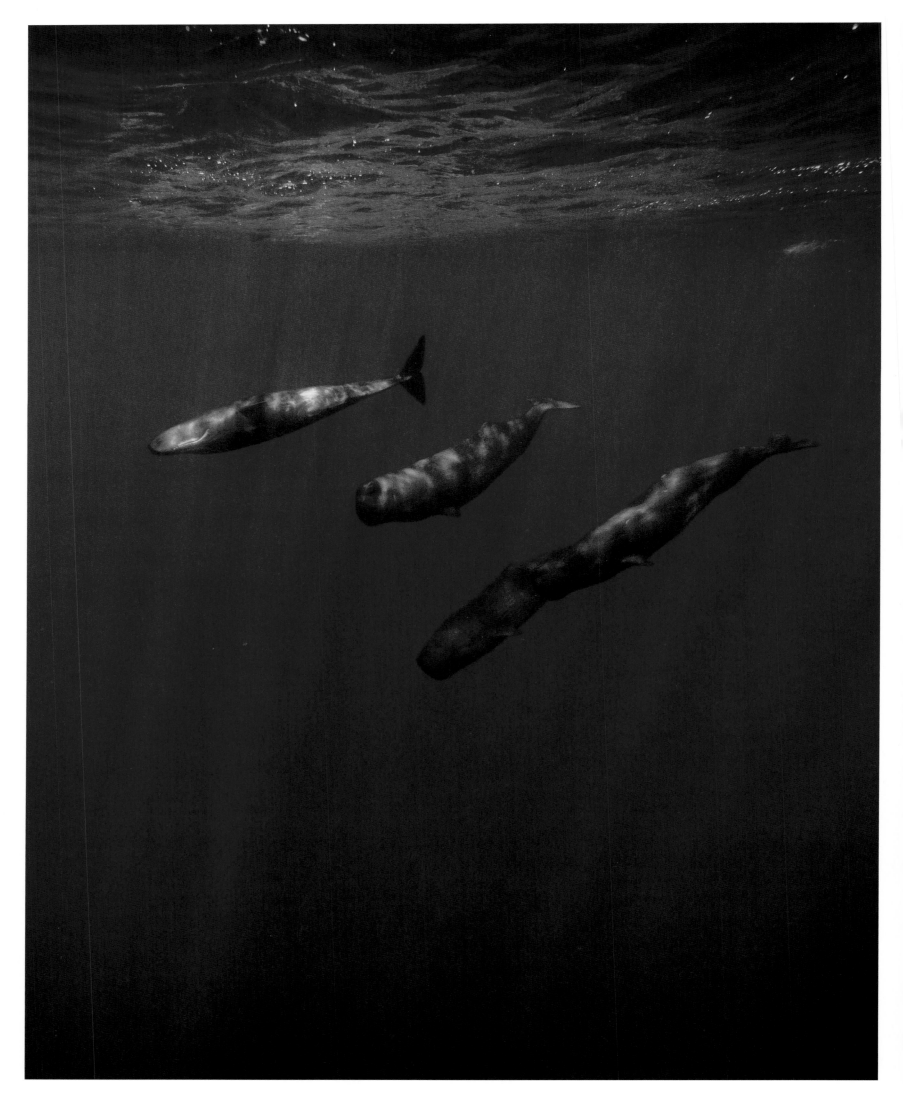

Our Planet's Biggest Predator

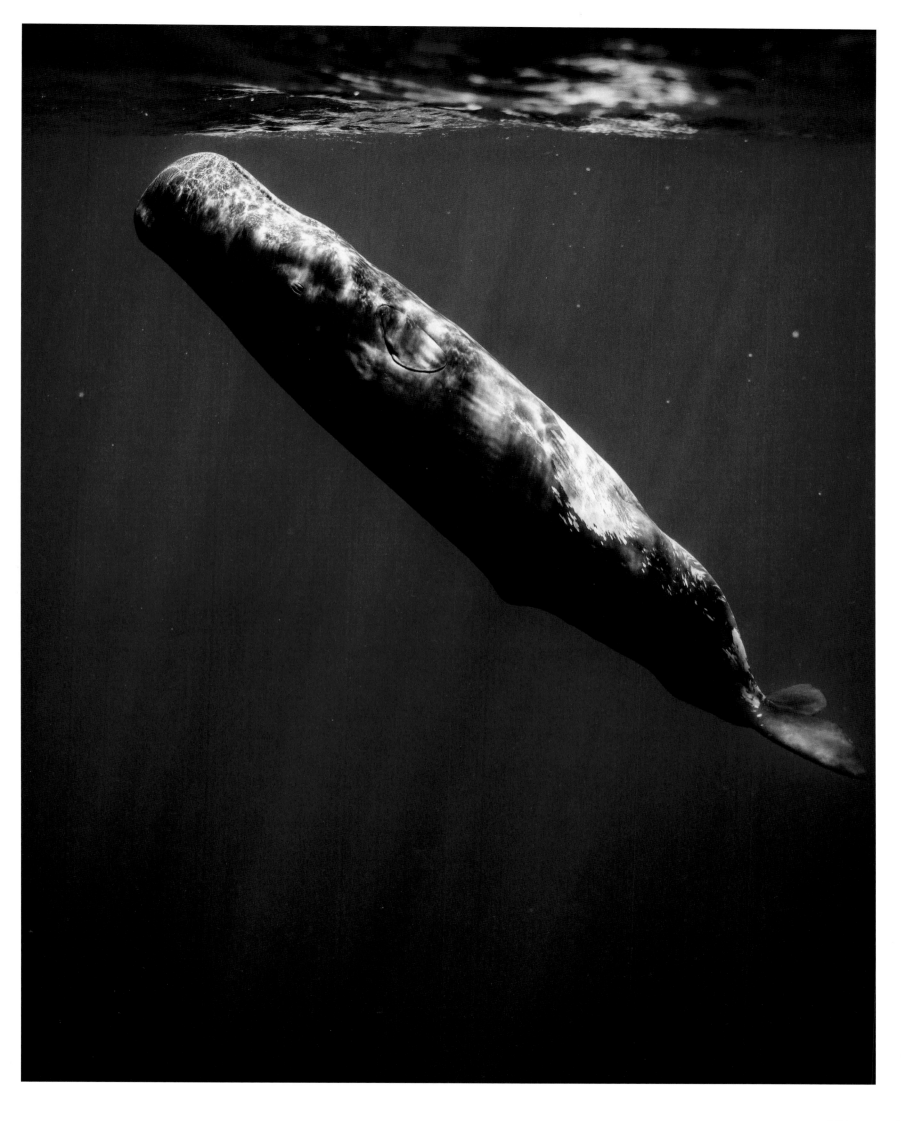

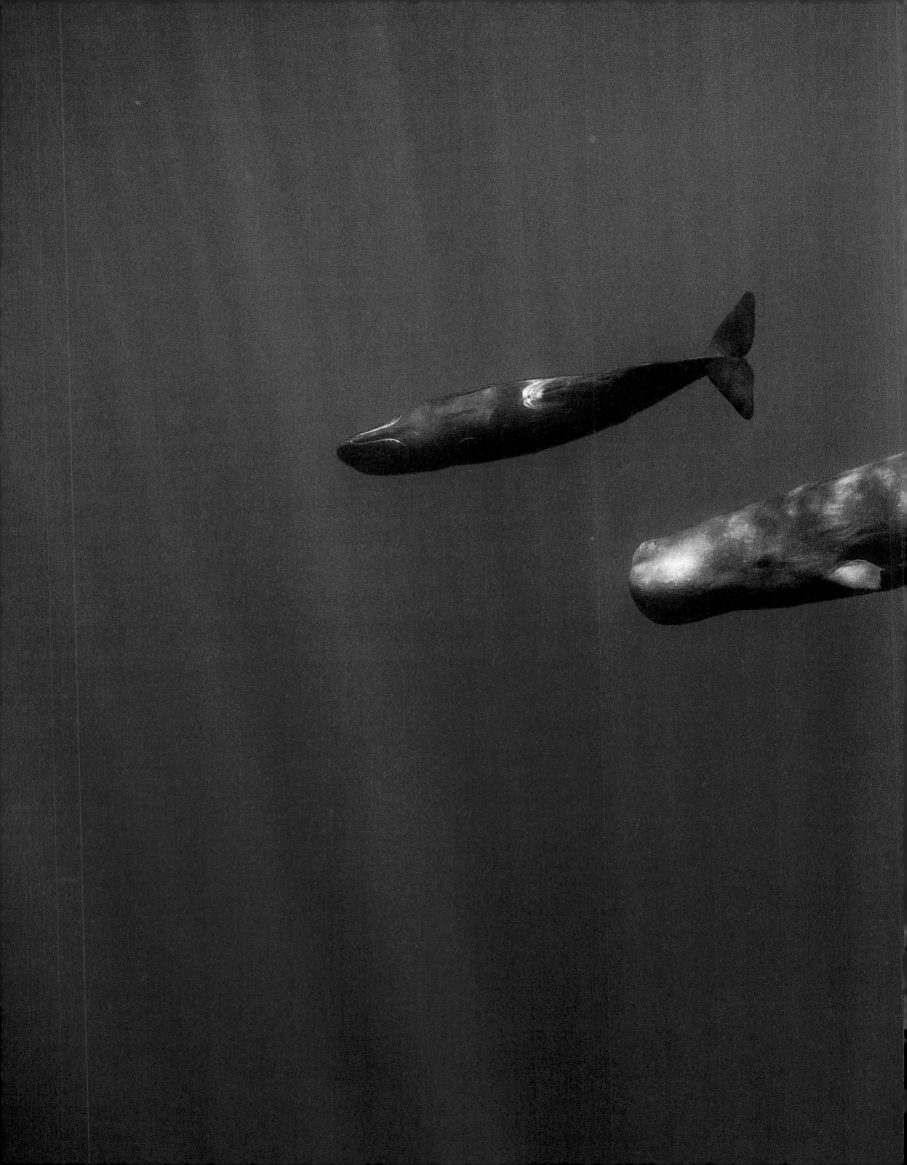

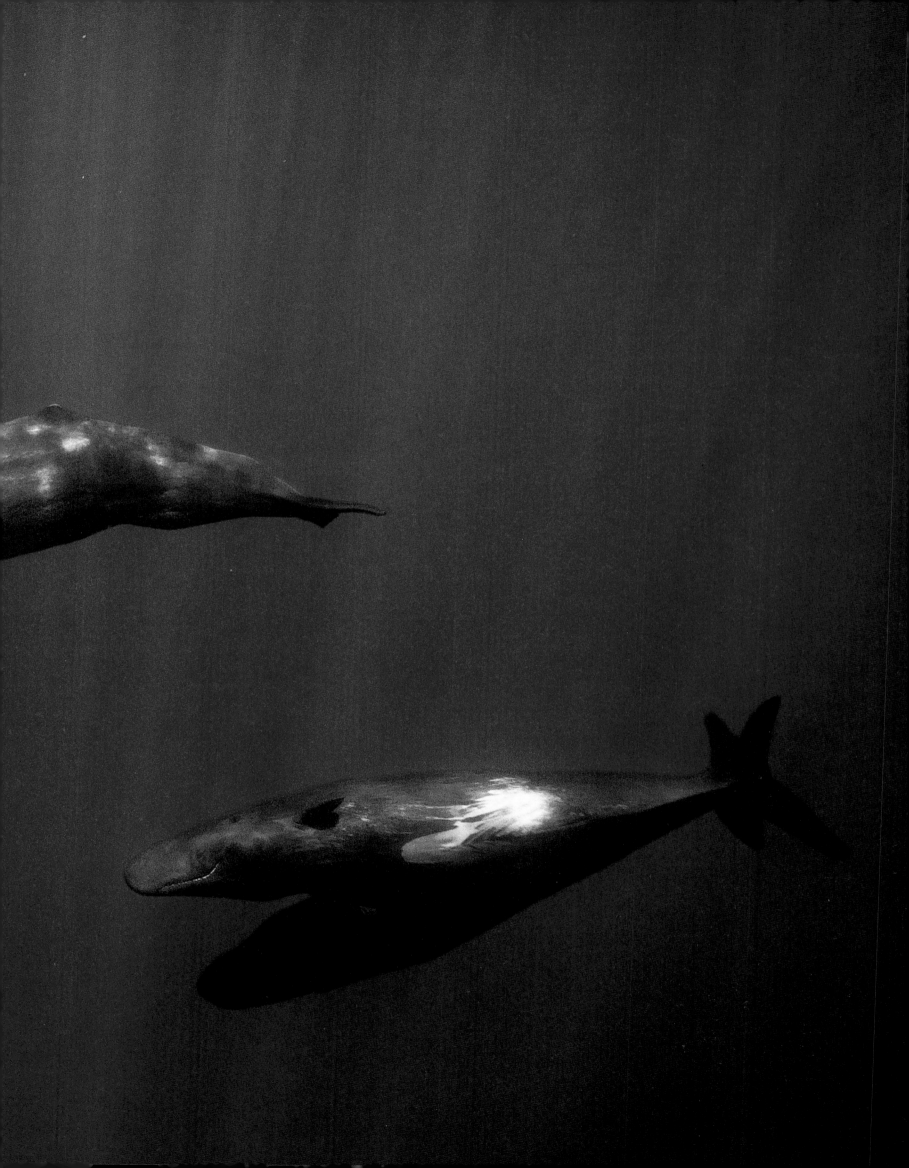

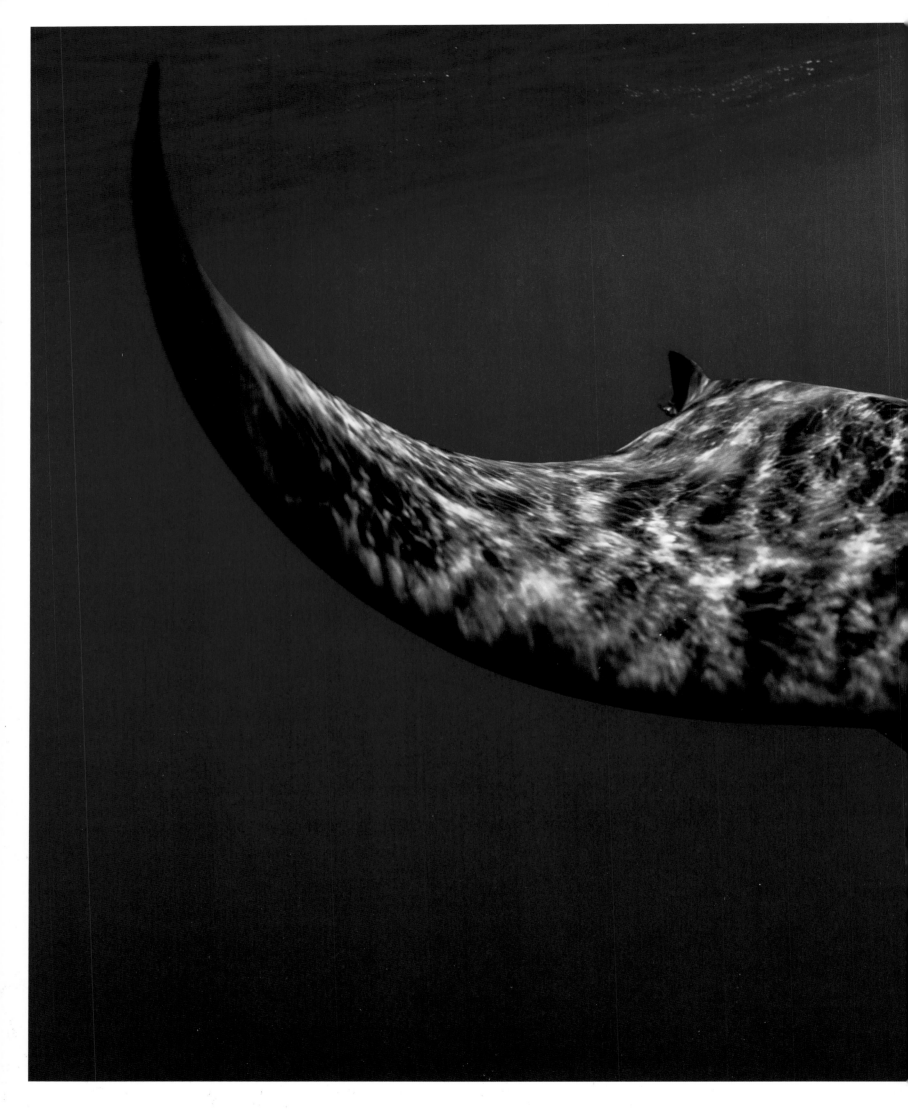

Our Planet's Biggest Predator

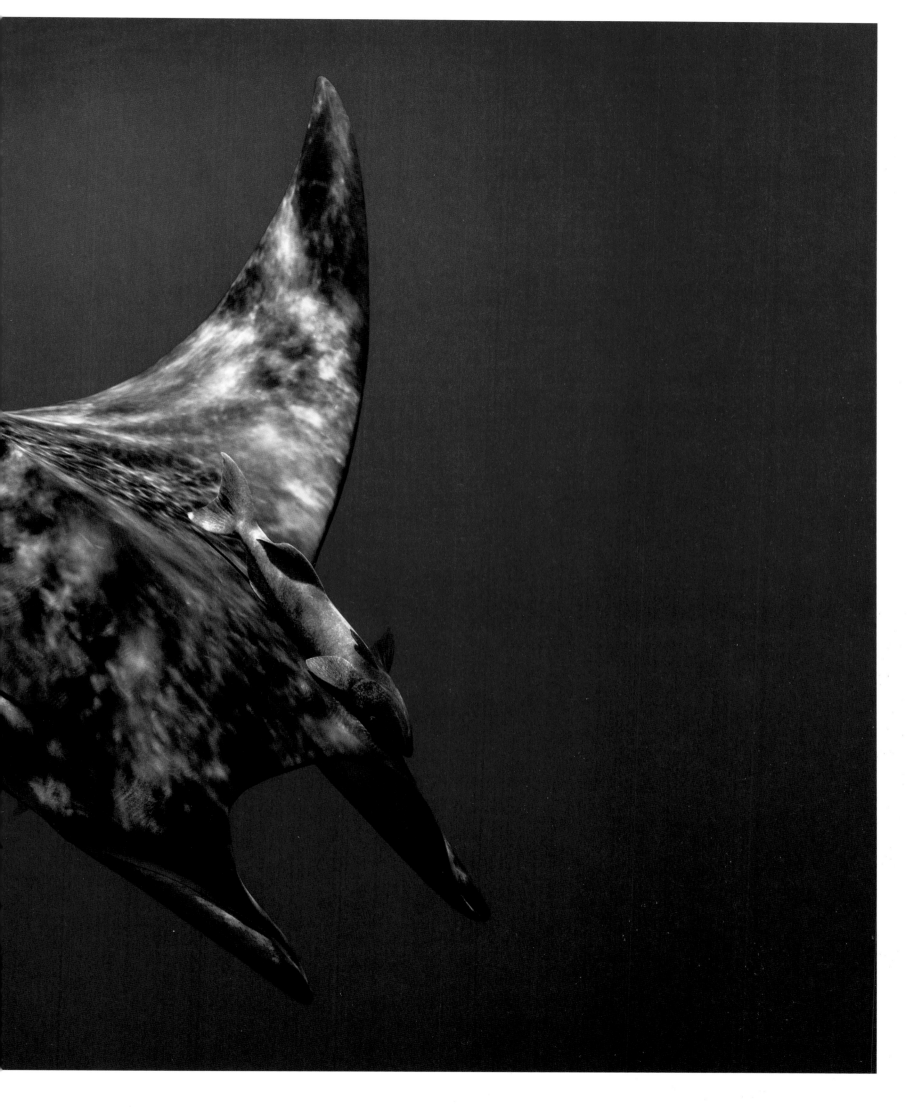

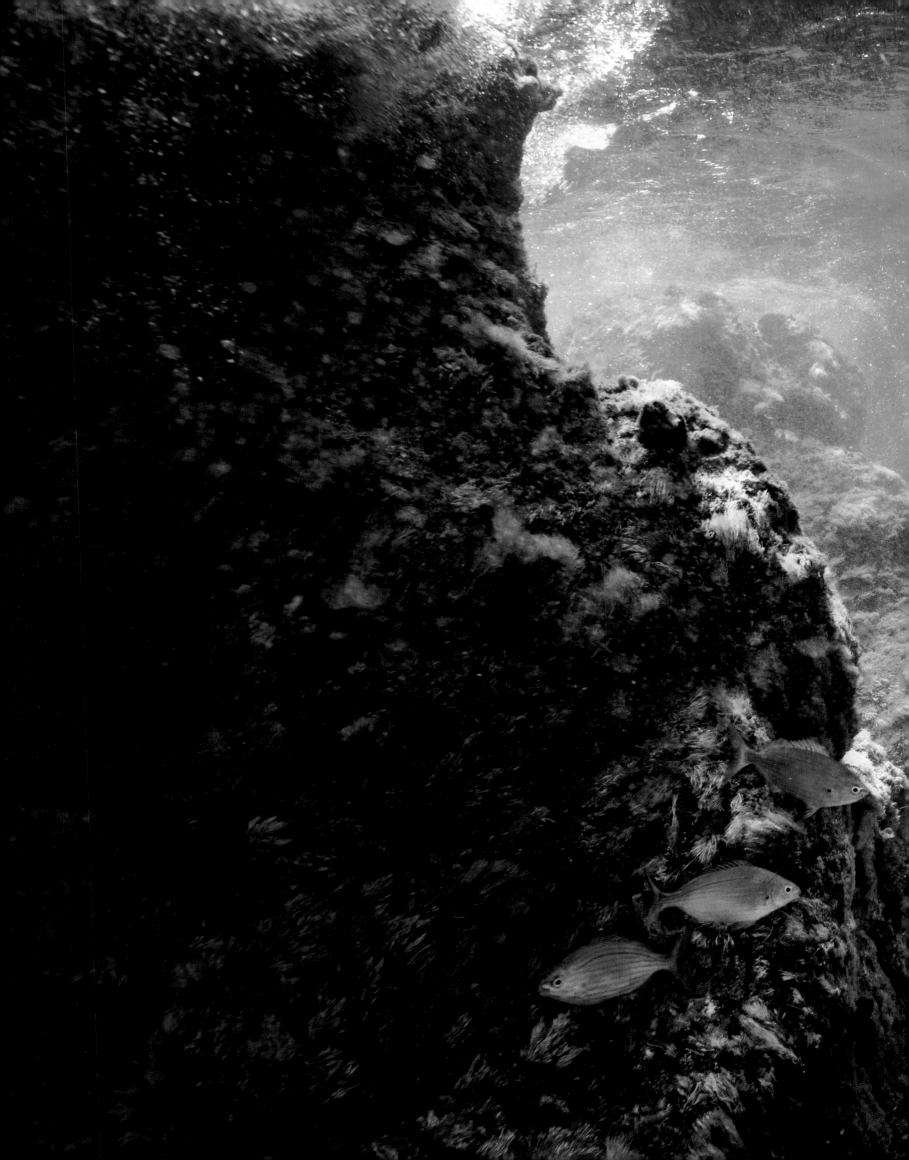

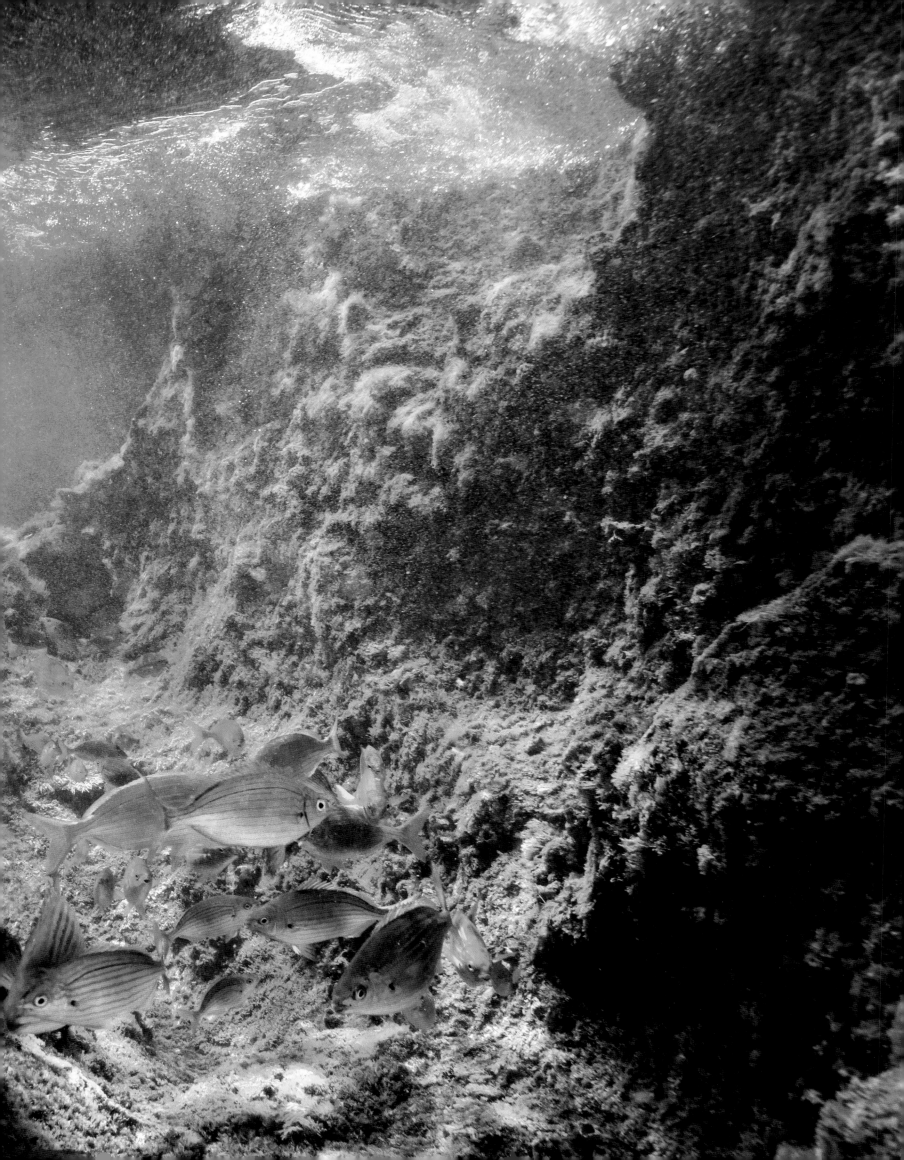

Our Planet's Biggest Predator

Sperm Whale

"Even when I was a kid, my favorite animal has always been the sperm whale. Back then I used to try and imagine what a fight between a giant squid and a sperm whale in the darkest depths of the ocean might look like. Even now, we have no photographs of such a struggle—we can only use our imagination."

Habitat:
oceans across the globe

Sounds:
Sperm whale can produce loud sounds. According to theories, these sounds may incapacitate or disorient the sperm whale's prey.

Depth:
they dive up to 10,000 feet deep (deeper than any other species of whale)

Sperm whale and humans:
There are verified accounts of sperm whales attacking whaling ships. In 1820, a sperm whale struck the Essex, an American vessel, causing it to sink.

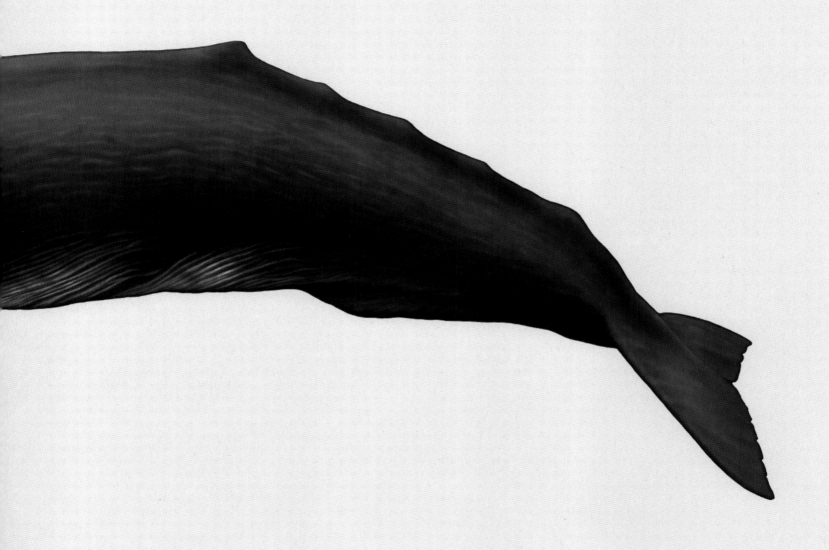

Info | Sperm Whale

Moby Dick—probably the world's most famous sperm whale. It is a gentle giant yet at the same time the world's largest predator. Sperm whales have been hunted for centuries for their blubber, spermaceti (a waxy substance in the sperm whale's head), and ambergris (produced in the whale's digestive tract). By now, sperm whales are lis- ted as vulnerable and are under protection. Male sperm whales can reach a weight of more than 60 tons and a size of up to 65 feet. Females are somewhat smaller, averaging around 40 feet. They mainly feed on squid and cuttlefish, and they dive deep on their hunts.

Behind the Scenes

After traveling to Tibet and the Amazon region of South America for my first two photography projects, the decision to make our oceans the focus of my third major project was purely intuitive from the outset. The choice reflects the prevalence of the subject, the need for change, and my love for the sea.

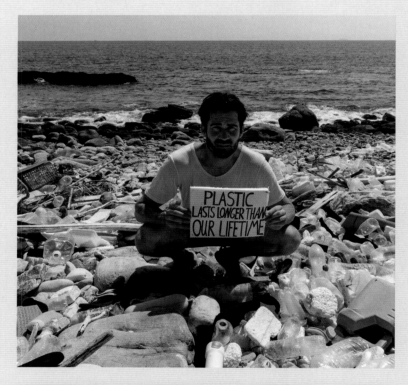

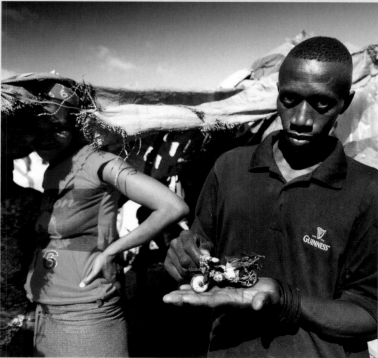

As with my previous books, I wanted to not only create a spectacular photography volume but also spotlight current topics that are meant to inspire reflection—and do it without wagging a moralistic finger. Through my work, I would like to impart to readers a feeling that there is something out there in need of protection. But how does one create such a book, and how does one provide an impetus toward a change for our planet?

The problems facing the oceans have been confronting us for some time now; and no doubt, there are plenty of very beautiful photography books on the topic of oceans. So what makes this book different than the others? The question is easily answered: The difference is that I establish a relationship between the beauty we must save and the tasks that lie ahead for all of us. These are problems we already know how to solve, and the solutions to them were developed by people no longer willing to watch but rather to take positive steps to save our oceans. Their work restores our faith that there is still time to act, and to me it makes them "heroes," and the protagonists of my project. And so the title was conceived: *Heroes of the Sea*.

But as with each of my books, a lot of work went into preparation, especially since there would be a documentary film to organize at the same time. Which problems were most important to me? The most inescapable? Where was I supposed to find my heroes? And above all: What was the best way to

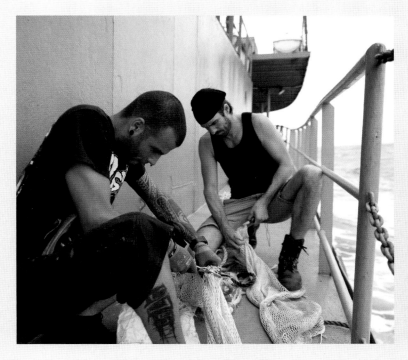

Together with the Sea Shepherd crew, we cut up ghost nets which we found floating in the sea during our mission.

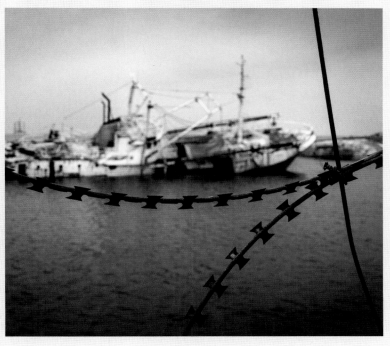

These former illegal fishing vessels were sunk just outside Port-Gentil harbor. They serve as a warning, reminding everyone that breaking the law in these waters will not go unpunished.

I will never forget this painful encounter with the tentacles of a jellyfish. The stings burn and throb like bee stings. The easiest and quickest way to lessen the pain is by pouring vinegar or urine on the wound.

represent their work? Sea Shepherd was intended to be part of the book from the outset. I am extremely impressed by this organization's work—which made it all the more delightful for me to have the privilege of being on board the Bob Barker and experiencing the activists live-and-in-person during one of their deployments. And David Katz, who took a lot of time from his schedule to spend with us in Haiti, was also one of my heroes from the very beginning. Through weeks of research, countless emails and telephone calls as well as a bit of luck, I eventually got the rest of the project's heroes lined up and was finally able to begin planning the trips.

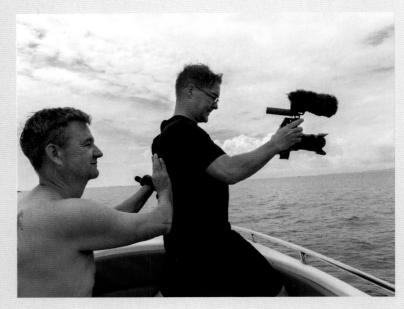

As probably anyone can imagine, some things do not go as planned on time-consuming expeditions like these. Underwater photography is moreover one of the most difficult kinds of photography—and I had a lot to learn in this area. The cameras, be it for stills or video, are stuck in bulky underwater housings, and you need a lot of extra light, not to mention the diving equipment. On top of that, there were the drones for aerial shots, storage media, and computers. It was often hard to fit all this gear into a simple suitcase, especially since the suitcase did not always reach its destination on time—which forced me, several times, to improvise with the simplest technology. But there were entirely different problems that caused me far more trouble.

On one trip in the Indian Ocean, I became seriously ill—and as if that by itself weren't enough, it happened on a tiny, totally isolated island. I developed an abscessed tooth that was getting worse by the minute; I had to interrupt my work and start the return trip pumped full of painkillers. Another time I suffered a ruptured eardrum which resulted in me getting a nasty middle ear infection. In West Africa, I got snared by the tentacles of several jellyfish—which is really painful and can end very badly depending on the species. In polar seas in the Arctic, the dry suits at the diving station were already all booked up, temperatures were icy, near freezing, and I got

to jump into a raging sea in a wetsuit when there were orcas about. Not to mention the rivers contaminated with feces that my camerawoman and I had to wade in up to our knees, the sabotage of our ship in the Azores, or the classic blow-out in our rental car . . . the list could go on forever; but the obstacles that can confront a person, even on a perfectly planned trip, are the point. What remains in the end are the memories of an unbelievable time and a great story. I love the obstacles just as much as the successes because they end up being stepping-stones for me in my work.

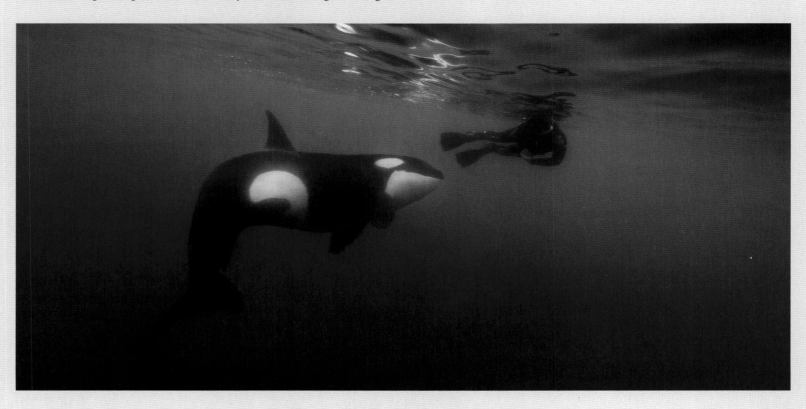

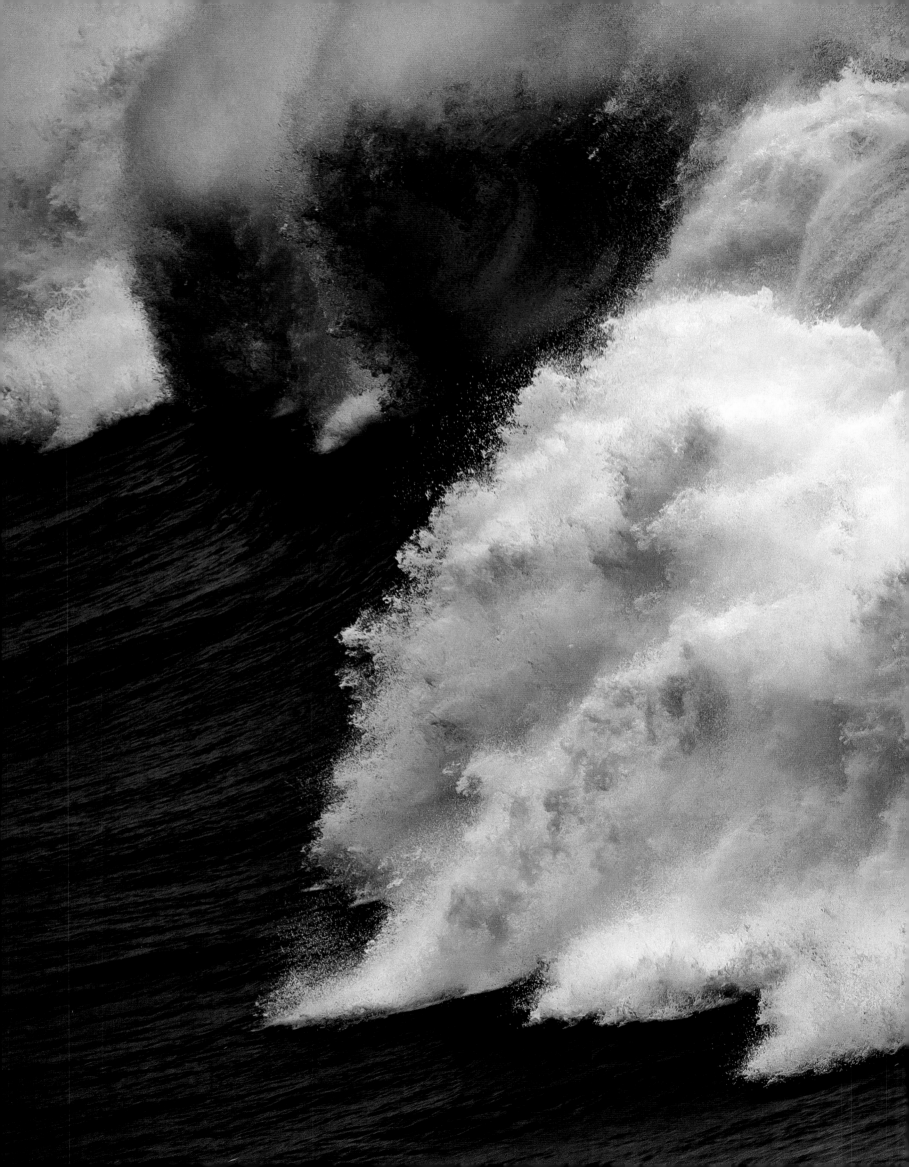

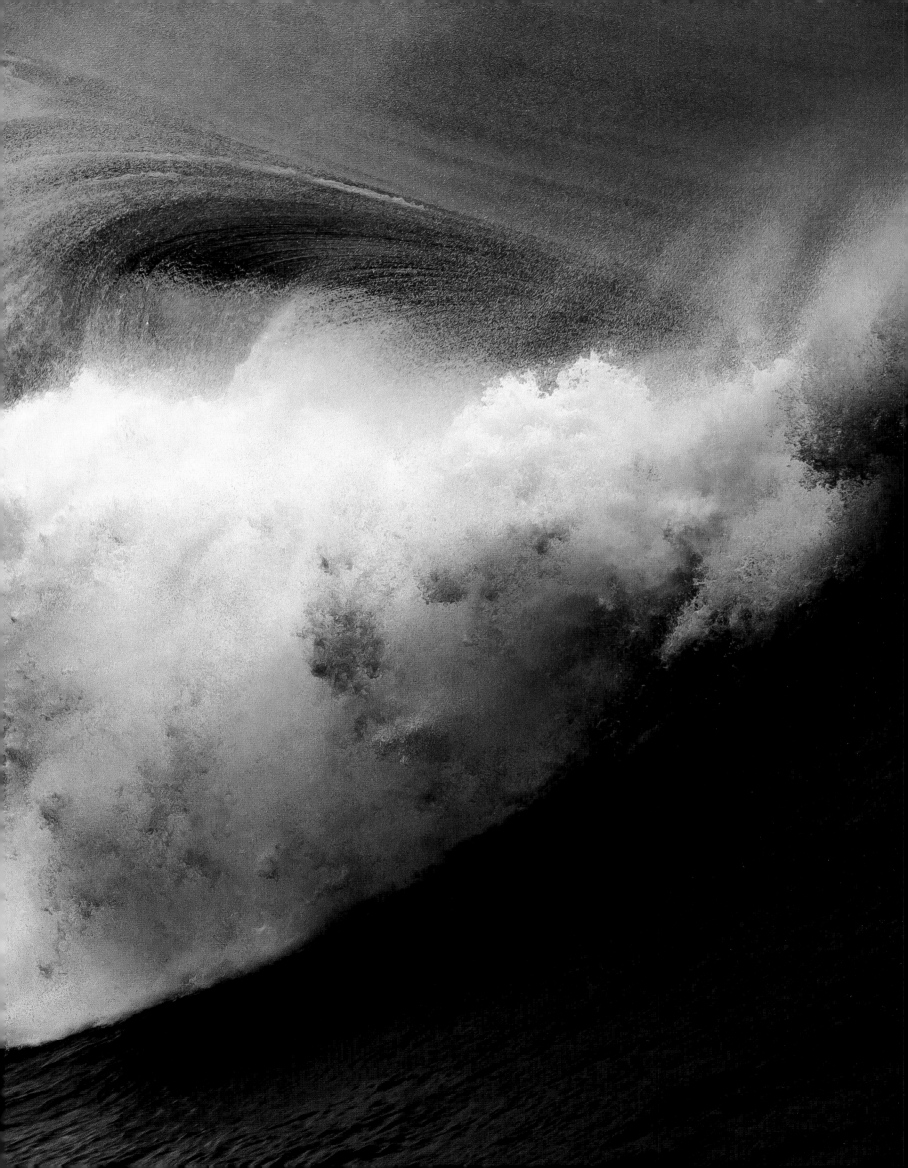

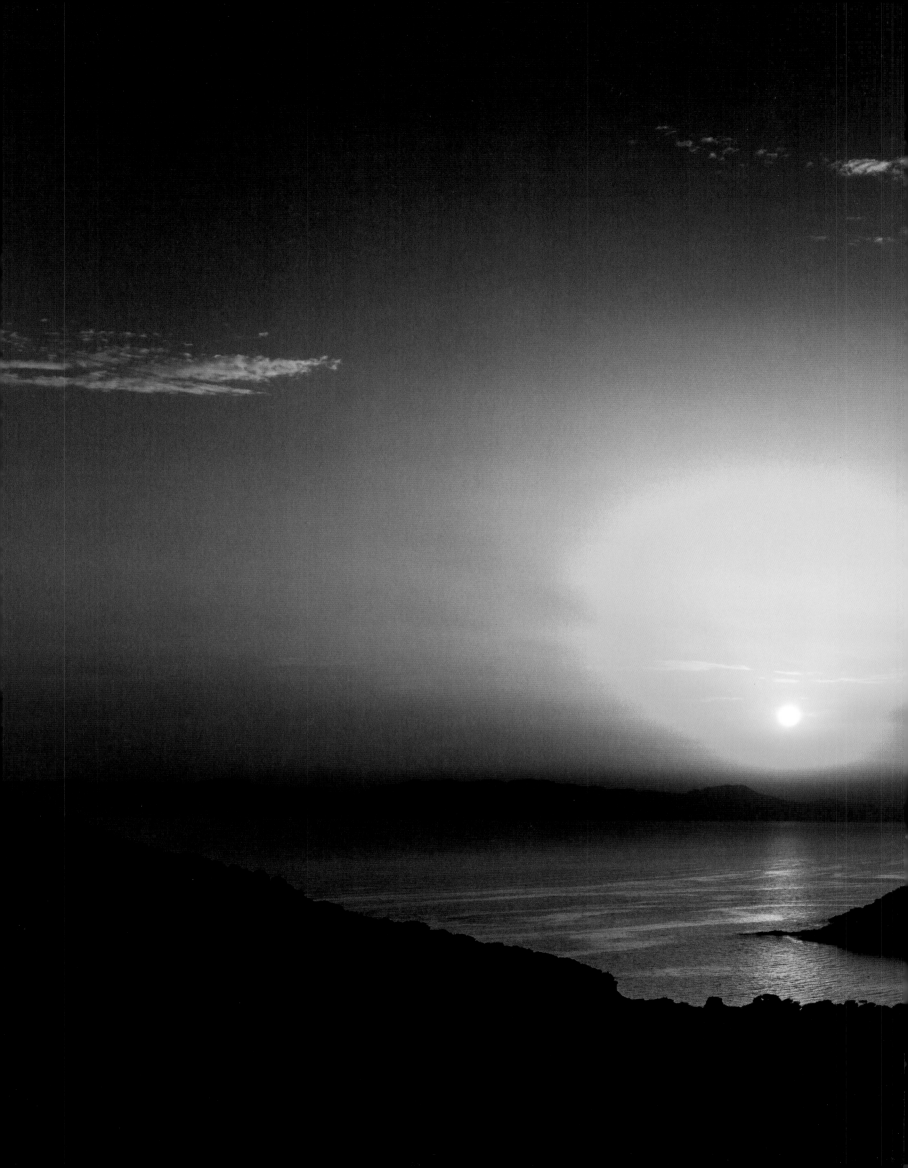

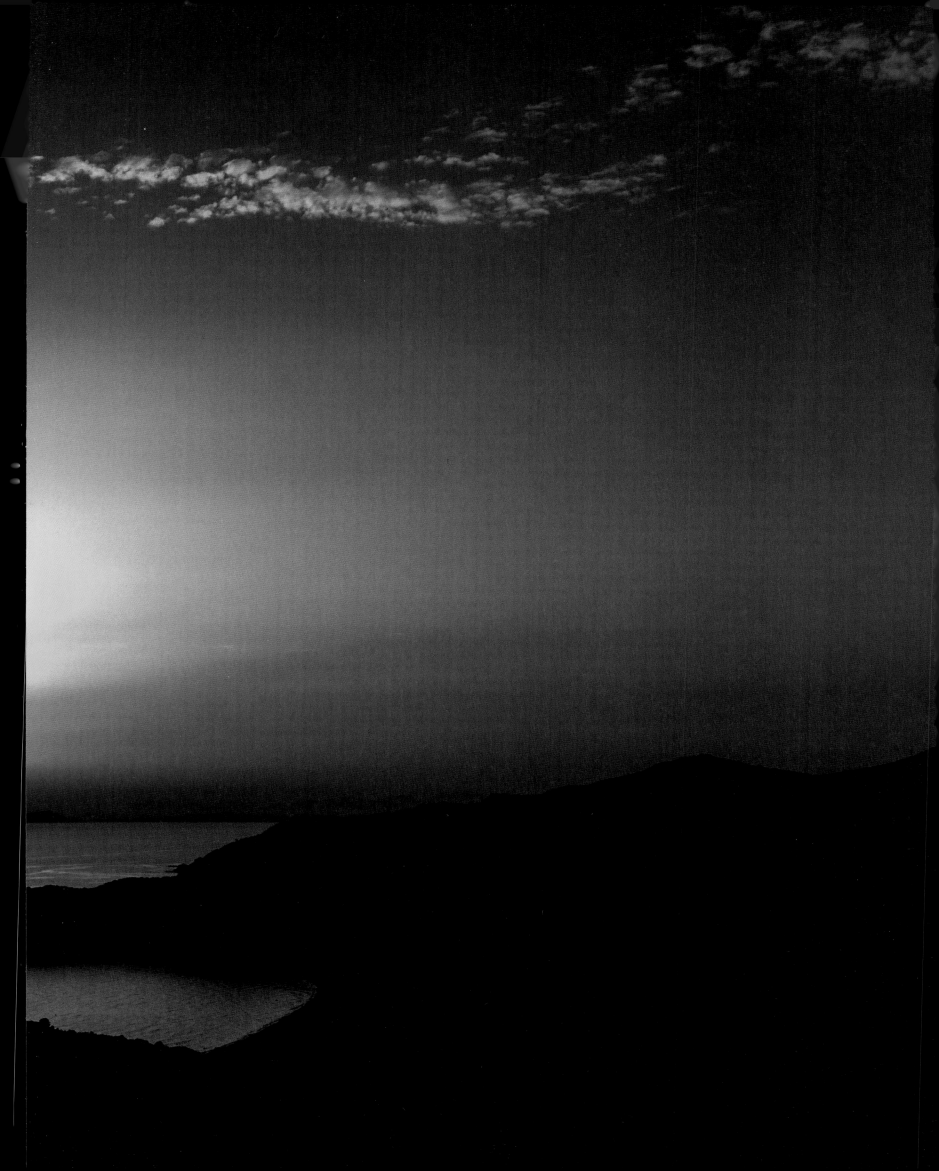

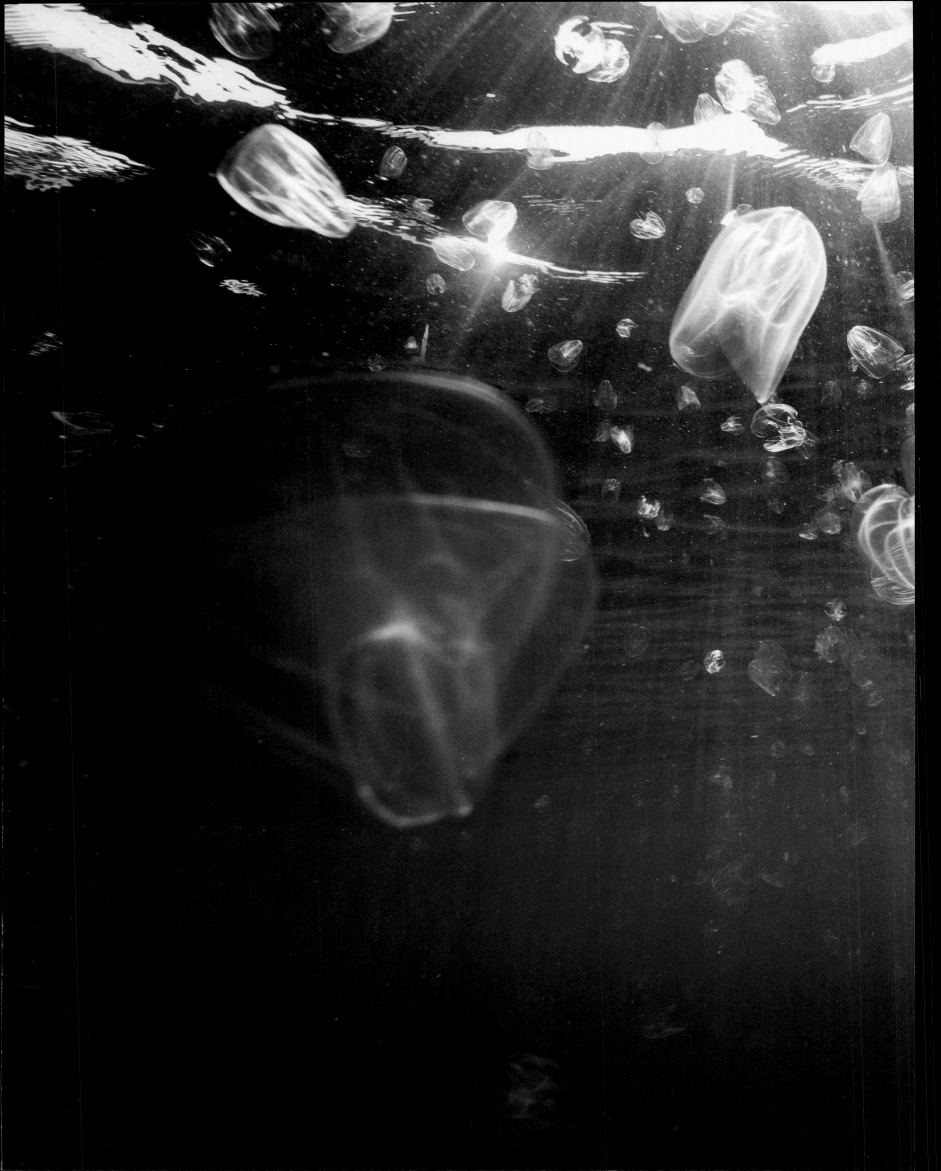

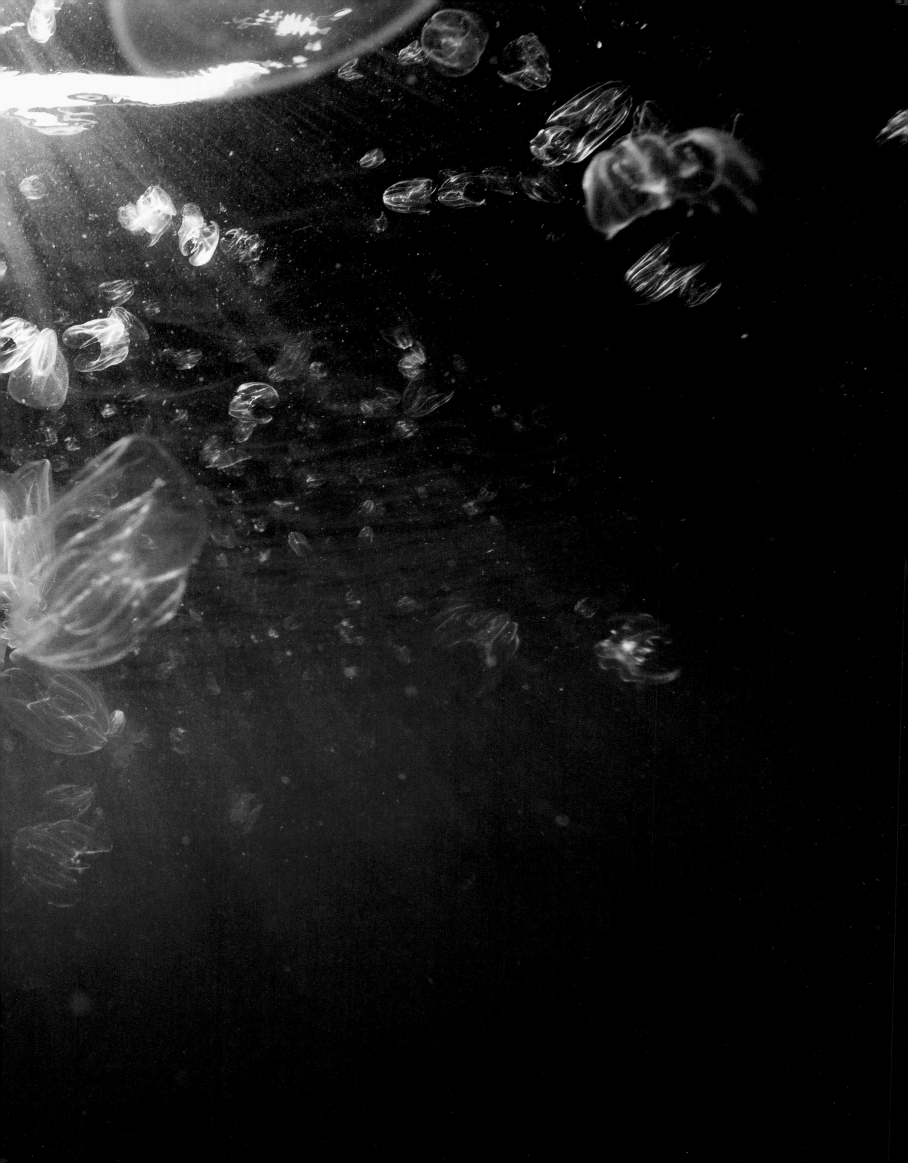

Imprint

p. 58, 115, 212, 217: © Katrin Eigendorf
p. 131 (below): © Alejandra Potter Gimeno
p. 172: © Sabine Streich
p. 211 (above left): © Michael Schinner
p. 211 (below): © Michael Rauch
p. 213 (below right): © Josh Guyan
p. 38/39, 80/81, 122/123, 148/149, 176/177, 206/207:
© Les Gallagher-Fishpics

Foreword by His Holiness, the Dalai Lama
Translations by John A. Foulks and Judith Kahl
Copyediting by Roman Korn
Proofreading by Christian Wolf
Design by Robin John Berwing and Robin Alexander Hopp
Editorial coordination by Roman Korn
Production by Nele Jansen
Color separation by Jens Grundei

ISBN 978-3-96171-215-1

Library of Congress Number: 2019945163

Printed in the Czech Republic / Tesinska Tiskarna AG

Bibliographic information published by the Deutsche
Nationalbibliothek
The Deutsche Nationalbibliothek lists this publication in the
Deutsche Nationalbibliografie; detailed bibliographic data are
available on the Internet at http://dnb.dnb.de.

Published by teNeues Publishing Group

teNeues Media GmbH & Co. KG
Am Selder 37, 47906 Kempen, Germany
Phone: +49-(0)2152-916-0
Fax: +49-(0)2152-916-111
e-mail: books@teneues.com

Press department: Andrea Rehn
Phone: +49-(0)2152-916-202
e-mail: arehn@teneues.com

teNeues Media GmbH & Co. KG
Munich Office
Pilotystraße 4, 80538 Munich, Germany
Phone: +49-(0)89-443-8889-62
e-mail: bkellner@teneues.com

Berlin Office
Mommsenstraße 43, 10629 Berlin, Germany
e-mail: ajasper@teneues.com

teNeues Publishing Company
350 7th Avenue, Suite 301, New York, NY 10001, USA
Phone: +1-212-627-9090
Fax: +1-212-627-9511

teNeues Publishing UK Ltd.
12 Ferndene Road, London SE24 0AQ, UK
Phone: +44-(0)20-3542-8997

teNeues France S.A.R.L.
39, rue des Billets, 18250 Henrichemont, France
Phone: +33-(0)2-4826-9348
Fax: +33-(0)1-7072-3482

www.teneues.com

teNeues Publishing Group
Kempen
Berlin
London
Munich
New York
Paris

teNeues